KAFFE FASSETT

—

THE ARTIST'S EYE

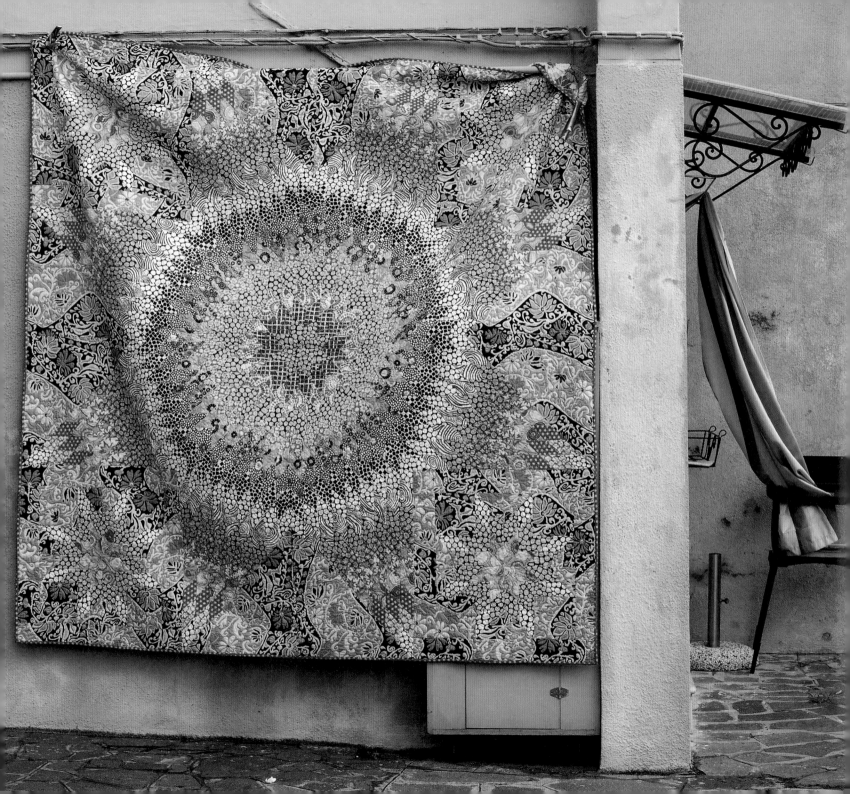

KAFFE FASSETT

—

THE ARTIST'S EYE

Edited by Dennis Nothdruft

With photographs by Debbie Patterson

Yale University Press, New Haven and London

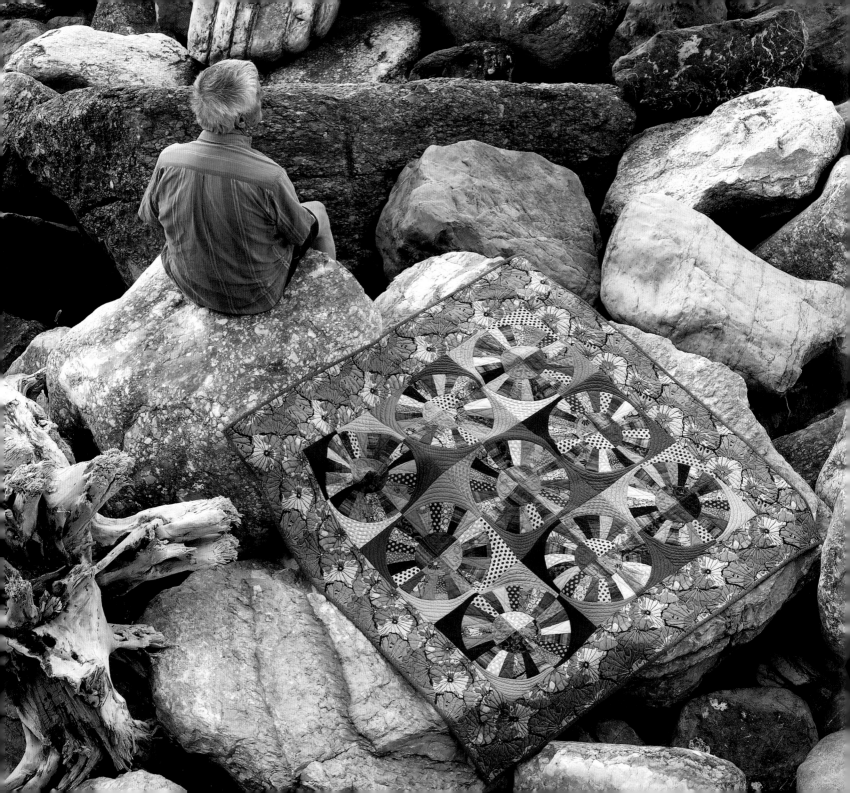

CONTENTS

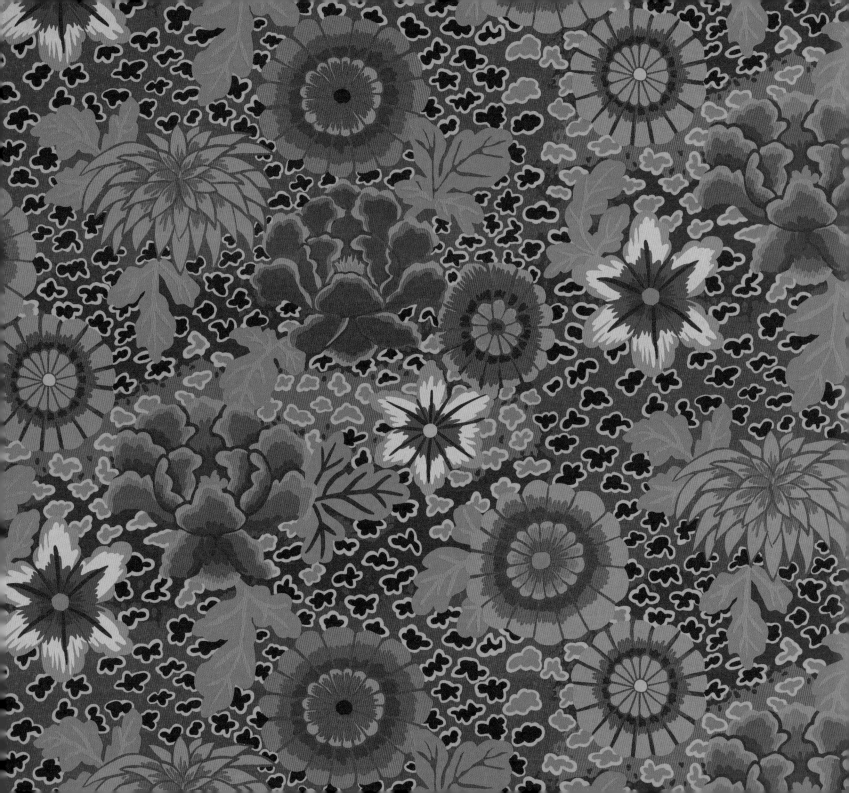

THE
ARTIST'S
EYE

Dennis Nothdruft

K affe Fassett. To his fans and admirers the name conjures colour, pattern and texture. Fassett's vivid vision has inspired people from all walks of life and all around the world to take up needles and fabric and paintbrushes. From his very early beginnings exploring painting and drawing, through to his international recognition as a designer in the textile arts, Kaffe Fassett has elevated making.

'I am definitely a missionary – my work brings me such joy achieved with such simple techniques that I want everyone to experience this way of expressing their own creative ideas...'[1]

This largely self-taught artist and designer has influenced the fashion industry, home knitters, artists, makers and needleworkers since the late 1960s. What is it about Fassett's work that has captured and held people's imaginations?

With his all-encompassing eye, Fassett absorbs the world around him. Everything is grist to his creative mill, what he has referred to as an 'intensity of seeing' as he processes everything around him.[2] Through the creation of quilts, paintings, knitwear and needlepoints Fassett's sensory experiences become pathways to the engaging of our own senses.

Fassett's career blossomed in a time of great creativity that emerged from the countercultural currents that were emanating from London, to which the artist relocated in the 1960s. The ideas of craft, of making, of ornament and decoration as seen in the past and repurposed for contemporary art and design would inform Fassett's creative processes – and continue to do so today.

This book of essays and interviews explores Kaffe Fassett's work in context and examines his career in relation to other movements in the art world and in craft, to locate his practice within a trajectory of the history of late twentieth-century art and design. The design historian Mary Schoeser celebrates Fassett's collaborative spirit in her essay, 'The Carnival of Creative Collaborations', and fashion historian NJ Stevenson examines the context of his career in 1970s London in 'A

The terrace at Nepenthe, Big Sur,
California, late 1950s

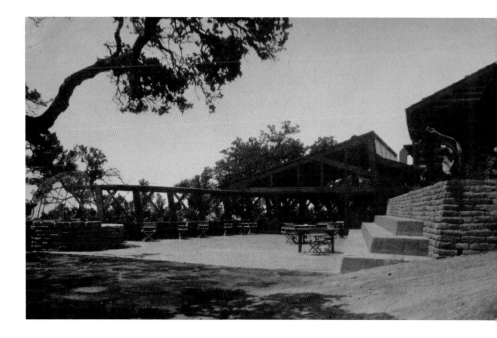

Continuous Connection'. Debbie Patterson, the photographer who has worked with Kaffe Fassett on his books since the 1990s, shares her own insights into the artist's work.

Kaffe Fassett emerged from the fulcrum of Northern California's artistic community in Big Sur, where his parents had established a restaurant and artistic centre they named Nepenthe, perched 800 feet above the Pacific Ocean. It was here that the young Fassett discovered the freedom of artistic expression, being encouraged to act, dance and paint in an atmosphere of creativity and experimentation.

'For artists, writers, and other counterculture types, Nepenthe became a mecca, a refuge for travellers and seekers, the famous and not so famous, and way station for those passing through, out of which grew the myth and legend of Nepenthe.'[3]

Kaffe and his siblings roamed the mountainsides and beaches around Nepenthe and in Big Sur, and the artist learned at an early age to use his environment to find inspiration: he noted that he could 'look at things more intensely if I got bored or sad. There was always something to light me up – even the greyest of rocks revealed delightful hidden shades when studied closely.'[4] This spirited family, with their sojourns in Europe and artistic temperaments, would inform Kaffe's childhood and be reflected in his own life and work.

Kaffe Fassett's early artistic career, which featured acting as well as painting, took him across the United States and eventually back to Northern California, where he continued to paint. His various experiences as he travelled from his home on the West Coast to the East Coast and back again included acting, modelling, drawing and painting, including a stay with the famous American heiress Doris Duke. His work at the time reflected experimentation as he painted landscapes, portraits and still lifes, working in a variety of styles.

Fassett's line drawings reflect the vision that he would bring to his craft and design work. These early drawings in

Self Portrait with Flower Vase, 1962

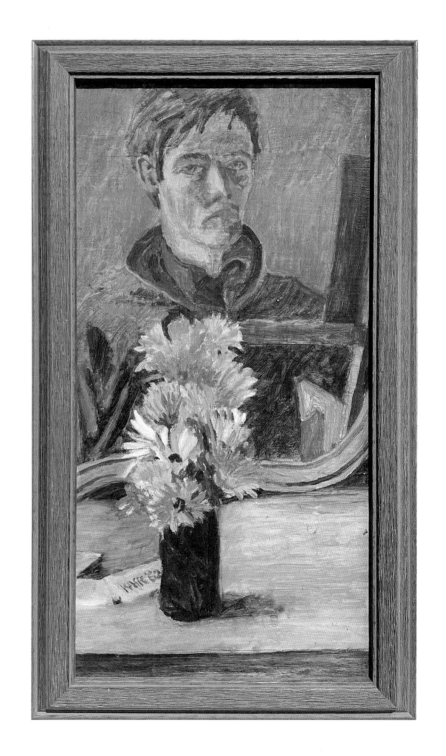

pen and ink convey a large variety of information in each illustration, complicated, full of detail and multi-layered. His later work would continue to explore this approach and feature the artist's attraction to groups of objects: the act of collecting, the putting together of found objects to create his still lifes informs his approach to the applied arts for which he is known today.

The American writer Henry Miller, a close neighbour in Big Sur, described Fassett's early paintings as 'joyous' and recognised in them a 'spirit of optimism' that remains key to the artist's ongoing production.[5]

Onward to England
In 1964 Fassett left for England to stay in the London flat of a friend, Jeremy Fry. This trip would prove to be a pivotal point in the artist's career, as he would never live in America on a full-time basis again.

'*I loved seeing lashings of colour and pattern in elegant room settings. Many great British houses made wonderful use of porcelains, carpets and patterned floors – an exciting mix...*'[6]

Fassett's move to England would prove to be the key to unlocking his creative energies – and his success. After the vivid light and brilliant colours of California, Britain's pearlescent atmosphere and subtle colour palettes were to prove an ongoing inspiration for him:

'*What I loved, which was strange, was that the love of colour and pattern came out but in a restrained way. You didn't pull out all the stops and have a Russian Circus, you had, you know, a very elegant way of coming in but was still full of pattern and colour.*'[7]

England's history and its decorative arts would also inspire him as he began to collect china such as creamware, patchworks and quilts. These treasured finds, collected in multiples, would form the basis of a significant point in the development of the artist's work.

Fassett would go on to exploit this repetition so skilfully in his knitting and quilting designs. He began with still lifes, stacking and arranging tablescapes of white china against a white cloth, occasionally adding found materials or 'sometimes eggs, or folded paper'.[8] It is in the 'white paintings' that we begin to see processes developing that continue to inform his career. These layered arrangements of white on white allowed the artist to create paintings 'centering on that world of light or reflected light and shadow'.[9]

KAFFE FASSETT

Line drawing of Bath, England, 1960s

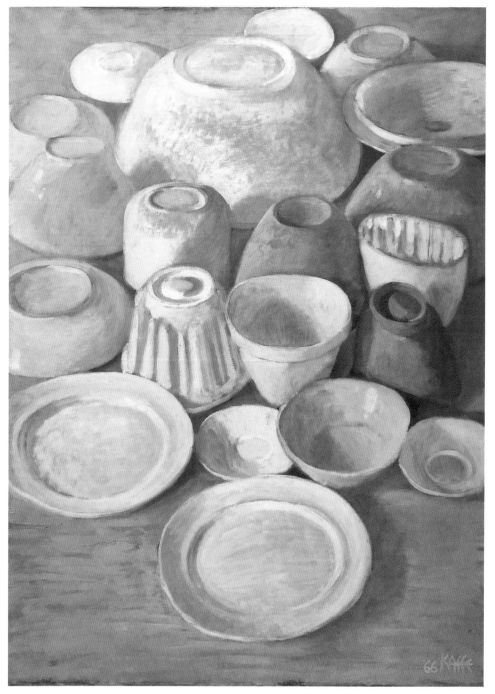

Line drawing of Widcombe
Manor, Bath, 1964

Pale Bowls, 1966

White on White, 1960s, shown
at the *Color Duets* exhibition,
Monterey Museum of Art, 2021

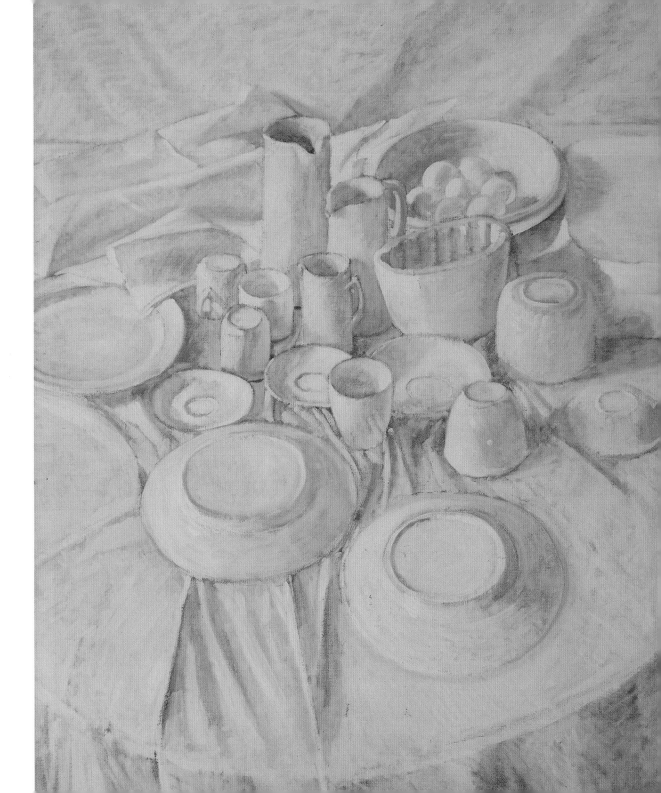

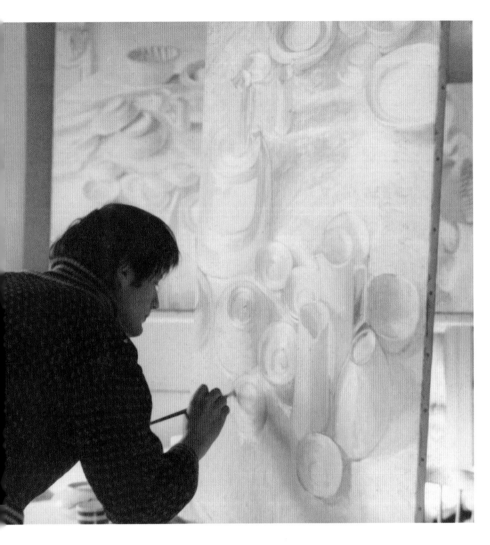

Fassett painting white china in the Lansdowne Crescent studio, 1969

Fassett in the Lansdowne Crescent studio, 1969

The first cardigan knitted by Fassett, late 1960s

We also begin to see Fassett's distinct relationship to colour and what can be perceived to be a starting point for his later explorations through a variety of material. Whereas we may look and see a stack of creamware bowls or an arrangement of pale vases and pitchers that are all more or less white, Fassett sees a myriad of colours: every possible shade of white and cream is noted by the artist and, importantly, he reveals to us, the viewers, those shades and tones as well.

Scotland and knitting

In 1966 Fassett had a fortuitous encounter. He met the Scottish fashion designer Bill Gibb, then a student at the Royal College of Art. It was a meeting that would form a relationship with important outcomes for Fassett, both personal and professional, and set him on a journey into the applied art of knitting that would change the course of his career.

It was on a trip to Scotland, to Gibb's family home in the far north of the country, that Kaffe Fassett became enchanted with the landscapes of the Highlands and the subtle but varied colours of the region:

'Our train to western Scotland took us through the most subtly coloured landscape I had ever seen. Lichen-covered stones rested beside rushing streams of peat-stained amber water. Bracken in strawberry-blond tones, mixed with purple and lavender heather, covered the rolling hills.'[10]

He also became intrigued by the beautiful woollen yarns produced there. On his first trip to Scotland he bought skeins of many different colours, which a family member of Gibb's knitted into a multi-coloured striped jumper. Although close to what Fassett had envisioned, this was still too vivid for what he had in mind. On a subsequent trip he purchased a large selection of wools in shades of heathers, mosses and stones. On the train back to London a fellow passenger, Alice Dunstan Russell, taught him how to knit, setting the artist on his path to becoming one of the most recognised knit designers in the world.

Kaffe Fassett's first knitted jumper was a simple long-sleeved cardigan but with a multitude of thin stripes in all the gradations of coloured wools reflective of the Scottish landscapes. His relationship to colour was immediately obvious and the explorations of subtle shades and tones in his white paintings and still lifes came to life in yarn.

The process of knitting unlocked something within the artist as his natural facility combined with the practices he had developed within his painting. Knitting would become the medium that would bring Fassett international recognition, allowing him to organise 'the tsunami of information that flowed through' his head,[11] and remains for him 'the most centering and therapeutic'.[12] Fassett's instinctive feel for colour and for pattern, for the rhythm of the knitted material, brought the concepts that he had been exploring in his artwork to life in a new, and unexpected, three-dimensional form.

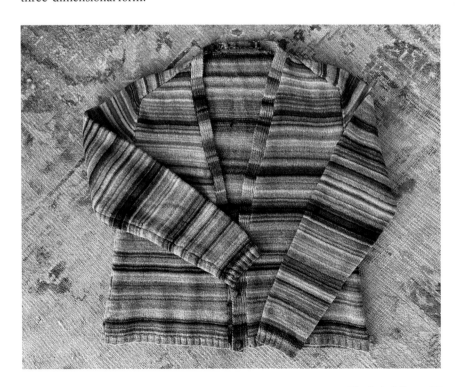

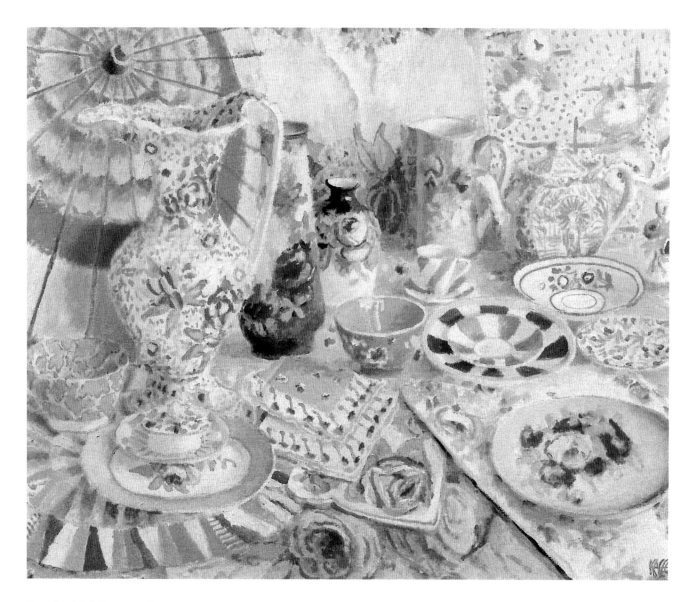

Parasol and Soft Flowers, 1998,
exhibited at Catto Gallery,
London, in 1999

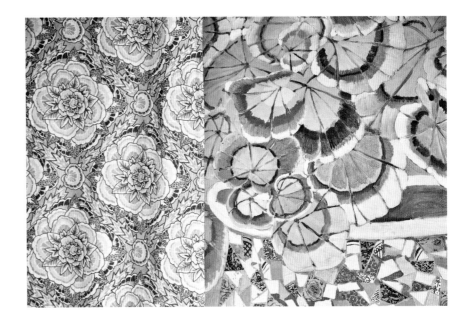

'Geranium' collection fabric
by Designers Guild, 1976, with
painting by Kaffe Fassett

Knitting takes off

Fassett's knitted designs began to be promoted through
influential magazines like *Vogue Knitting*, which had
published his first knitting pattern and where he became
good friends with the editor, Judy Brittain. Through his
collaborations with Gibb to create knits for the designer's
fashion collections, his ability was noted by others. A call
in 1969 from Tai and Rosita Missoni – then running an
internationally successful knitwear business in Italy – found
Fassett showing them his recent 'collection': a box of small,
'gnarled' knitted swatches that the artist kept in his flat.[13]

This was enough for the Missonis, who promptly invited
Fassett to come to their factory in Italy to design a collection
of knitted fabrics for them. The visit allowed him to explore
in depth his ideas of colour and pattern with the latest
technology. The resulting designs were used by Missoni for
several collections and helped to ensure the firm's reputation
as one of the most fashionable knitwear brands of the time.
Tai and Rosita Missoni, with their innovative approach to
machine knitting, recognised and shared Fassett's sense of
colour. Working in the factory, Fassett was in his element:
'watching colours come alive when they connect with each
other and exude their innate richness is a joy I connect with
every day as I work ... Rosita and Tai Missoni, being sensual
Italians, saw at once where my talents lay. I never had to
explain myself.'[14] The chance to work out his designs for
knitwear on such an advanced and comprehensive scale
gave Fassett the opportunity to push the boundaries of his
own designs.

Alongside work for Gibb and the Missonis, Fassett
continued to paint. In 1975 he was visited by Tricia Guild
of the interior firm Designers Guild, who came to purchase
a painting. Guild was inspired by Fassett's artistic eye and
suggested that he work with Designers Guild to create
textiles for their collections. The resulting designs, including
the seminal 'Geranium' design, were successful, and Fassett
would work with Designers Guild for several seasons.

The focus of Fassett's work during the 1970s continued to
be painting and knitting, with commissions to create hand-
knit garments to order for private clients. Weaver Richard
Womersley began to work with Fassett in 1972, assisting
him with knitting and needlework. A veritable *Who's Who* of
London's style cognoscenti and international stars such as
Barbra Streisand made their way to Fassett's studio to order

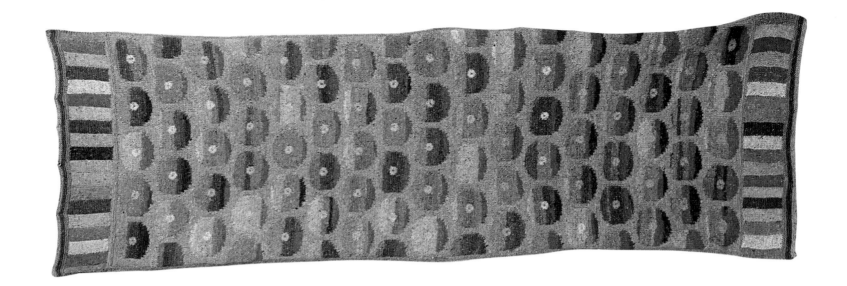

unique pieces of wearable art. It was during this period that Fassett also began to work with the knitter Zöe Hunt in his studio, to help keep up with demand and to help develop new designs. Hunt was able to create patterns for knitted garments from Fassett's ideas and inspirations. As his textile work gained more and more recognition, Fassett noted that:

'Textile designs were starting to captivate me like this at every turn. After trying to remain a pure fine artist, I thoroughly gave in to the life of a craftsman – or, you could say, my artistic ideas transferred to the textile world. Something about creating fabric – be it knitting or needlepoint – was far too motivating for me to abandon and return exclusively to easel painting.'[15]

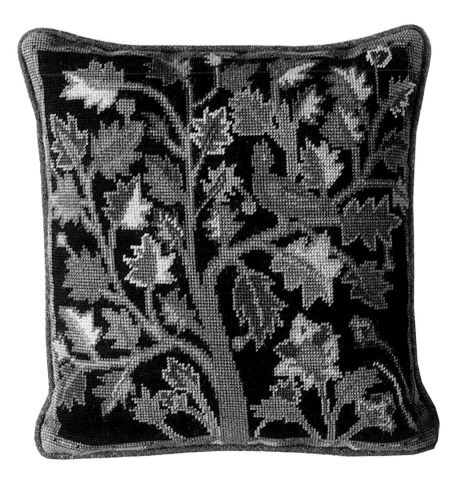

Persian Poppy shawl,
commissioned piece, 2021

Night Tree needlepoint cushion,
2015

By the 1980s Fassett's knitting had gained much attention. With the photographer Steve Lovi, a close friend and collaborator, in 1985 he created his first book, *Glorious Knitting* (published as *Glorious Knits* in the United States), conceived as a large-scale art book with beautifully composed and photographed full-page images of the knits but also including patterns. Fassett credits Lovi with providing the impetus for the project, his inspiration and art direction pushing Fassett to experiment with his knitting. It took some convincing to get a publisher on board, yet when it was published, *Glorious Knitting* caused a sensation in the knitting world. Fassett's patterns were complicated, with multiple colours and intricate patterns, but knitters embraced his vision. *Glorious Knitting* sold out its initial run of 40,000 copies in two weeks, such was the appetite for Fassett and Lovi's vision.

Fassett's knitting books introduced one of the keys to his success – the idea that we, too, can create, that the richness of colour and pattern that the artist sees is available to us, to make for ourselves. Fassett has always encouraged people, through his books, television programmes and the workshops, to have a go, to *try*. It is the possibility and potential of creation that weaves its way through his work to the viewer and active participant.

Needlepoint and mosaics

From the knitting and the successful books and television shows that accompanied them, Fassett began to work with needlepoint, another domestic craft that he would use as an artistic medium to great effect. His experience of England, and of visiting stately homes where antique needlepoints and tapestries were used and seen in the setting for which they were intended, and the patina that they acquired over decades, provided inspiration for the works he went on to design in needlepoint.

His first needlepoint was originally intended as a design for his friend Pamela, Lady Harlech, who had asked him to create a design for her to stitch. He painted out an original design for her on canvas, deciding to add in a few stitches to indicate the colours. Before he knew it, he had completed the design.

In his knit designs for Bill Gibb and Missoni and in his own work, Fassett had explored pattern and colour. With his needlepoint, the artist was able to work highly intricate pictorial designs that utilised far more colours than he had been using in the knitwear. Fassett created detailed designs, closely related to his paintings, in which he could explore reflected light and shadows. His book *Glorious Needlepoint* (1987), which his collaborator and the photographer Steve Lovi encouraged him to produce, went on to be an even bigger bestseller than *Glorious Knitting*.

In 1999 Kaffe Fassett published *Mosaics* with his friend Candace Bahouth, a fellow American living in the West Country. Bahouth's home, where Fassett had stayed, had wonderful mosaic details around doorways, window frames and sinks. Bahouth taught Fassett mosaic techniques and they worked together on the book. Mosaic work features in Fassett's North London home, framing the entryway and adorning the bathrooms and kitchen. His love of found objects is apparent in his approach to his mosaic work as cups, saucers and broken shards of china find their way into the designs he created with Bahouth. Antonio Gaudí's mosaic work in Barcelona and the famous Watts Towers in Los Angeles provide another inspirational starting point for Fassett's work in this particular medium, as have the colourful mosaics encountered on his travels, 'one of the wonderful flights of fancy you would see. Even in drab cities or very formal cities, you would suddenly see a little mosaic that was just divine...'.[16]

Quilting

After much prompting, Fassett decided to try his hand at creating quilts, encouraged by his good friend and colleague Liza Prior Lucy. Like knitting, this first attempt at making patchworks and piecing quilts was a watershed moment in Fassett's career and his quilts would become the main output of the second half of his career. The first result was his book *Glorious Patchwork* (1997).

America has a long and rich history in quilt-making, and perhaps something of Fassett's American background spoke to this art form. He had visited and still remembers the seminal exhibition *Abstract Design in American Quilts* shown at the Whitney Museum in 1971. He felt that 'Large quilts would give a grand sense of scale to dramatize my use of colour, which my knitted garments could only hint at'.[17]

His very earliest quilts, made with Prior Lucy, used quilting materials that Fassett laid out in complex patterns. These quilts referenced traditional quilt forms and patterns; it is in the placement and mixing of colours and pattern that the artist's eye comes into play. Fassett's first quilts were an immediate success. Noticing that antique quilts used much larger-scale prints, Fassett began to design his own prints and colourways for quilting material. The first textile for patchwork designed by Kaffe Fassett, 'Roman Glass', continues to be produced today, its *millefiori*-inspired pattern, contemporary yet antique, showcasing his sense of colour and rhythm.

As Fassett developed his own fabrics, other quilters began to work with his prints, designing and making quilts that would sit alongside his own in the series of patchworking and quilting books that would inspire a whole generation. The response to his textile designs and his quilting was immediate and positive and continues unabated today: Fassett and his partner Brandon Mably now travel around the world giving workshops and seminars. These interactive sessions reflect the spirit of generosity within Fassett's work and have developed into a crucial link between the artist and makers. For Mably, the workshops have 'been a great part of both our educations – because we learn so much from doing those classes'.[18] Working with the participants, Fassett and Mably give people the confidence to explore ideas of colour and pattern in new and challenging ways, often with astounding results.

Vegetable carpet, or six cushions
made for Ehrman Tapestry, 1999

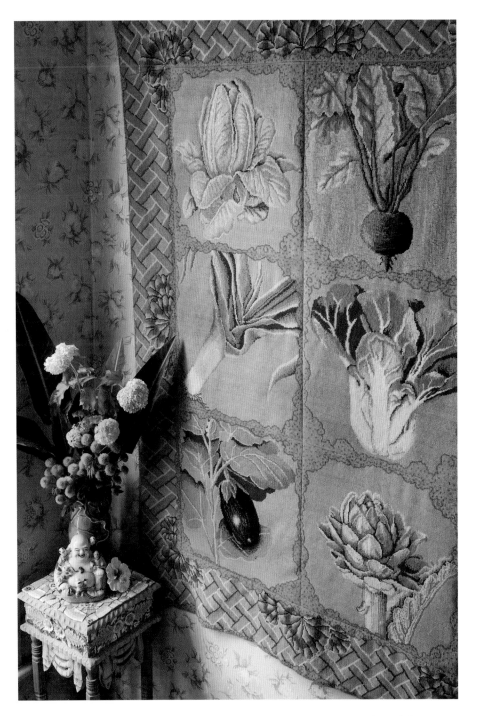

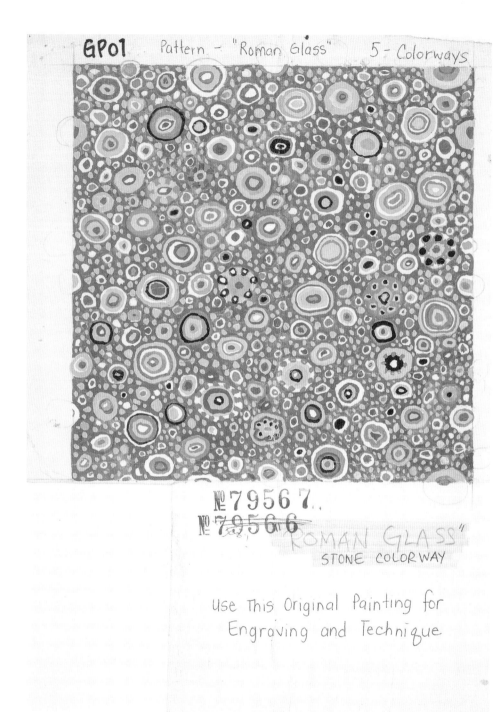

GP01 Pattern - "Roman Glass" 5- Colorways

№ 7956 7..
№ 7956 6

"ROMAN GLASS"
STONE COLORWAY

Use This Original Painting for
Engraving and Technique

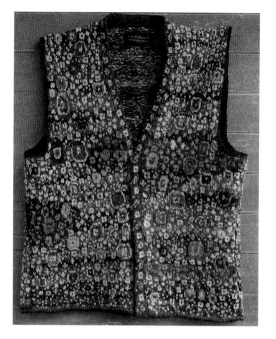

'Roman Glass', original artwork in gouache, 1994

Knitted waistcoat with 'Roman Glass' motif, 2000

Stoneware vase with 'Roman Glass' motif, 2000

Knitted coat – Fassett's first private commission piece, late 1960s

Brandon Mably and The Kaffe Fassett Collective

Today Kaffe Fassett works with a group of textile designers to develop collections of printed quilting fabrics under the umbrella of the Kaffe Fassett Collective. These designers include Brandon Mably and Philip Jacobs.

Mably met Fassett in 1990 and joined the studio as what he described as 'general dogsbody', doing general administrative work,[19] eventually coming to design alongside Fassett. Mably grew up in Wales and found Fassett's colourful and creative home and studio unlike anything he had experienced: 'it was like Aladdin's Cave. Everything was out, everything was patterned'.[20] Bringing order to Fassett's maximalist domestic sensibilities, the house and studio would become the 'colour lab' where design ideas were explored and developed. Kaffe Fassett and Brandon Mably continue to create together, living and working in an ever-evolving environment where the lines between art, design and craft merge.

With the introduction of the Kaffe Fassett quilting fabrics, and their attendant success, classically trained textile designer Philip Jacobs began to provide print designs for the new collections. His lush floral designs were developed in a variety of colours reflecting Fassett's use and understanding of colour, while Mably's designs for the fabric collections provide what he has called 'breathing space'[21] between the detailed and often pictorial designs by Fassett and Jacobs with their graphic and 'zany' abstract prints and witty motifs. The prints are presented under the Kaffe Fassett label and highlight the collaborative way in which his career has developed, as Mably explains:

'I will say Kaffe throughout his whole career ... has collaborated. He collaborated with Steve Lovi, he collaborates with Zoe Hunt, he collaborates with me, with Liza Prior Lucy. You know we love collaboration!'[22]

Tusker Bull, textile artwork by
Sophie Standing, created with
Kaffe Fassett Collective fabrics

Tea Party, knitted coat by Janet
Lipkin, California, 1987

The Roseville Album, quilt by
Kim McLean, created with Kaffe
Fassett Collective fabrics

Kaffe Fassett in context: the Pattern and Decoration movement

What has been interesting is the lack of critical evaluation
of Kaffe Fassett's career. His work across a varied field of
traditional crafts – knitting, needlepoint, quilting – and
his worldwide popularity in those disciplines has kept his
oeuvre out of the fine art world. Wearable art flourished in
California in the 1970s and '80s and it is perhaps fitting that
Fassett, also a product of California, should sit alongside
such important textile artists as Marian Clayden, James
Bassler and Janet Lipkin. Clayden, like Fassett, enjoyed
commercial success translating her resist-dyed artworks and
hangings into fashionable garments. Lipkin, whose primary
technique for both wall-based and wearable art is knitted
textiles, cites Fassett's work as an inspiration, noting that
'knitting did not limit him, he expanded his technique to
accommodate his ideas'.[23]

Kaffe Fassett's work – in both its fine and applied forms
– also sought to challenge the primacy of traditional fine art
approaches. For him the disciplines with which he has built
a career are important because they democratise his work:
the quilting, knitting and needlepoint he creates can be – and

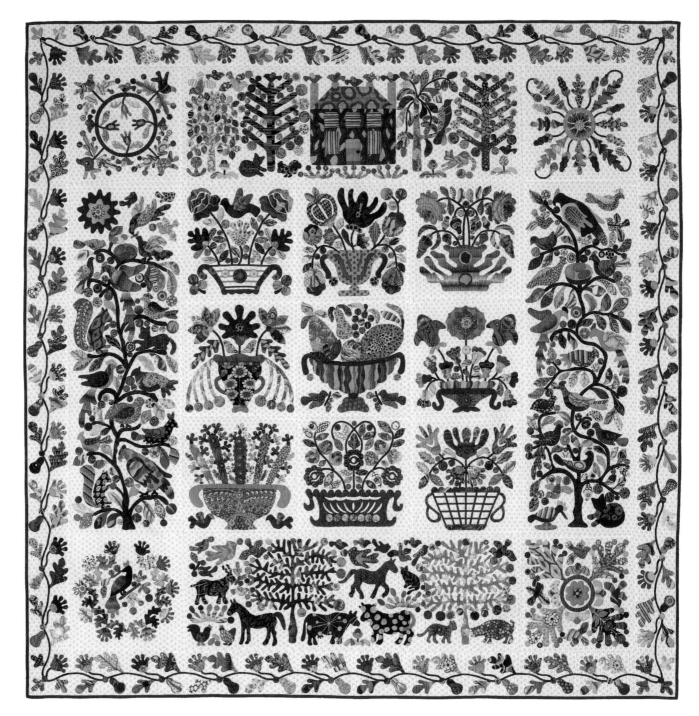

are – done by people around the world. According to Fassett, 'what I loved about crafts was that everybody could join me. They could and they did, it's not a mystery to them'.[24] This aspect, that his work can be shared with others, circles back to Fassett's early days in late 1960s London, where a communal spirit infused his early career.

Although Fassett's work developed in a craft medium, this was something that the artist had initially resisted. Reacting to the hierarchical structures inherent in the art world, Fassett viewed his paintings as the focus of his career. It was the sharing of his ideas, and that others could join in, take and adapt his work, that eventually won him over:

'This just is one of the reasons why I finally gave in and stopped fighting the idea of working in the crafts field. It was "Oh, Oh, as a Fine Artist do you really want to be dabbling in the crafts?" but what I loved about crafts was that everybody could join me.'[25]

This concept, that one could either be a fine artist or that one could make things, but not both, would be the point around which a group of artists in the United States would begin the pushback in the 1970s and '80s that would become the Pattern and Decoration movement, or P&D as it came to be known. Many of the ideals of the P&D artists of the time were shared by Kaffe Fassett: while their work would be celebrated in galleries and museums, Fassett's would remain, to many, outside the sphere of fine art and exist as craft.

The P&D artists sought to realign the established, mostly male, hierarchies of art history, and to reclaim the applied or decorative arts that had been consigned to the domestic, mainly female, sphere. P&D set out to destabilise 'systems of valuation that had dominated Western art history for centuries, and the primary focus was the hierarchy of fine arts above decorative arts, the cognates of the latter being ornament, craft, decoration, applied arts and sometimes folk art'.[26] Fine artists such as Miriam Schapiro, Robert Kushner, Sandra Sallin and Betty Woodman created art that disrupted the traditional view of male- and subject-centric art history and embraced ornament, pattern and craft.

The art of seeing

Kaffe Fassett's career over six decades has been one of seeing: seeing everything around him and taking it all in. His eye has captured the vividness and the subtlety of the world. An inveterate traveller and collector of experiences, he has found inspiration everywhere – from the most mundane street to the most colourful, exhilarating landscapes.

His home and studios are filled with his own creations, treasured objects collected over many years, the 'yarns, fabrics, photos, and manuscripts'[27] of his travels, talks and workshops. With Brandon Mably he continues to circle the globe, spreading his love of colour and pattern. What is striking is the joy that Fassett brings to the act of making; his visceral response to the pleasure of creating is evident – and contagious.

For this author, what Kaffe Fassett's work has come to represent is the possibility that we, too, can see the world with fresh eyes. We soak in the brilliance of brightly coloured flowers, we delight in the subtleties of a seashell's pale spots and swirls against the sand. Fassett shows us that it is possible. We can create, too, in whatever way appeals: through yarns and threads, needles and sewing machines, palette and brush.

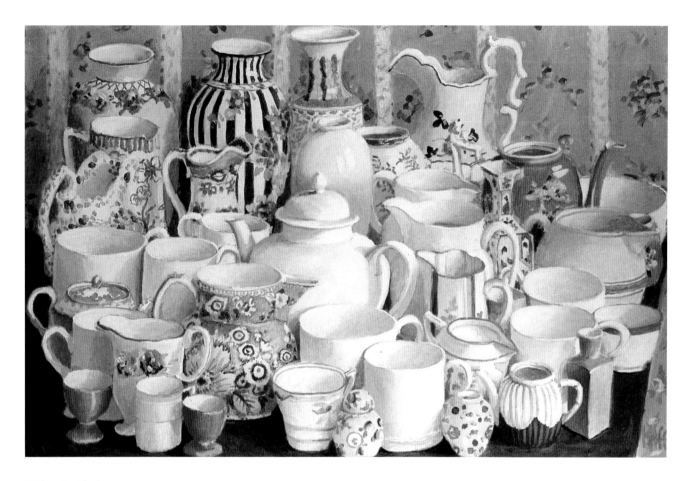

*Bridgewater Blanks, c.*2002,
exhibited at Catto Gallery,
London, in 2002

Notes

1 *Dreaming in Colour* 2012, p. 160.
2 Ibid., p. 28.
3 Steele 2009, p. 81.
4 *Dreaming in Colour* 2012, p. 28.
5 Kaffe Fassett in conversation with the author, 2022.
6 *Glorious Interiors* 1995, p. 6.
7 Kaffe Fassett in conversation with the author, 2022.
8 Ibid.
9 Ibid.
10 *Dreaming in Colour* 2012, p. 87.
11 Kaffe Fassett in conversation with the author, 2022.
12 *In The Studio* 2021, p. 171.
13 Kaffe Fassett and Brandon Mably in conversation with the author, 2022.

14 *Dreaming in Colour* 2012, p. 103.
15 Ibid., p. 95.
16 Fassett and Mably 2022.
17 *Dreaming in Colour* 2012, p. 95.
18 Kaffe Fassett and Brandon Mably in conversation with the author, 2022.
19 Ibid.
20 Ibid.
21 Ibid.
22 Ibid.
23 Email to the author, 4 March 2022.
24 Kaffe Fassett in conversation with the author, 2022.
25 Ibid.
26 Katz 2019, p. 21.
27 *Dreaming in Colour* 2012, p. 213.

KING OF COLOUR

Zandra Rhodes

Kaffe Fassett is the undisputed king of colour and patchwork. He has brilliantly transformed printed quilted textiles and the crafts of knitting and crochet into his own. Kaffe has very practically applied his designs to the home crafts movement, turning them into his own worldwide art form. He is a magician in the field of the home and home crafts, which have become so essential and meaningful to our lives, particularly during the Covid lockdown, when people had additional time to explore their creativity. Kaffe has given a new artistic approach to the world of home crafts, adding colour and style. He is additionally a great craftsman himself.

THE TANGIBLE AND THE INTANGIBLE

Sarah Campbell

Kaffe and his work have always been part of the landscape of my working life; there are only a handful of designers so single-mindedly pursuing the cause of colour and pattern.

In a field in which fashion and glamour can ignite with a whoosh and die back just as quickly, Kaffe has maintained his lifelong relationship with the absolute essence of his art – the tangible yarn, fabric, paint – and the intangible effect of colours upon each other and upon our senses.

His intense involvement with what colour does is a private and enduring passion; he has great skill in translating that into the accessible – knitting, stitching, quilting, sewing – so that everyone can be welcomed into his world, pick up their needles and re-invent his discoveries for themselves.

In sharing his work so generously he shares his enduring love affair with his art; it's no wonder that his influence is felt so far and in so many homes. The enormous contribution he has made to the understanding of colour, composition and construction within hand-sewing and knitting and beyond, cannot be underestimated. His revelations get right to the heart of the matter.

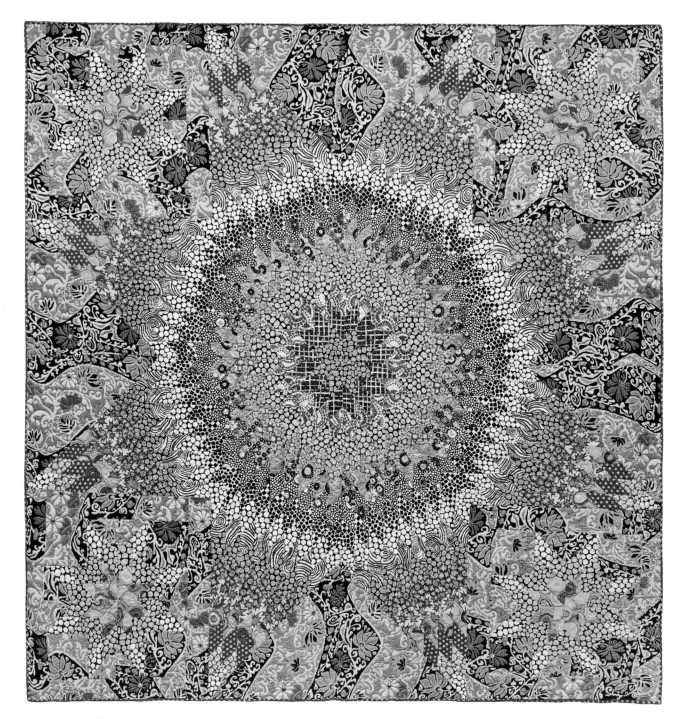

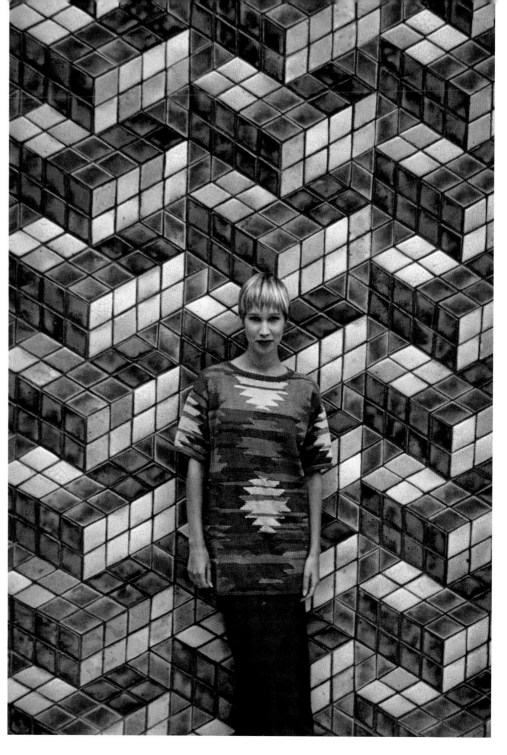

Shimmer Star quilt from *Quilts in Burano*, 2020

Kilim knit against tiles by Rupert Spira, London

OVERLEAF
'Roman Glass' fabric in various colourways – Fassett's first fabric design for Westminster/ FreeSpirit Fabrics

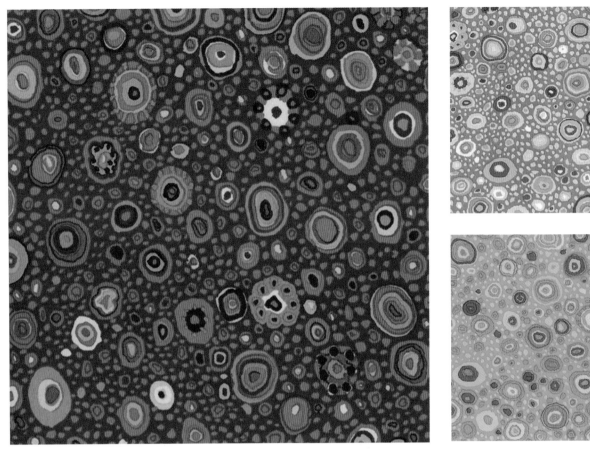

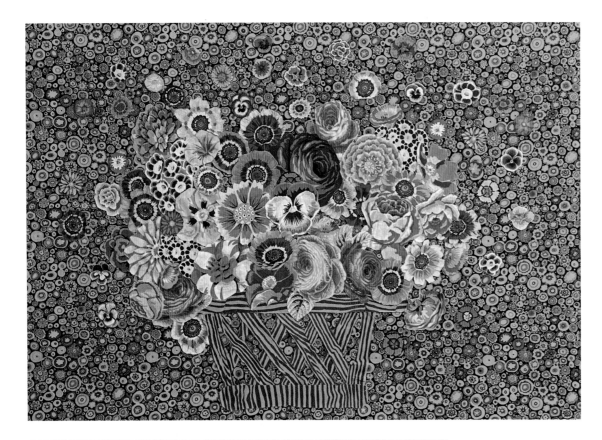

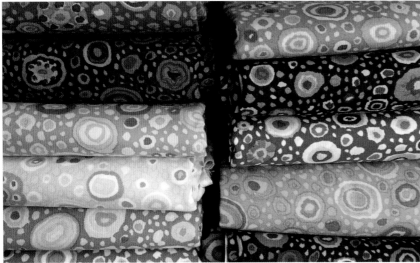

Achillea Flower fabric collage, created for Heathcote and Ivory's 'Achillea' range

'Roman Glass' fabrics

Schoolhouse quilt detail from *Welcome Home*, 1998, with 'Roman Glass' fabric

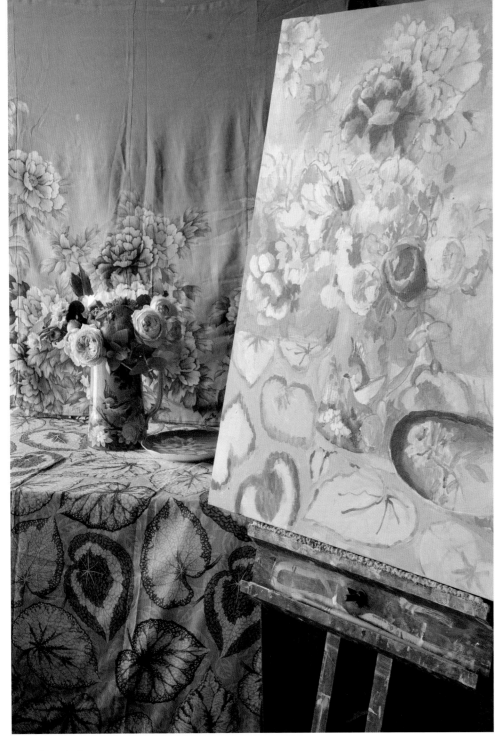

Still Life of Jug of Flowers on Leaves, 2015

Shadow Pinwheel quilt from *Quilt Grandeur*, 2013

Pink Ginger Jar cartoon for a tapestry, exhibited at Dovecot Studios, Edinburgh, 1992

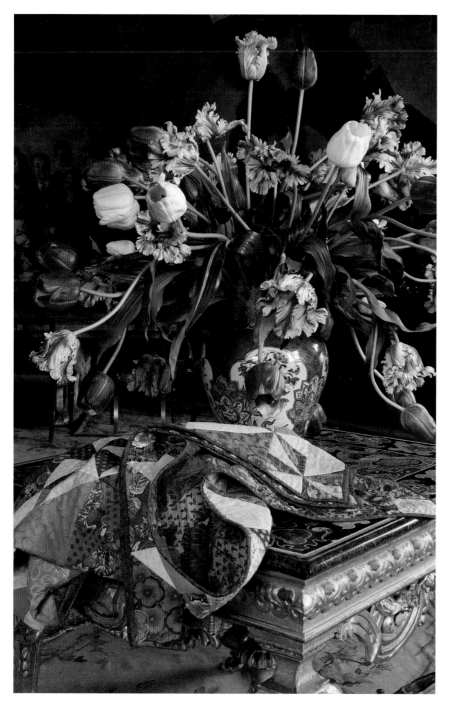

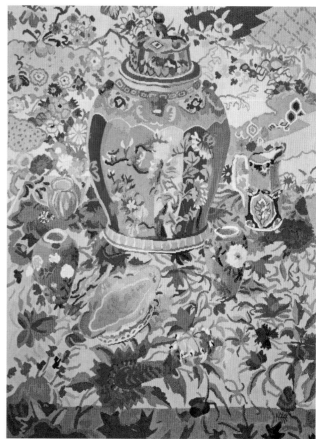

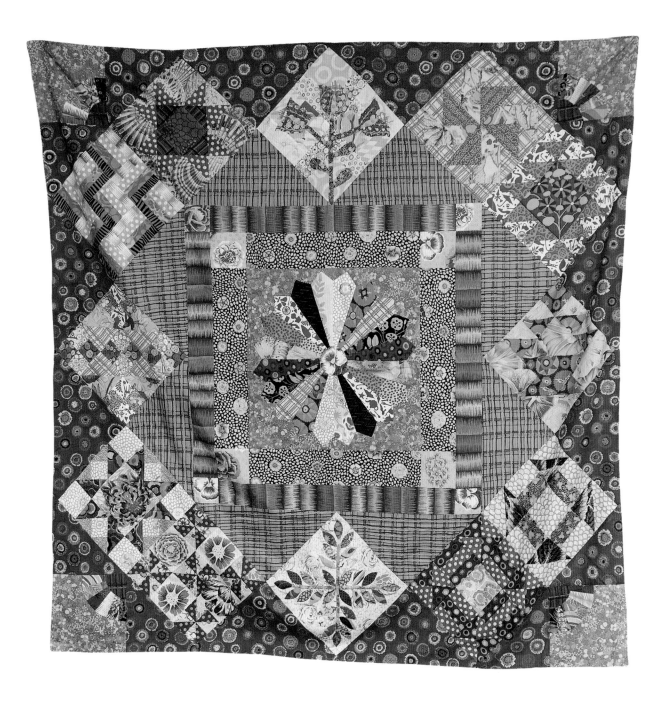

Kaffe Fassett Sampler quilt by
Kathy Doughty using Kaffe
Fassett fabrics

Interior design featuring Kaffe
Fassett's 'Needlepoint Mosaic
Prayer' chair, 'Dahlia Mosaic'
needlepoint, 'Dark Stars'
needlepoint, 'Pansy' jug, 'Blue
Star' quilt and 'Pinwheel' rag rug

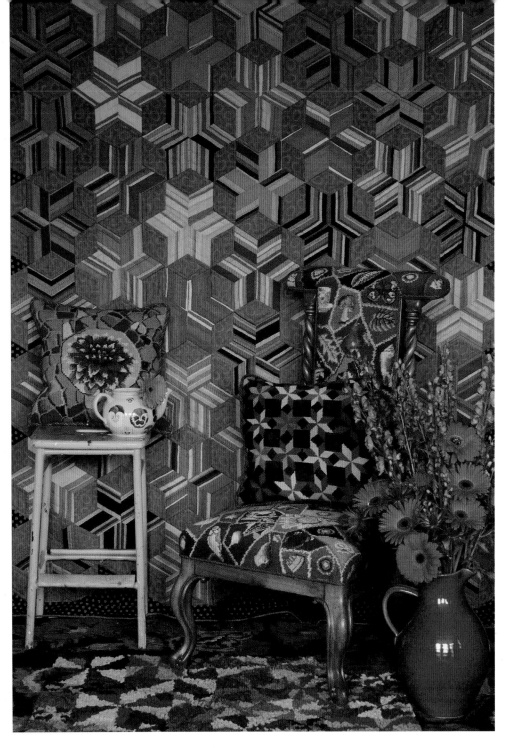

A CONTINUOUS CONNECTION

NJ Stevenson

In her book *In Vogue: Sixty Years of Celebrities and Fashion from British Vogue*, Georgina Howell summarises the entry for 1969 thus: 'British fashion has never before had the world prestige it commands at the end of the sixties.' Howell's source material credits the British art school system for discovering and training indigenous talent, including Jean Muir, Ossie Clark, Mary Quant and Zandra Rhodes, and concludes: 'And American painter Kaffe Fassett is living in London and inventing a new tapestry of patterns for knitting'.[1]

In Vogue was published in advance of the magazine's Diamond Jubilee in October 1976. Howell had painstakingly researched the magazine archives, leafing through each edition to pick out clues of how *Vogue* held 'a mirror up to its times'. The page opposite the summary for 1969 is a composite of images, including a Norman Parkinson photograph featuring Clark's chiffon dress with a shamrock print by Celia Birtwell; Muir's appliquéd suede waistcoat; and a David Bailey image of Fassett's 'tapestry pattern knit cardigan coat and stripe sweater'. That Howell had chosen to include Kaffe Fassett as one of the names that encapsulated fashion's finest creative output six years previously is an indication of the effect that his knitted coat had on the fashion establishment.

Now in his eighty-fifth year, Fassett is the most recognised contemporary contributor to the textile world in the United Kingdom. But in 1969, although his burgeoning interest in textiles had captured the imagination of *Vogue*, his intention was to still follow his path in the world of fine art.

Kaffe Fassett's journey to achieve recognition as an artist had taken him from his home on the wild coast of California to the decayed yet vibrant urbanism of London's Notting Hill. His work combines the influences of colour from nature – dynamic tones of earth, sun and sea and the soft pastels of English gardens with the majestic presentation of high art and a kaleidoscopic vision. Fassett's self-styled, 'kaleidoscopic approach' that he takes to produce his synthesis of colour and pattern is instantly recognisable. Yet the young Fassett who arrived in London in 1964 was occupied in observing the tonal differences in his white on white painting compositions and producing detailed line drawings that illustrated his travels. The journey that led him to finally reject the discipline of restraint and embrace the colour that is his 'obsession in life' to develop his 'vocabulary

of pattern' saw Fassett meet key characters who were to have influence on his life and career. His natural attitude was to embrace new ideas and opportunities that were presented to him and reciprocate with an easy exchange of creative conversation. It was this openness and enthusiasm that led him from a 1940s free-spirited American childhood to recognition in the pages of *Vogue*. As for his immortalisation by Howell as a fashion contributor as significant as the British greats Clark, Muir, Quant and Rhodes, he said that 'they were calling me the "King of Knitwear" in London. Well maybe I would be one day, but I certainly wasn't yet'.[2]

Bland and beige to looking for the details

From birth there were clues to Kaffe Fassett's colourful future. Born in 1937 in San Francisco, Frank Fassett was later to rename himself after an Egyptian boy in a childhood storybook. His parents, Bill and Lolly, were both from families of an 'eclectic mix of art philanthropists, entrepreneurs, academics, artists, suffragettes and writers. This made my parents encourage creativity in anyone who crossed their paths'.[3] Fassett was the second of five children and when he was ten the family moved to Big Sur. His parents built and opened Nepenthe restaurant 30 miles south of Carmel-by-the-Sea, where Lolly's grandparents, Frank and Jane Powers, had founded an artist's colony at the turn of the twentieth century.

Lolly was the creative driving force behind the restaurant, which was designed by architect Rowan Maiden, who had studied with Frank Lloyd Wright. Nepenthe was built on the clifftop above the Pacific Ocean with terraces overlooking the sea on the plot bought from Orson Welles and Rita Hayworth. Welles had bought the land and the existing log cabin but it was extremely remote and the couple had never visited. When the Fassett family moved in to the cabin it had no electricity. In his autobiography Fassett remembers his upbringing as idyllic, tempestuous and steeped in culture. The children had an outdoors existence, 'surrounded by oak trees and redwoods'. Lolly hosted Sunday night dinners in the cabin for the neighbours, who were typically international artists, writers and actors, which were jolly precursors to the subsequent restaurant parties. The famed Halloween costume parties, signalling Nepenthe's winter closure, were decadent galas frequented by colourful characters. Henry Miller was a friend and the restaurant numbered Gloria Swanson, Steve McQueen. Ted Turner, Jane Fonda and Olivia de Havilland among its visitors. The lively bohemianism of the summer contrasted with the isolated and lonely winters, when Fassett would dress his little sisters 'in romantic costumes, dreaming we were in the time of Shakespeare's Henry V'.[4]

In 1952 Fassett was sent to Happy Valley School in the Ojai valley, a progressive private boarding school founded in 1946 by a group of creative free-thinkers including the philosopher Jiddu Krishnamurti and the author Aldous Huxley. During his two years there Fassett thrived on the ethos of freedom: 'there was a kind of pre-hippy vibe where kids wore what they wanted'.[5] Already showing individualism in the school dress code of thrift store jumble, one of Fassett's first engagements with craft was cross stitching the white smocks worn for folk dancing in 'a palette of rusts, golds and greens'. Later, at Monterey High School, he stood out in 'bright orange trousers and tennis shoes dyed pink'.[6]

The restaurant was often staffed by struggling artists and out-of-work actors, and work was interspersed with drawing, dancing and dressing up. A chef knitted jumpers of multicoloured stripes made up of unravelled thrift store sweaters, 'the first knitting that attracted my attention'.[7] It would be rather too easy to surmise that it was factors such as these, far removed from the clean-cut 1950s representation of American children in advertising for soap powder and cereal, that spurred Fassett on his path. At a loss, he joined the army at 18. His horrified father sent him to Europe under the ruse of 'education' to escape conscription and Fassett's eyes were opened to the possibilities of travel, visiting exhibitions in Paris and staying with a family friend, the artist Daniel Harris, known as 'ZEV', while he and his wife were in Rome.

ZEV, another resident of Big Sur, often used found objects in his sculpture and had made mosaic tables for Nepenthe 'in brilliant colours ... the bright collection of a magpie'.[8] The artist was one of a number who nurtured the young Kaffe's artistic ambitions. On his return to America Fassett won a scholarship to the School of Museum of Fine Arts in Boston. As a new graduate in the early 1960s he gravitated towards creative communities, making new artist and acting friends. It was on a trip driving across America

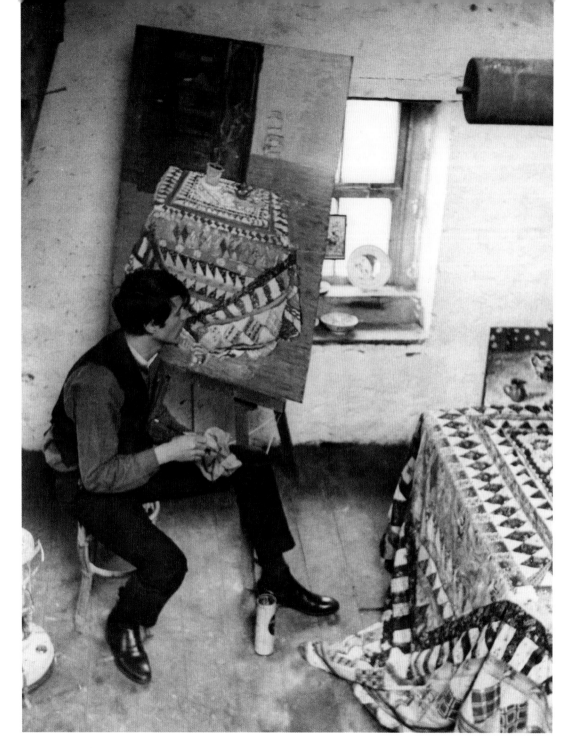

Fassett painting a quilt-covered table, Bath, 1965

with his New York flatmate, actor Alvin Epstein, to see 'the wonderful old towns' that he realised that the vastness of the country, with its overarching post-war conservative structure, was too rigid and bland. 'It was endless parking lots surrounded by bland modernity ... a sort of beige nothingness ... that blandness is what drove me mad'.[9] Restless, he bought a plane ticket to London.

Just before he left, Fassett was introduced to the British inventor and engineer Jeremy Fry in San Francisco. Fry, who was known for supporting the arts, offered to let Fassett stay in his London flat. A week later Fry arrived in England and took Fassett to stay at his house, Widcombe Manor in Bath, where he installed him in an attic studio. It is surely every young artist's dream to find a patron, especially one as connected as Fry, who was born into the English chocolate family. Fassett's arrival in 1964 coincided with a particular time of mobility in British society, when the post-war opportunities enabled ambitious youngsters from working-class backgrounds to mix with nonconformist members of the upper classes. Fassett was intrigued:

'Part of the tradition was eccentricity, what I loved about England was that you could go to an aristocratic house and a man would turn up in a dress and everyone would just not bat an eye, and if you could speak well, it didn't matter what level of society you came from. I saw England as this amazing, tolerant place. I came at the time when David Bailey and all these people were coming up from the lower classes and becoming stars and so I was at country houses with Duke So-and-So and then in would come the real talent, which would be the boy from the working classes who

had made it big as a hairdresser, dancer, musician or photographer. That was my kind of Pollyanna way of seeing England. What was interesting about being in this country was being a foreigner. It was wonderful to be somebody who didn't have to obey the rules, because I didn't know what the rules were.'[10]

Fassett's experience of being drawn into an English society where the new met the old was similar to that of Peter Schlesinger, the Californian artist who came to London with his lover David Hockney. Schlesinger chronicles the sometime hedonistic, sometime laconic life in his book of photographs, *A Chequered Past* (2003), including visiting Cecil Beaton with Hockney at his home, Reddish House, which Fassett also did with Fry. The images seem to capture the 'pearly light' of England that Fassett had been told to expect by a friend before he arrived.

In 1965 Fassett had an exhibition of his line drawings at the Hazlitt Gallery in London. Fry introduced him to the publisher and author Anthony Blond, who commissioned him to illustrate *The New London Spy: A Discreet Guide to the City's Pleasures* (1966). Fassett's subjects ranged from the John Soane Museum to tramps sleeping rough and bustling markets. Subsequently commissioned to illustrate the Paris and New York books in the series, Fassett walked the streets of the cities, producing detailed drawings of, among others, the buffet at the Gare de Lyon and the House of Common Sense and Home of Proper Propaganda bookstore in Harlem. The intricacy of his monochrome images reveal his eye for pattern which, once he nurtured his 'obsession for colour', would come to define the artist.

Counter-culture and craft

By his own admission, Fassett had a certain naiveté towards this charmed country life with the rich and famous. After six months he moved to Notting Hill Gate in London, renting 'a fabulous big room with a marble fireplace for £3 a week'.[11]

The area was run down, with many of the crumbling stucco terraces rented out by exploitative landlords to the multicultural immigrant community in slum conditions. The vibrant neighbourhood and affordability also attracted young people. The market held on Portobello Road, as well as selling fruit and vegetables and cheap household commodities, was 'a vast emporium of Victorian bric-à-brac and inter-war kitsch ... [and] a world capital of hippiedom'.[12]

The 1960s cult of doing your own thing, part of the counter-cultural ethos, which saw the inception of the London Free School and Craig Sams's first macrobiotic restaurant in Notting Hill, also gave rise to the practice of collecting second-hand goods and clothing in an 'anti-consumerist' stance. Portobello market was the hunting ground for the fashionable seeking to distance themselves from the ubiquitous 'swinging' modernism. Among these were Jane Ormsby-Gore, who wore stall-foraged laces and velvets to her job at *Vogue* and with her husband, Michael Rainey, opened the boutique Hung On You in 1965 in Chelsea. Turning the corner one day, Fassett came upon the market and was fascinated:

'What a breath of fresh air to come and see everybody dressed out of Portobello flea market. Wonderful! My God, it was great! We were living in the middle of the hippie revolution and it was all happening, that was extraordinary and thrilling, there were no bounds, it was completely free. [We would] go down the flea market and find a pair of cowboy boots and put it with an African robe and a crazy hat and just dance through the streets with these wonderful concoctions.'[13]

This area of London was close to South Kensington, where Fassett also spent time studying the collections in the Victoria and Albert Museum:

'It contained so many things I was growing to love and identify with my life: the great oriental galleries with carpets, tiles and pottery; the top floors of porcelains and clayware of every mood and period of history; the costume court with fashion going back to medieval times.'[14]

Having previously discovered the art of Odilon Redon at an exhibition in Paris, Pierre Bonnard while studying in Boston and the mosaic architecture of Antoni Gaudí in Barcelona, Fassett was captivated by the way in which colour could be used. Although the canvases he was producing were still lifes in neutrals, he often used textiles as a backdrop and his inclination for collecting also opened his eyes to colour composition:

'I was surrounded by a kind of bohemian group of Americans who had found their way to Europe. We were living on a shoestring, but a very wealthy boy who had the money to buy things from Christie's and Sotheby's ... came in with three or four patchwork quilts, that was just something else entirely. I remember my mind just went into a kaleidoscopic thing – I had been aware of patchwork quilts in America but not in a way that I saw them as art – there was one silk patchwork, a crazy quilt done in the

*most wonderful patterns and colours and
embroidery and it was just mind-blowing.
He would put these on the wall and we would
just stare at them and I was thinking, these
are more interesting than any painting I'm
seeing at the moment, this is just engaging
my mind in such a fabulous way.'*[15]

If a childhood at Nepenthe had prepared the young
Fassett for a colourful life, then London immersed him in it.
'I was raised in the atmosphere of this fantastic restaurant
where people came from all over the world, you would get
amazing people coming from all sorts of societies and
telling wonderful stories. It gave me a lot of confidence'.[16]
An opportunity to model for *Queen* magazine connected
Fassett to the fashion world. Julie Hodgess, an interior
designer whom he had met through Fry, got him work as an
extra on Michelangelo Antonioni's film *Blow-Up* (1966).

Fassett was impressed with the easy relationship that his friend David Hockney, who lived nearby, had with his sexuality in a country where homosexuality was not decriminalised until the Sexual Offences Act of 1967. In 1966 Fassett met Bill Gibb, a Scottish fashion student, at Le Gigolo, a gay bar on the King's Road. At 28 Kaffe Fassett was urbane and sophisticated compared to the 23-year-old Gibb, who was studying at Saint Martins School of Art; he later won a scholarship to the Royal College of Art to study under the renowned professor of fashion Janey Ironside.[17] There was an instant rapport between Gibb and Fassett; on travelling to Gibb's childhood home in the Scottish Highlands they discovered more common ground. Gibb had been brought up by his grandparents after his mother, finding that she was pregnant, had promised to give the baby to her mother in return for permission to marry. This unconventional upbringing on a remote farm chimed with Fassett, particularly when he discovered that Gibb had painted his childhood bedroom to resemble an Egyptian tomb. Gibb's grandmother had recognised and encouraged the artistic potential of her grandson, who was otherwise destined to become a farmer:

'He was a rare soul. He was this raw little student when I met him, really nervous and shy of the world and yet he'd made the breakthrough and come to London … he grew up on the next farm looking at his brothers and sisters all playing and having another kind of life and he was this very studious little boy raised by older parents.'[18]

A nomination for the Yardley 'London Look' awards sent Gibb to New York, dropping out from his studies. In London he opened the Alice Paul boutique in Kensington with Alice Dunstan Russell as shop manager.

It was during a trip to a mill in Inverness that Fassett, captivated by the colours of the Highland landscape, found yarns that replicated the tones of surrounding nature. Russell taught him to knit on the train on the way back to London, using the 20 different coloured wools he had bought. *Vogue* art director Barney Wan suggested that Fassett take the resulting cardigan to show to the head of *Vogue Knitting*, Judy Brittain: 'I went in to see her and put this ragged old sweater down, with all the ends hanging out, and she just took one look and she said, "My God, this is where knitting is going in the future!"'.[19] Brittain became a close friend and the two went on long walks, talking about ideas and plans, and visited the V&A together to research traditional knitting in the library:

'We would talk about what we loved, what was exciting about the past and where it was giving us a gift of something we could reproduce now, the conversations were soaring imaginative castles that we were building in the air. I think we both felt that the past was so rich and wonderful because we were looking at things that were made from the heart, things that were just so full of humanity and real. I remember there was a knitted men's sweater, it was so beautiful and simple yet it had all kinds of imaginative things about the stitching. Maybe she was just making me more aware of the sensitivity of English people.'[20]

Brittain asked Fassett to design a men's sweater in a Fair Isle pattern, although a sub-editor in the *Vogue* office had to show him how to change colours in a row. This first knitted waistcoat was featured in *Vogue Knitting* magazine. Before the pattern was printed, the 'Men in Vogue' column in the December issue of *British Vogue* for 1968 published

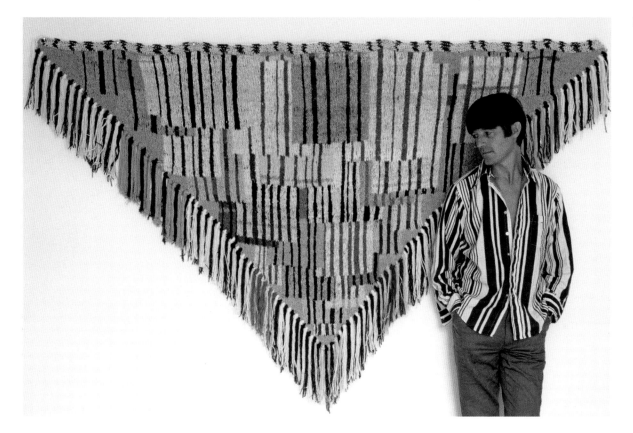

a picture of a model wearing the made-up version with the following caption: 'Kaffe Fassett is a painter. He designed this neat knitted waistcoat with a decorative eye. It's a mixture of soft, dark colours and peasant and Fair Isle patterns, in lambswool from William Fuller, 15 North Audley St, W1. The instructions will be in Vogue Knitting, on sale in early March, or you can buy it right away, £14 from Mr Fish, 17 Clifford St, W1.'[21]

The commission for the design for the tapestry knitted coat for a full colour spread in *Vogue* in 1969 came next and was accompanied by a picture of Fassett in his apartment wearing his first cardigan, against a backdrop of textile wall hangings, rugs and cushions. 'It was the first time I began to realise how powerful publicity was and how easy to get when you were such a bizarre creature in the world of so-called "women's work"'.[22]

'The freak element was huge, that was a big draw. I didn't give a damn in many ways whether I got attention or not, I was just so fascinated in making textiles, first in knitwear, then making needlepoint ... to be able to use all my painting skills and drawing skills and fascination with colour. So it drew me along, it wasn't difficult to keep supplying ideas.'[23]

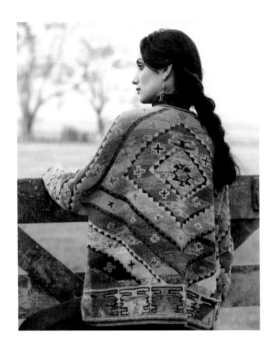

Bill Gibb at this time had started working for the British couture house Baccarat. For Alice Paul his designs had been 'little pillbox hat, little pink coat that went with it, but he also had this other edge'.[24] Knowing their shared attraction to historic influence, Fassett intervened:

'I would drag him down to the V&A. I knew he was open to the kind of ideas I was starting to have, going and looking at these little Indian and Persian miniatures of these women in fabulous saris of wonderful patterns, passing through a room that was all flowers and stripes and paisleys. I'd say, "Look at all that pattern, it's all working beautifully together, it's creating a wonderful excitement, don't you think we could do that with fashion?" We started by going up to Scotland and looking at the tartans, trying to capture his history. Then he would put together an outfit that was a big plaid skirt with a big section of roses or geometric flowers going around the edge and I'd do a piece of knitting to pull those two ideas together on the top of that outfit. I loved the limitation of what we could find that was available commercially from the fashion fabric houses and putting it together in exciting new ways and then creating a totally new fabric out of the knitting that would bring those ideas and colours together.'[25]

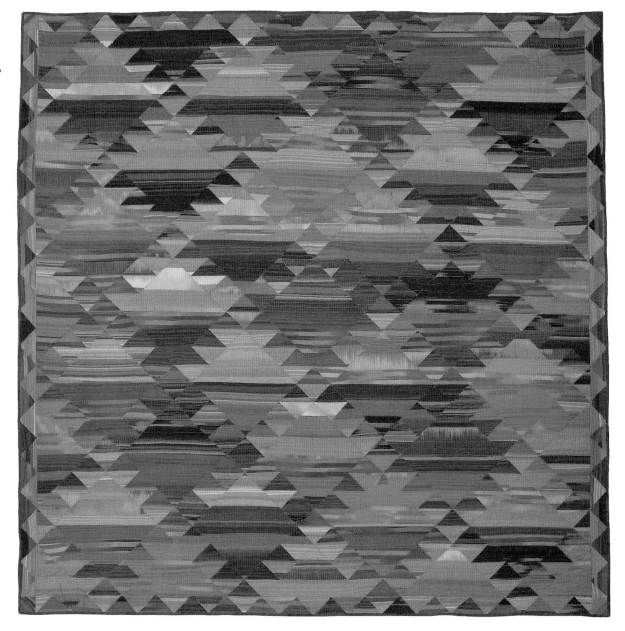

Kilim knitted jacket designed for Peruvian Connection, 2005

Haze Kilim quilt by Fassett and Liza Prior Lucy for *Simple Shapes, Spectacular Quilts*, 2009

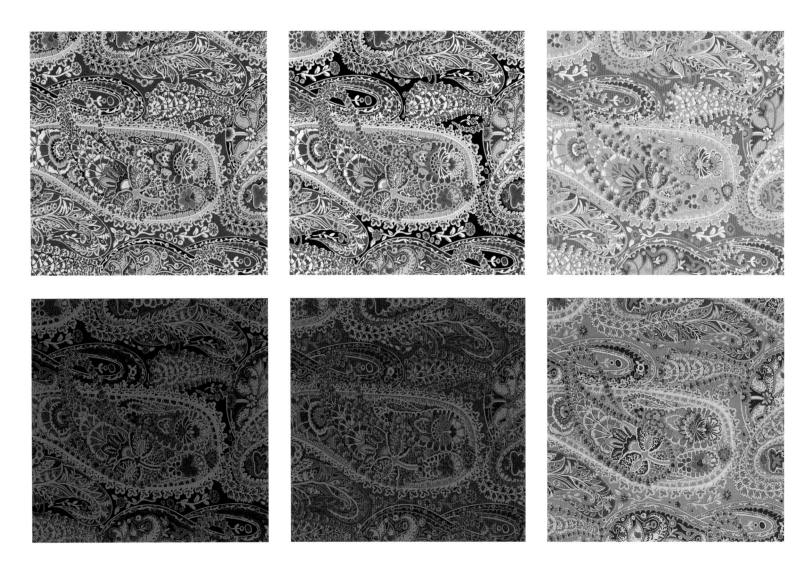

'Paisley Jungle' fabric in various
colourways

A spread photographed by Sarah Moon was printed in the January 1970 issue of *Vogue* with the headline 'Glorious Confusion'. This collection, produced in a small run by Baccarat with the knitwear made up by Mildred Boulton, won Gibb the title Vogue Designer of the Year for 1970.

Simultaneously, the day after the knitted coat was published in *Vogue* in 1969, Kaffe Fassett was contacted by Tai and Rosita Missoni of the Italian knitwear label. Attracted by Fassett's unique style, they commissioned 12 designs. *Vogue* writer Pamela Harlech asked him for some needlepoint designs, which he then showed to Beatrice Bellini, who was running 'a bespoke needlepoint shop' at Women's Home Industries (see p. 58 below). Bellini had already knitted the coat featured in *Vogue* and commissioned more designs from Fassett.[26]

'I thoroughly gave in to the life of a craftsman ... my artistic ideas transferred to the textile world. Something about creating fabric – be it knitting or needlepoint – was far too motivating for me to abandon and return exclusively to easel painting. I could express all my passion for colour and form in these soft human textures and longed to create bigger and better examples.'[27]

A culture of creativity

According to Fassett, his partnership with Bill Gibb was a meeting of minds and their conversations had material results in the first collection for Baccarat.[28] Fassett brought his confidence and expansive vision, which Gibb, with his shared sense of drama, used to design clothing that was instantly successful. Working with Gibb, Fassett found an outlet for his curiosity in other cultures that had brought

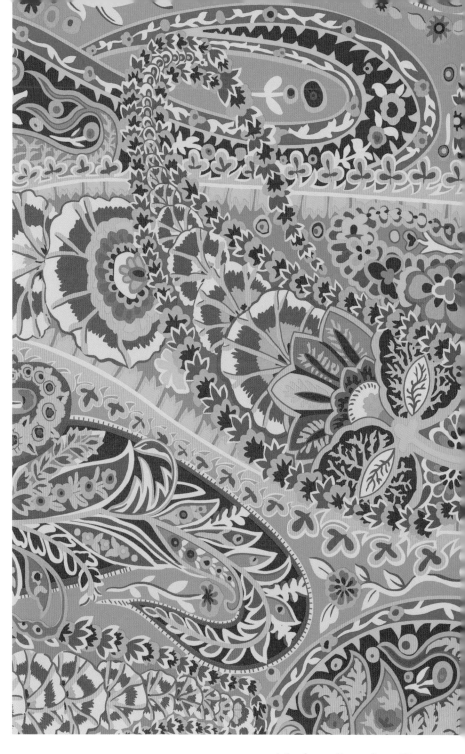

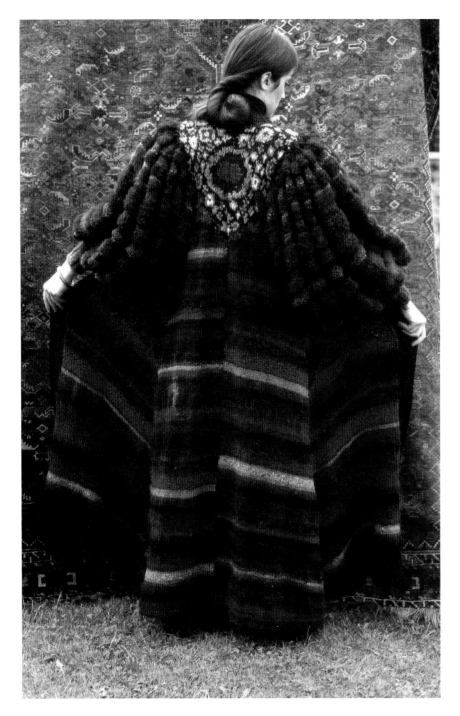

Zöe Hunt modelling the *Romeo and Juliet* knitted coat, 1970s

him to Europe: 'London is a city on the edge of Europe and Scandinavia and the Middle East, you just have to get in a boat and go across the sea and connect with all these fabulous worlds. I'm very thrilled by history, the history of design and pattern'.[29]

With the influence of the treasures in the V&A and market finds, Gibb and Fassett had started to make connections of these 'fabulous worlds' and initially there was concern that the colour compositions that Fassett was proposing would be anathema to British taste:

'One of the things that was very interesting to me about a lot of English people was that they talk about things in an enthusiastic way that was full of colour and pattern but when you actually went to their houses there was a kind of restraint in the colour and [I thought] if I'm going to go flat out in my gypsy way, I'm going to alienate a lot of people. But on the other hand, I couldn't resist it.'[30]

Fassett's 'gypsy' way was actually chiming with the times. *Nova* magazine for August 1969 featured a fashion spread by Brigid Keenan entitled 'Learn From The Gypsies'. Eclectic exoticism executed with a bold hand, using print and colour, was capturing the attention of designers, including Yves Saint Laurent and Thea Porter, as travel and authenticity became preoccupations for the creatively minded. Fassett acknowledges that the way in which colour and pattern were being put together was influenced by the anti-conformist counter-culture of the time and asserts that his and Gibb's work together was 'done with a sense of richness and harmony and history because I was thinking of Russian peasants and the Chinese and the way that they have a wonderful flowery robe with a wonderful stripe at the edge bound in a wonderful plaid'.[31]

The desire to translate curiosity about other cultures into material objects was a common preoccupation in alternative communities in the late 1960s. Developing his knitting skills, Fassett remembers craft at the time as part of the language of expression:

'We'd get together and somebody would be doing American Indian beading on leather trousers or a beautiful bag, somebody else would be writing music or working on poetry and we would all be sitting around doing something creative. I felt that was the really good side of the hippy revolution, the togetherness and the acceptance. Very often there would be a mixture of ages, anybody that was on the wavelength would be welcomed.'[32]

This ethos of making, as a form of self-expression and identity, was widespread among those wishing to be aligned to the 'revolution'. In Fassett's birthplace of California, Alexandra Jacopetti was part of a community of self-taught embroiderers, patchwork makers and quilters, leatherworkers and jewellers whose folk art was recorded in her publication *Native Funk and Flash* (1974). The British underground magazine *Country Bizarre* carried listings of independent craftspeople selling goods from tapestry weaving to stained-glass art all over the country. Its sister publication, *Country Bazaar*, was a manual that covered traditional craft from smocking to spinning wool. The 1972 *Time Out's Book of London*, then very much 'alternative' in its ideology, included listings for craft adult education and evening classes and places where makers could sell their home-made wares, such as the Craft Centre in Covent Garden.[33] The late 1960s encouragement of 'being unique', which saw rock stars Eric Clapton and Roger Daltrey wearing Swedish designer Birgitta Bjerke's custom-made sculptural crochet pieces, contributed to the retreat from mass-production.[34]

Continuing to exhibit painting, Fassett received unsolicited advice from art world professionals about losing his credibility as a fine artist if he pursued textiles,[35] but he simply found craft irresistible. The 1970s craft revival has been attributed to a shift towards nostalgia for simpler times that came out of socio-economic difficulties and ecological awareness.[36] However, although Kaffe Fassett was more interested in the act of creating than in an ideological approach, it could be said that his adoption of 'women's work' was actively progressive rather than retrogressive. Historically, the word 'spinster' came from the job of spinning wool, which was given to unmarried women who needed to support themselves. Fassett's 'freak' status, subverting gender roles, was embodying the new, unconventional attitudes of the counter-culture. Conversely, the Women's Liberation Movement was using craft as a strategy of activism: 'Second wave feminism, and the questioning of women's roles in society, led to a subversive reclamation of "feminine pastimes" including sewing, embroidery, knitting and weaving'.[37] Fassett was to become part of another organisation that was set up by women, for women.

Women's Home Industries was founded by Stella, Marchioness of Reading, in 1947 to employ women at home making traditional craft products, which were then exported to America and Canada. Its success meant that by the 1950s, designer Beatrice Bellini was moving production into the fashion market for both home and abroad. The fashion editorial 'Gathering Wool' in the July 1968 edition of *Nova* uses a 'Spotted knitted dress with puffed sleeves, 22gns; cable stitch stockings, 4 1/2 gns; both by Beatrice Bellini at Women's Home Industries'. By the September issue of *Vogue* for 1970, a caption for a Norman Parkinson fashion editorial reads: 'Needlepoint waistcoat by Kaffe Fassett for Beatrice Bellini, £25 to order, Women's Home Industries' Tapestry Shop.'

Working with both Beatrice Bellini and Bill Gibb established Fassett in creative communities that were at the heart of a shift in design and production that nurtured craft at this time. Gibb surrounded himself with artisans who contributed a particular aspect to each collection, including specialist printers and hand painters Sally MacLachlan, Valerie Yorkston and Ellen and Robert Ashley; Alison Combe, who made beaded and feathered accessories; and the quilter Sue Rangeley, who made appliquéd silk jackets.[38]

Both Rangeley and Fassett exhibited work at the Hugh Ehrman Craft Gallery store on the Fulham Road in London. Rangeley lived communally and worked with 13 other creatives in Fosseway House Studios, Gloucestershire.

Bellini and Fassett suggested to American textile designer Lillian Delevoryas that she move to England to concentrate on her tapestry hanging commissions. Delevoryas founded Weatherall Studios for tapestry and needlepoint in the Forest of Dean, which she ran with Fassett. Similar networks were appearing nationally and this system of mutual support and collaboration coincided with the establishment of the Crafts Advisory Committee in 1971, which was to become the Crafts Council. The Crafts Council's remit was to support the 'artist craftsman',[39] differentiating between conceptual craft, made to be exhibited, and functional craft. However, the work of Fassett, Delevoryas, Rangeley and many artist craftspeople working with textiles demonstrated that this separation was an outdated concept.

The Fashion Guide by Kaori O'Connor was an annual independent directory of sources of fashionable clothing in London, from designer to second-hand, published by Farrol Kahn. The 1976 edition lists Kaffe Fassett knitwear as made to order in 16 weeks at Beatrice Bellini handknits in West Halkin Street, SW1: 'knits like no other, that use needles like brushes and yarns like paint',[40] while rugs and paintings by Kaffe Fassett are stocked at Browns Living on South Molton Street. The twice annual collections of knitwear that Fassett designed for Bill Gibb were now produced in a factory in Leicester and were always produced as an entire capsule wardrobe: jumpers, skirts, bloomers, knickerbockers, tabards, hats, scarves and leg-warmers, customarily finished with voluminous capes and kimonos that showcased alluring colour and pattern combinations. In Kaori O'Connor's *Creative Dressing* (1980), which reproduces patterns by fashion designers for people to make themselves with the 'designer's view of style', Fassett provides patterns for a slipover and a cardigan, saying: 'I always go back to handknitting ... to try for really complicated effects ... so you look and look and *look*, and try to figure out what sense it's making. It's an *adventure*'.[41]

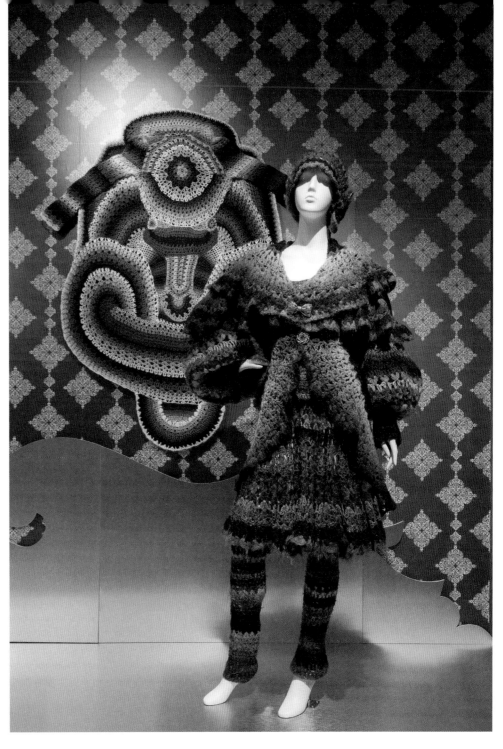

Going Back to Sweden outfit with jewellery by Birgitta Bjerke, 1974, installation view of *Counter-Couture: Handmade Fashion in an American Counterculture* at the Museum of Arts and Design, New York

Fassett photographed for *Creative Dressing* by Kaori O'Connor, 1980

Cottage Garden Flowers quilt from *Quilts in an English Village*, 2021

A seamless vision

Kaffe Fassett's textiles are consistently compared to painting, which is unsurprising as he has approached all aspects of his work with a painterly eye. He embraced knitting, historically viewed as a domestic and unexciting pastime, and imbued it with imagination, capturing attention in a way that he felt was not rivalled by his fine artwork as a young painter. However, as an artist Fassett 'sees a continuous connection that flows between my paintings, tapestry work, fabric designs and my knitting. They all feed each other.'[42] With his textile work he has contributed to systems of nurturing, developing and supporting craft in the United Kingdom, which mirrors the way that art is viewed.

Like his first portrait in *Vogue* in 1969, the photograph of Fassett in *Creative Dressing* shows him at home, wearing a knit of his own design against a backdrop of his workshop wall pinned with painted designs, reference images, ceramics, swatches and jugs filled with brushes. It is a collage of colour and pattern with Fassett in the centre, a representation of his daily life. An article entitled 'Hang 'Em On The Wall' in *Cosmopolitan* of March 1975 includes Fassett as one of 'six talented people' who decorate their living spaces with textiles and artisanal artefacts. The profile describes him as making 'needlepoint hangings of magical intricacy and originality'. Here again, Fassett is pictured in one of his own cardigans against a backdrop of swatches for needlepoint and knit designs, some of which are recognisably for Bill Gibb, including a palm tree motif that was inspired by a trip that the couple took across Morocco. Looking through subsequent portraits, it becomes apparent that Fassett is always photographed like this, smiling delightedly and blending into a background of intense colour and pattern. Just as the discriminate elements of his creativity appear seamless, so do his life and work, approached with his 'kaleidoscopic vision'. Georgina Howell's summary of British fashion in 1969 quotes *Vogue*: 'You can dress as you please in any look', reflecting the freedom and sophisticated assurance that made the capital a destination for the creatively minded to live, work, learn, explore and collaborate. Untrained, Fassett garnered all the lack of restraint of the self-taught counter-cultural craft movement and, applying his own echoes of bohemian childhood and influences of artists, travel and history, harnessed it into an output of extremely disciplined, harmonious drama with 'qualities that will go on *saying* something'.

Notes

1 Howell 1975, p. 300.
2 Kaffe Fassett interview with the author, 2022.
3 *Dreaming in Colour* 2012, p. 13.
4 Ibid., p. 18.
5 Ibid.
6 Interview with the author, 2022.
7 *Dreaming in Colour* 2012, p. 37.
8 Ibid. p. 20.
9 Interview with the author, 2022.
10 Ibid.
11 Ibid.
12 O'Neill 2007, p. 97.
13 Interview with the author, 2022.
14 *Dreaming in Colour* 2012, p. 69.
15 Interview with the author, 2022.
16 Ibid.
17 Among Ironside's graduates were a number of distinguished designers cited by Georgina Howell (1975).
18 Interview with the author, 2022.
19 Ibid.
20 Ibid.
21 *Vogue UK*, December 1968, p. 16.
22 *Dreaming in Colour* 2012, p. 93.
23 Interview with the author, 2022.
24 Ibid.
25 Ibid.
26 *Dreaming in Colour* 2012, p. 95.
27 Ibid.
28 Interview with the author, 2022.
29 Ibid.
30 Ibid.
31 Ibid.
32 Interview with the author, 2022.
33 Bygrave et al. 1972, p. 140.
34 Marks 2021.
35 Interview with author, 2022.
36 Lutyens and Hislop 2009, p. 118.
37 Robertson in Peach 2013, p. 184.
38 Webb 2008, p. 42.
39 Peach 2013, p. 19.
40 O'Connor 1976, p. 145.
41 Fassett in O'Connor 1980, p. 126.
42 Ibid., p. 125.

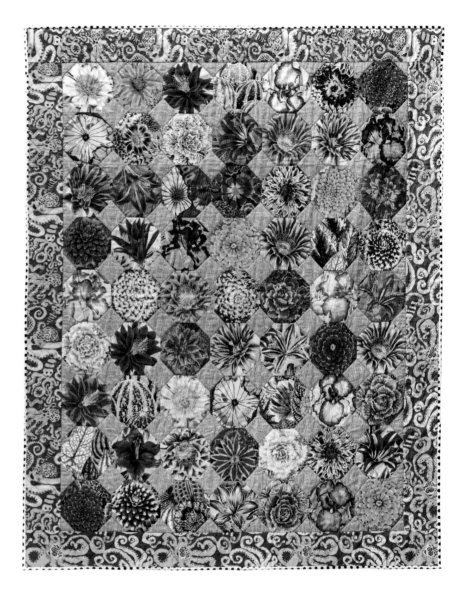

A DEEP CONNECTION

Janet Lipkin

I first became aware of Kaffe Fassett's knitting process with the publication of *Glorious Knits* in 1985. I was immediately struck by his fabulous use of colour and pattern, intricacy, and surfaces he created just utilising the stockinette stitch. I felt a deep connection to his visuals. As a machine knitter I was challenged by creating intricate, graphic statements using only two colours per row. Kaffe had found a way to introduce many colours per row. Knitting did not limit him, he expanded his technique to accommodate his ideas. I attended a lecture he gave in the Bay Area and have followed his work ever since. Currently I am hand knitting story panels and Kaffe's book *Pattern Library* is at my side. I only regret that I never got to meet Kaffe, as he always was and still is an inspiration to me.

KAFFE FASSETT:
MAKING COLOUR AN ART FORM

Suzy Menkes

Kaffe Fassett, emperor of decorative arts and king of 'free spirit' fabrics, learned to knit on the train from Scotland back to London. In the north of the United Kingdom, the artistic creator from California had visited a friend, Bill Gibb, the designer from the Scottish Highlands who had become part of the scene on London's 'happening' King's Road back in the 1960s and 1970s.

The two started an intense friendship, melding their work into particular shapes and magical colours that brought a whole new spirit to dreamy fashion effects. They had taken over as the short, sharp fashion of the 1960s melted into something more poetically colourful.

Today Kaffe Fassett, with his partner Brandon Mably, has kept the flag flying for intensely colourful, three-dimensional fabrics that are worked with imaginative patterns and vivid colours. At the age of 84, the famous creator of shades and shapes seems as active as ever.

William Elphinston (Bill) Gibb – the gentle, artistic fashion designer with 'a funny little elf quality' – died so relatively young in 1988, at the age of 44,

that the romantic eclecticism of his work was never imprinted on fashion history. But Kaffe Fassett picked up their shared threads and their love for handcraft. That was shown in a 1970 joint creation for *Vogue* magazine, where Gibb's pleated tartan skirt was shown with Fassett's knitted waistcoat. It was the Kaffe Fassett creations, planted in the 1970s era, that grew – still to this day – into dense, uplifting patterns that are now considered more as an adornment for the home than for the body.

Yet in a single decade, Bill Gibb had created mixes of geometry and flowers, a patina of patterns, magic carpets of knitting and Renaissance fantasies. Fassett is a constant admirer of Bill Gibb's work – as is John Galliano. In 2008 Galliano, a creator of fashion with passion, said: 'British designers are storytellers, dreamers, and I think this was really the essence of Bill Gibb.' Another enthusiast was the model Twiggy, who described the designer as her 'knight in shining armour' and as 'a sweet, sunny farm boy'.

Could Kaffe Fassett – more hippie, American Woodstock than from the Scottish Highlands – have developed his layers of intense colour and workmanship without his friend Bill Gibb? The duo seemed to create a sweet harmony in all the wild mixes of colour and texture.

As we head into the Metaverse era, with 'Neon Tropical' or 'free spirit' fabrics, and the visually noisy 1980s faded away, the designer,

with Brandon Mably, has kept the pattern and print of a pre-digital age in handwork skills of quilted patchwork. As Kaffe Fassett had insisted in the 1990s: 'People are dressing in grey and beige, but there is mileage to be had from absolutely passionate pools of colour.'

The revolution in pattern-making, produced by the move from hand to digital machine, has left a romantic memory for the wild and uncontrolled mix.

In 2019 the American company Coach – and its British-born creative director, Stuart Vevers – explored the nostalgic earlier world of dense patterns, colourful knits and weaves from the pre-digital age. 'Plants, pleats, flowers', said Kaffe Fassett, who was sitting front row, while the models wore floating chiffon patterns or a similar effect of psychedelia on Coach's signature handbags. 'I was in my library and up came Kaffe Fassett with his quotes about colour and emotion', said Vevers. 'I wanted a show that was optimistic and joyful, but still with the Coach attitude.' Yet, significantly, the show did not seem to come from 'the age of Aquarius' – but rather a muted version appropriate to a less joyous era.

Is the world today too dark a place to embrace the colourful and overwhelming joy spilled out for half a century by the incomparable Kaffe Fassett? Give peace – and wild, wonderful handwork – a chance.

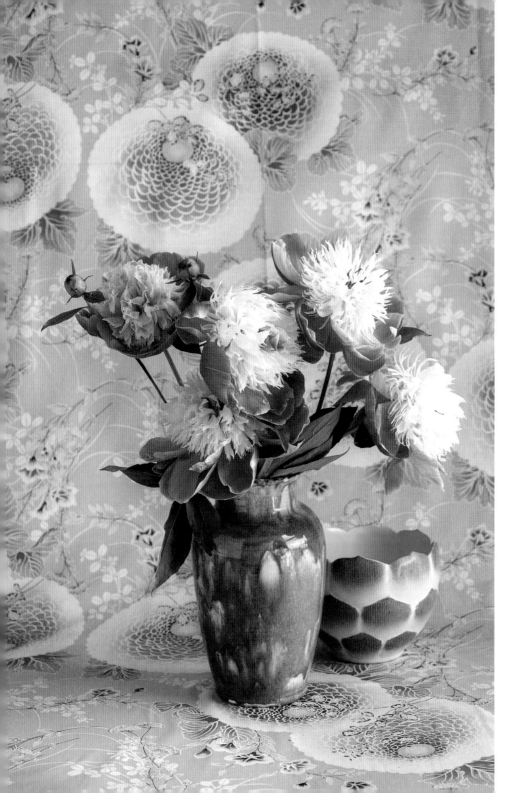

A still life set up on vintage fabric from Fassett's private collection

Vintage beaded bags from Fassett's private collection

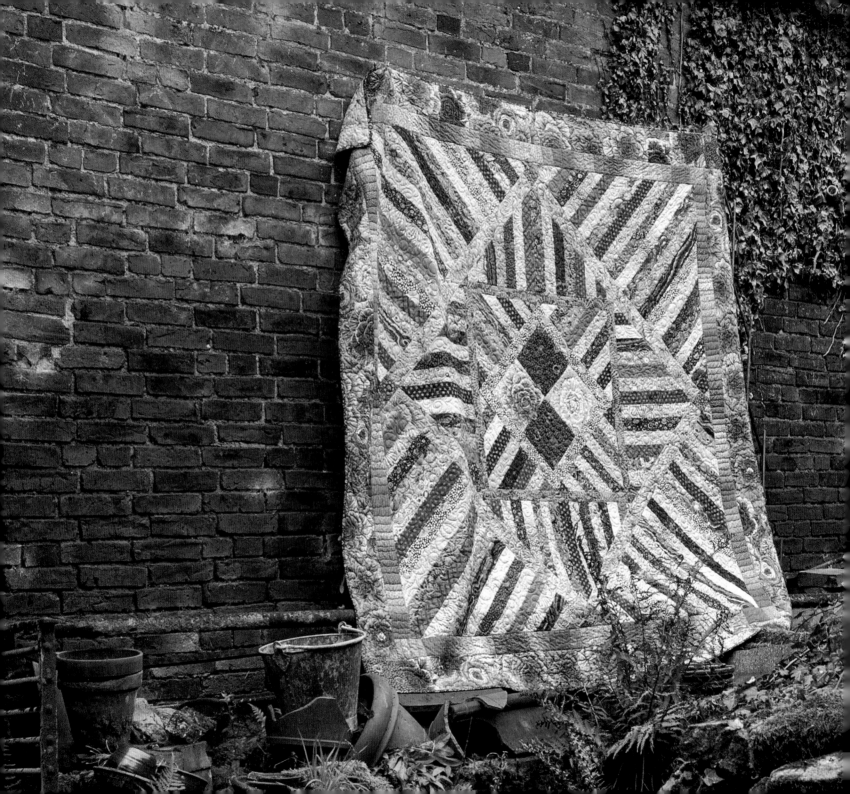

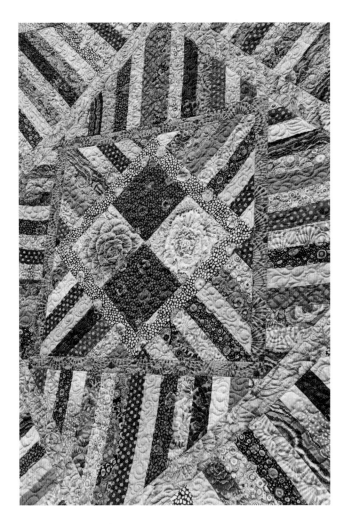

Organic Radiation quilt from
Heritage Quilts, 2015 (with details)

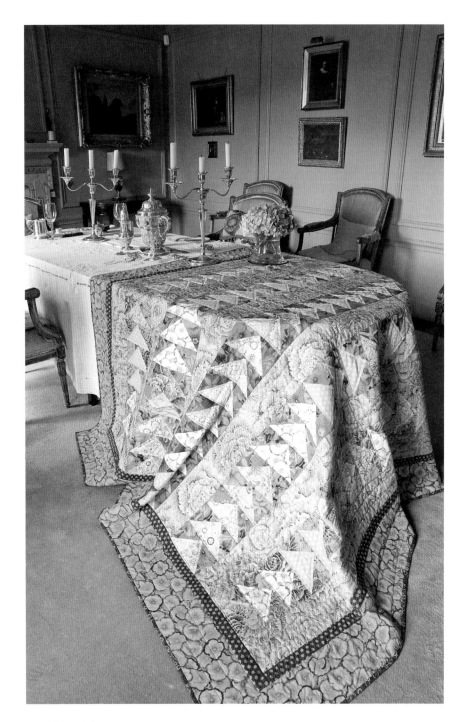

Geese in Flight quilt from *Quilt Grandeur*, 2012 (with detail)

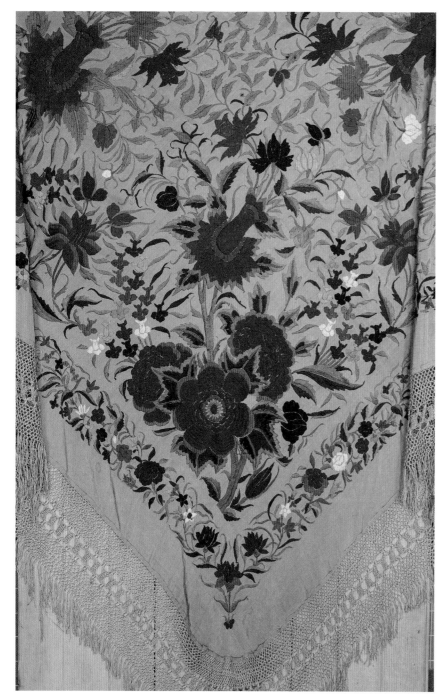

Antique embroidered shawl, inspiration for 'Embroidered Shawl' fabric, 2009

Flowers in waiting for a still life set-up

Marmalade quilt from *Quilt Grandeur*, 2013

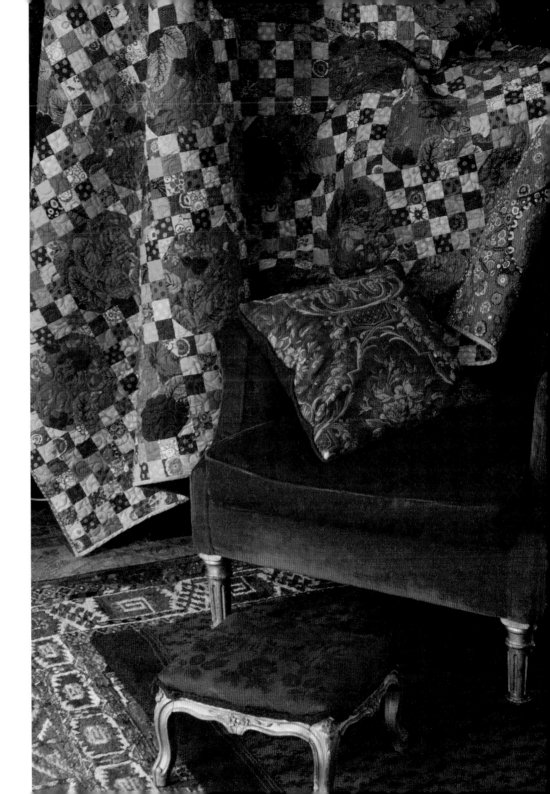

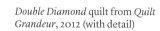

Double Diamond quilt from *Quilt Grandeur*, 2012 (with detail)

THE CARNIVAL
OF CREATIVE
COLLABORATIONS

Mary Schoeser

When Idries Shah wrote 'Right time, right place, right people equals success. Wrong time, wrong place, wrong people equals most of the real human history', he could have been drafting a summary of Kaffe Fassett's life. A spokesman for Sufism in the West, Shah was equally acclaimed and criticised but, like Kaffe, a foreigner in England, he mixed with prominent people and forged his own path. In 1960 he founded Octagon Press in London, which published *Reflections* – from which the lines above are taken – in 1968, just one year before Kaffe's first knitting pattern was published in *Vogue Knitting*. There are other parallels to be drawn: both had an unconventional upbringing and both 'acquired a truly international outlook, a broad vision, and an acquaintance with people and places that any ... might well envy'.[1]

One of those places was northern California, where Shah was associated with the Institute for the Study of Human Knowledge, founded by Robert Ornstein in 1969 in Los Altos, today most famous as the home of the late Steve Jobs, the co-founder of Apple Inc. Some 80 miles south by road is Carmel-by-the-Sea, where Frank Powers, Kaffe's grandfather, had founded an art colony with Frank Devendorf in 1902.[2] By 1927 this transformed into the Carmel Art Association, achieving its own gallery in 1939, which is still extant.[3] Here Kaffe resided with his family from 1943 until 1947, when they moved 30 miles south to Big Sur, then a wild setting without electricity. By 1949 his parents Bill and Madeleine ('Lolly') had opened Nepenthe, the eccentrically furnished restaurant that featured a terrace with extraordinary views of the Pacific Ocean and the frequent presence of folk dancers – and famous people.[4] Kaffe, in his autobiography *Dreaming in Colour*, recalls his father's friend, the author and artist Henry Miller, as 'one of the first famous regulars'; Miller's own home nearby was 'full of delightful colours (mainly pink), bits of mosaic, colorful mosaics, children's artwork, and a motley collection of the crockery found at charity shops'. Clearly Kaffe's own interiors reflect his absorption of Miller's aesthetic as well as the latter's belief that 'to paint is to love again'.[5]

Similarly bohemian was Happy Valley School, founded in 1946 in Ojai, California. There Kaffe spent two years during which time he celebrated his sixteenth and seventeenth birthdays, performed in plays, danced with a troupe costumed in Ukranian dress, adopted the name 'Kaffe' and

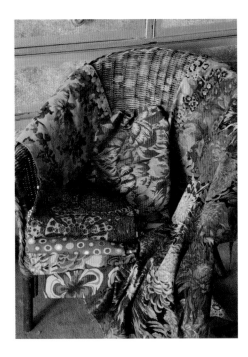

Kaffe Fassett Collective fabrics

Rupert Spira tiles in Fassett's
bathroom

Open Bowls, exhibited at Catto
Gallery, London, in 2002

discovered gin and himself. Today it is known as Besant Hill School after the setting's original owner, Annie Besant, among other things a British socialist, women's rights activist and theosophist, who from the years around 1900 became increasingly involved in the drive towards Indian self-rule. Theosophy was also an influence over a number of early pioneers of abstract art and was central to the Happy Valley ethos. It was founded by Jiddu Krishnamurti, the Theosophical Society's 'world teacher', under the direction of retired Vassar philosopher Dr Guido Ferrando, who advocated a Socratic method of teaching, and co-founder Rosalind Edith Rajagopal, a member of Besant's circle. Their friend the author Aldous Huxley was also involved. It was an open-minded, free-spirited setting. Against this background Shah's words of 1968 make greater sense: he was simply a latecomer to a Californian environment long known for its artistic and intellectual exuberance, favouring the bright, the funky, the risk-taking, the ingenious.

If Kaffe began his life in an environment perfect for a budding artist, he continued thereafter to be in the right place with the right people. After eight years of world roaming – New York, Paris, Italy, New York, Big Sur, New York, Boston, New York, Big Sur, San Francisco, Bath – by early 1965 he was ensconced in Notting Hill, an inexpensive multi-ethnic area close to central London, perfectly compatible with the emerging alternative lifestyles of the era. The year before, the Beatles had filmed part of *A Hard Day's Night* there. Portobello Road and its market became the place where trendsetters gathered. In 1965 Ian Fisk and John Paul (soon joined by Robert Orbach) opened I Was Lord Kitchener's Valet, a Swinging Sixties boutique promoting antique military uniforms as fashion items, bought by the likes of Eric Clapton, Jimi Hendrix, Mick Jagger and John Lennon. Less than 2 miles south was Biba, the trendsetting shop that had been founded in 1964 in Kensington by fashion illustrator Barbara Hulanicki and her advertising executive husband, Stephen Fitz-Simon. Moving to 19-21 Kensington Church Street early in 1966, the soon-to-be-famous interiors were created by Julie Hodgess. She herself was to become known for her restaurant, Julie's, opened in 1969 and just three minutes away from Kaffe's flat. It seems no surprise that on its fiftieth anniversary Julie's could still boast of itself as a 'hang-out for the Hollywood set, high society and

rock stars' with a 'distinctive decadent style'.[6] Kaffe himself describes it as a 'bohemian eatery'[7] and the parallel with his own parent's restaurant is clear. He also describes Julie as a great fan of Bill Gibb, the Scottish fashion designer who tempted Kaffe to make that train journey to Inverness in 1968, an event now central in the Fassett hagiography. (Billy died in 1987, Kaffe having done 30 collections with him.)

Kaffe's early experiments with knitting, including his designs for Missoni from 1969 into the 1970s, sat perfectly with the fashion for rich, complex colourations. The latter were everywhere to be seen. Couture catwalks in 1963-4 had been awash with the luscious mohair and velvet ribbon-tweeds of Bernat Klein, woven in the Scottish Borders. Bernard Nevill was already designing flamboyant patterns for Liberty. Initially from 1961 a design consultant, then until 1972 design director, 'Nevill's Liberty collections came out of the decorative encyclopaedia in his head, referencing Hungarian embroidery, Javanese sculpture, Ottoman ceramics, 1920s stained glass and Tudor brocades in a Tate Gallery portrait exhibition'.[8] Also from 1959 to 1974 lecturing at the Royal College of Art (where both Julie and Billy studied), his influence was widespread. A Royal College student in this period was Gina Fratini, who had her own fashion business from 1964 to 1989 but also designed for Liberty, where her use of ethnographic and historical references fitted perfectly. In 1970, when Britt Eckland modelled a Fratini outfit for *Vogue*, the Slav-inspired layered ensemble featured boldly coloured and patterned fabrics: 'styled with bright red shoes and stockings ... [it] was described as a "frogged wallpaper print surcoat opening on a tucked strawberry wool crepe tunic and magnificent Liberty wool skirt, full and braided"'.[9] Another of the designers from whom Nevill purchased on Liberty's behalf was Susan Collier, in 1969. Collier replaced Nevill, and she and her sister, Sarah Campbell, were later to become known for their vivid, painterly patterns. Billy himself created garments from Collier Campbell Liberty fabrics in the early 1970s, as well as creating fabrics of his own. By now embrowned in colouration, the same tones and lively juxtaposition of patterns, unsurprisingly, also typified Kaffe's work.

As to the appetite for crafts, this too was growing throughout the 1960s, especially among creative weavers and dyers. It is easy to overlook now, but by the late 1960s

the preference for limited hand production – as opposed to commercial overproduction – was a philosophy held by many, and one that was especially apparent in the American wearable art movement and its transition from crochet to hand-operated machine knitting. In 1980 the movement was introduced to the wider world at the World Crafts Council convention in Vienna, by a delegation from the University of California, Davis.[10] The intervening years were marked by seminal events also destined to alter preconceived notions about the status of 'home-made' textiles. The Crafts Advisory Council (CAC) was founded 1970. A British government-supported organisation, it eschewed any association with craft as a pastime, aiming instead to promote and support the needs of 'artistic craftsmen', one of whom was Kaffe's design associate Richard Womersley,[11] who received a grant for a loom in 1975.

The initial CAC reticence to embrace all textile forms was soon challenged: textiles were recognised as forerunners of the modern art movement in the summer of 1971, when the Whitney Museum of American Art staged *Abstract Design in American Quilts*.[12] With this pivotal exhibition raising the status of quilts to a fine art,[13] in 1973 the Institute of

Contemporary Arts showed Navajo blankets and the CAC exhibition *The Craftsman's Art* at the Victoria and Albert Museum presented traditional crafts as enriched with new ideas. For Linda Parry, a curator in the Textiles and Fashion department of the V&A for over thirty years, Kaffe's heyday was the early to mid-1970s, when 'he reinvented knitting as a fashion statement alongside the likes of Foale and Tuffin, Mr Fish etc.' Parry's advice is: 'if I were him I would be boasting more about being selected by Cecil Beaton as one of the new contemporary designers for his V&A exhibition *Fashion* in 1971, which many now claim led to a revival of interest in couture. Beaton chose a man's lilac tweed knitted waistcoat.'[14] This garment, bearing a Boulton & Kaffe label, was among those machine-knitted by Mildred Boulton for the first Bill Gibb collection and represents a short-lived enterprise through which Kaffe and Mildred made limited edition garments.

The floodgates opened: there were television programmes such as Melvyn Bragg's BBC2 1975 *2nd House* documentary 'Two Contemporary Craftsmen', one being John Hinchcliffe, who was celebrated for his use of colour in a vibrant yet harmonious way after two years of rag rug

Icon crewneck jumper, knitted
for *Kaffe's Classics*, 1993

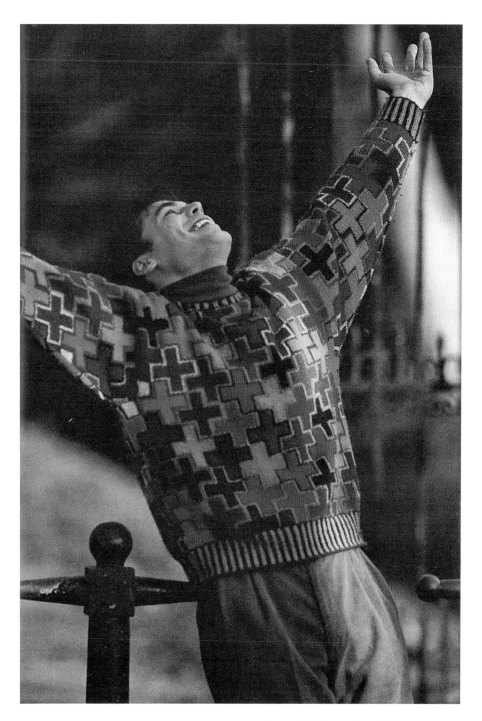

weaving. Kaffe took part in the gathering momentum, undertaking CAC-organised lecture tours from 1976, including some to the Woman's Institute, which until the filming of *Calendar Girls* in 2003 had been frequently pigeonholed as a staid, tradition-bound organisation. Nevertheless, the enthusiastic response undoubtedly prompted the CAC to create a solo show of Kaffe's work in 1977. Two years later the CAC became the Crafts Council and among the exhibitions in its new Craft Centre was *The Knitwear Review*, in 1983. Nevertheless, by 1985 its collection still held only three examples of knitting – one a cardigan hand-knitted by Kaffe and Nora Mitchell in 1979 – which 'certainly do not reflect the advances made within this craft over the last decade'.[15] This comment by Barley Roscoe, then curator of the Crafts Study Centre, Bath, may well have prompted the Crafts Council to create *Knitting: A Common Art*, a touring exhibition of 1986–7 whose title went some way towards acknowledging the contemporary discussions regarding the distinctions between art, design and craft.

The V&A had joined in this debate with *Knit One, Purl One: Historic and Contemporary Knitting from the Victoria and Albert's Collection*, curated by Francis Hinchcliffe and opening in November 1985. Soon afterwards came *Ascher: Fabric, Art, Fashion* in the spring of 1987, possibly the first celebration of the work of a living textile designer, Zika Ascher, then aged 78; his wife, Lida, although deceased in 1983, had by then made a significant contribution to the book accompanying the exhibition.[16]

In 1988 the V&A's Kaffe Fassett show highlighted his creative response to the museum's treasures, particularly in the ceramic, glass and enamel collections.[17] Sandy Black, the influential knitwear designer turned historian, documents this period: 'The industry', meaning yarn, pattern and fashion publications – and in response, museums and galleries – 'eventually polarized between "designer" patterns focused on natural yarns, intricate stitchery and the craft of knitting, exemplified by Rowan Yarns, Patricia Roberts and Kaffe Fassett, and the diminished family knitting market.'[18] Patricia Roberts was the knitter's knitter among these three, having from 1967 to 1971 served as knitting editor for IPC Magazines, director/designer of Patricia Roberts Knitting Ltd from 1971 and, through *Vogue*, supplied knitwear for London shops. She designed her own yarns (Patricia Roberts

'Kirman' fabric swatches in various colourways, 2008

Original 'Antwerp Flowers' painted design with swatches in various colourways, 2013

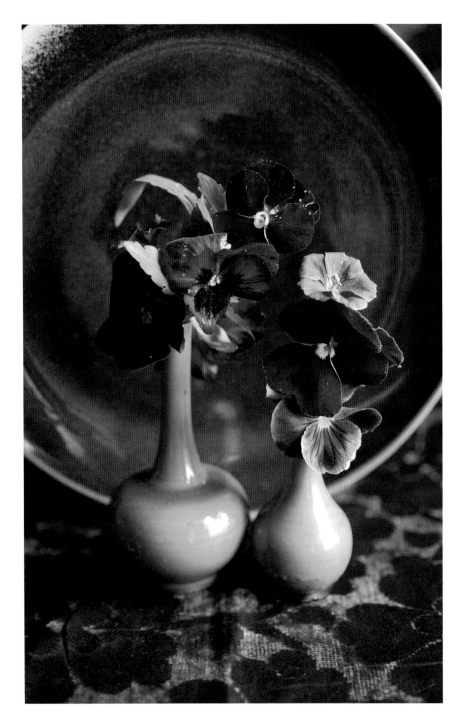

Still life set-up of pansies

Yarns and Woollybear Yarns) from 1976; from the same year she was director/designer of Patricia Roberts shops, which by the mid-1990s were franchised in Hong Kong, Cyprus and Melbourne. She also produced numerous books between 1977 and 1992. Recipient in 1986 of a Design Council award and subsequently its supreme accolade, the Duke of Edinburgh's Designer's prize of the year – never before awarded to a clothing designer – her work was compared by designer Jean Muir, who chaired the Knitting Committee of the Design Council, 'to that of a painter or sculptor, calling her "a craftsman who has made her work commercial.... [she is] a leader in the resurgence of artists and craftsmen who are bringing about the most exciting movement that has happened in this country for a century"'.[19] Kaffe was indeed in good company.

Nevertheless, from today's perspective, the fact that Kaffe has been supplying designs to Rowan since 1981 makes his position increasingly unassailable within the world of hand-crafted knitwear. And soon it was not just knitting. By 1982 he was stitching needlepoint cushions and panels for Hugh Ehrman; this, too, continues to the present day. This activity received a boost when BBC television's *Pebble Mill at One* followed Kaffe and Steve Lovi's six-month collaboration with over two thousand viewers on 'The Heritage Tapestry' project. Actually a panelled screen made up of submitted 6-inch stitched canvases, in the end two such 'tapestries' and one smaller panel were the result. Its completion coincided with Kaffe's first book, *Glorious Knits*, published in 1985; re-titled *Glorious Knitting* for its 1989–99 reprints and editions in Japanese (1991), Danish and Finnish (1995), it sold some 180,000 copies. This figure can be compared to sales of Montse Stanley's *Knitter's Handbook: A Comprehensive Guide to the Principles and Techniques of Handknitting*, which sold some one million copies via *Reader's Digest* between 1993 and 2001. Little wonder that publishers have since been keen to obtain a Kaffe Fassett title; in all languages and editions WorldCat lists some 350 in total, including exhibition catalogues and videos, an indication of a mutual benefit that typifies Fassett's ability to gather together makers, designers, manufacturers, photographers and bloggers for communal benefit. As Hugh Ehrman puts it, 'He is always thinking bigger and imagining wider possibilities'.[20]

Kaffe has also consistently urged a fearless approach to creative activities. For 'The Heritage Tapestry', he explains, 'I didn't mind how primitive or simplified the image was, they could just send me their offerings'.[21] Similarly, in the book accompanying the 1988 V&A exhibition he urged his readers to develop their own colour sense and experiment; his advice has remained thus ever since. Andrew Salmon, the influential and far-sighted developer of the Twistedthread brand responsible for organising *The Knitting & Stitching Shows*, *The Festival of Quilts* and *The Stitch and Craft Show* – the largest textile events in the UK from 1991 to 2012 – has pinpointed this capacity: 'Kaffe has never lost his touch in exciting people and encouraging them to take risks in their own design process.'[22] As to the Twistedthread shows – large, bustling four- to five-day events that finally broke the barriers between amateurs and professionals,

'Kaffe came to all the shows, possibly with the exception of Stitch. Initially we asked him to do specific things which he responded to with enthusiasm. Latterly, and knowing the shows well, he would arrive; teach; exhibit what he fancied and always hit the right spot. I seem to remember a lecture he gave in Harrogate, handing over a mixture of glass and plastic slides to the distress of the technician who told him that the slides were likely to jam. Naturally they did, producing a blur of colour as the plastic slide melted. Kaffe simply ad libbed whilst the audience loved the way the colours morphed away like a Pink Floyd light show! He always sold out.'[23]

Salmon, the consummate businessman, also saw that Kaffe 'had the professionalism to be surrounded by great supportive people such as Brandon Mably, Steven Sheard, Hugh Ehrman and Ken Bridgewater [Westminster Fibers]'. In other words, 'in dealing with Kaffe, he was so professional absolutely *because* he was surrounded by people who actually made things happen, allowing Kaffe to be Kaffe'.[24]

So, one asks, just who *is* this Kaffe? Salmon refers to 'the charm and communication skills that have elevated him to the star status he has enjoyed since his V&A show', which toured in Northern Europe. Today it is still recalled by Dilys Blum, curator of costume and textiles at the Philadelphia Museum of Art: 'I vividly remember his one-person show … I saw it in Stockholm when it was on tour. I was overwhelmed by the color and pattern, which was a welcome antidote to Scandinavian minimalism.'[25] That Kaffe was able to overcome the growing fashion for minimalist styles in the 1990s is a further testament to his confident artist's eye. His consistent devotion to complex colourations can be likened to the world traditions he celebrated in his work, seen in person in America and the UK and as a result of exhibitions and lecture tours in Japan, New Zealand and elsewhere that had begun in the mid-1980s. Now there was a new 'tradition', one we might call the Kaffe Fassett Carnival. Capturing the gaiety of the Euro-American circus, the swirling dragons in Asian celebrations or the fantastic feather-splaying garb of Latin American carnivals, his work speaks of joyous communal gatherings. The most telling parallel is with the circus ringmaster, who beckons all in, orchestrates the performances and produces a shared and happy experience.

If ringmaster he is, he leads a three-ring circus. The knitting and stitching might have been enough for another person, but the third arena – fabrics and especially those for patchwork – came to the fore in the latter part of the 1980s. However, designing furnishing fabrics was already part of his back story, having begun in about 1973, when Kaffe met Tricia Guild of Designers Guild, which she had founded with her husband, Robin, in 1970. She commissioned needlepoint cushions for her decoration of Browns, which had launched in 1970 as a luxury fashion boutique on South Molton Street in London's Mayfair. She saw the potential in Kaffe's designs and between 1975 and 1978 she launched three collections of fabrics that he had designed. In another instance of 'the right time', the support of the Design Centre turned out to be pivotal. The public face of the Design Council, founded in 1944 as the world's first government-funded design promotional body and by the 1970s prioritising rewarding design talent, it promoted the young company, partly via a publicly accessible slide collection (now in the archives at the University of Brighton). This included images from the company's 1975-9 collections of fabrics and wallpapers, the first of which was called 'Village' and, aside from 'Chrispin', a small trellis and dot design by in-house production manager Chris Halsey, consisted mainly of recoloured Indian patterns. More evident support came via the Design Council's display of room sets in 1978 and 1980, in its Haymarket, London, headquarters. The slides included two Kaffe designs of 1978 but the more visible room sets both included his 'Geranium', designed in 1975.[26]

'Geranium' became something of a signature fabric for Designers Guild, consistently featured in the press for close to another decade and another example of the mutually beneficial partnerships that typify Kaffe's career. In 1980, porcelain printed with a version of the design could be seen in the 24 June edition of the *Daily Telegraph*; it also featured in a June 1983 issue of *Woman's Weekly* as a window blind: 'a touch of something special without spending a fortune'. This and other Fassett designs facilitated Kaffe's own ventures into interior design, while at the same time relieving Tricia of the need for a design studio: 'Instead, she has arrangements with several artists, usually friends whose paintings she has admired'.[27] Among these was Lillian Delevoryas, a friend of Kaffe's, whose collections were released in 1977 and 1979.

Robin Guild, by this time no longer active in Designer's Guild, nevertheless continued to support it, featuring a number of images of Tricia Guild's own home in his 1979 book *Homeworks*: *The Complete Guide to Displaying your Possessions* (this influential volume was republished in four languages over the following five years as *The Finishing Touch*). One image shows her bay window, the caption concluding: 'Tricia's love of flower and plant forms is established in the upholstery fabric and in the window blinds and curtains.'[28] The fabric illustrated is by Kaffe. With the larger, watercolour-like designs by Kaffe and Lillian Delevoryas, as well as bold plaids, solid-coloured fabrics

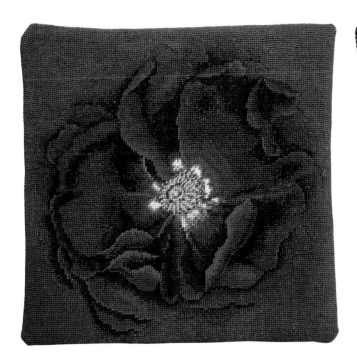

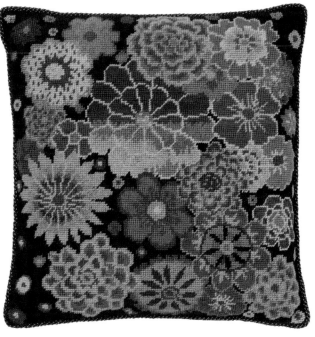

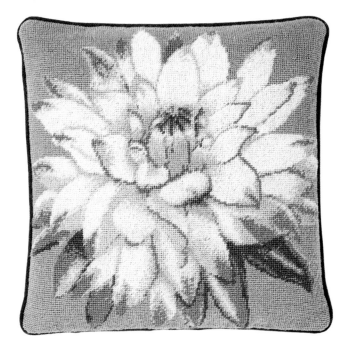

Blood Red Rose, *Fire Flowers* and *White Dahlia*, needlepoint cushions made for Ehrman Tapestry

Kaffe Fassett for Designers
Guild, with custom needlepoint
on chair, 1970s

and woven throws – often supplied by Richard Womersley – Designers Guild composed an endless array of room sets, table accessories and other items, including Kaffe-knitted throws, cushion covers and paintings. All featured in their 1980 book, *Soft Furnishings*.[29]

Journalist Louise Bootes-Johns in *Harpers and Queen* summed up the type of customers who sought out Designers Guild in 1981: New Romantics ('soft, loose, fabricky, lacy ... with ribbons and tassels'), Sloane Rangers ('chintzy drawing-room, always in the best tradition'), First-Homers ('working within a budget but with definite ideas on style – they don't always shop at Habitat') and Home-Lovers ('Broke-but-in-love-with-home').[30] What she was describing, of course, were the wide range of people who appreciated the output of the design studio that Kaffe and Richard had created in 1976. That appreciation continued, particularly as tastes moved from sweet, soft tones to deep, rich colourations, prompted in part by the impact of the opening of the most comprehensive Matisse exhibition to date at the Museum of Modern Art in New York in September 1992. In 1985 Designers Guild reissued the Kaffe Fassett and Lillian Delevoryas bestsellers from the late 1970s. Kaffe's final contribution to their range was in 1994.

Kaffe himself marks 1995 as a turning point, when he embraced patchworking at the instigation of Liza Prior Lucy, the Rowan representative who accompanied him on his first book tour in the United States. Having depicted patchworks in his paintings of 1974–6 and taken note of pieced work during his trip to India in 1992, the result was their jointly authored book *Glorious Patchwork*, published in 1997, available in Japanese in the following year and 11 years later reissued as a paperback. The fabrics used include those woven in India and Guatemala under the auspices of Oxfam and prints issued by Westminster Fibres USA and Rowan UK (and, more recently, Free Spirit Fabrics). Turning 60 in 1997, Kaffe's world was expanding rather than diminishing, with more worldwide lecture tours followed by a growing internet presence. His continuing popularity can be measured in his growing followers on Facebook and Instagram.[31] Dilys Blum has watched his progress:

'Fassett continues to design knitting patterns for Rowan and needlepoint designs for Ehrman. However today he is best known, particularly in the United States, for his vibrant colorful quilt fabrics and innovative patterns. He and his team offer new interpretations of classic patchwork designs and encourage makers to experiment with placement and color.'[32]

Kaffe's patchworks have been featured in the United States in several exhibitions, including those at Minneapolis Institute of Art (1997 and 2010), Michener Museum (2016) and Texas Quilt Museum (2018).

At America's first specialist museum, San Jose Museum of Quilts and Textiles, the *Blanket Statements* exhibition captured a key element of Kaffe's modus operandi. This colour-saturated display featured historical quilts from the eighteenth and nineteenth centuries and Kaffe's recent work responding to them. The exhibition was created in England by the York Quilt Museum and Gallery and had toured already to two other venues in the United States. Among those present at the San Jose opening was Jo Ann C. Stabb, herself an influential educator and influencer in the world of American wearable art. She recalls Kaffe as 'gracious, genuine, very generous and polite ... no airs, just very supportive of the field'. To those present he was 'very available, taking the compliments and comments but not dwelling on himself, instead asking about their interests – one could get close!'[33] Once again, Kaffe's ability to please the crowds was apparent. The 'buzz' of his personal appearances has survived the Covid pandemic, for instance with 'Creative Conversations', a Zoom event in which he and his niece, painter Erin Lee Gafill, discussed a decade-long exchange that culminated in a weekly painting session over a year-long period. Recorded in October 2020, 'Creative Conversations' was followed soon afterwards by their publication of *Color Duets* and a linked exhibition at the Monterey Museum of Art in 2021.

The name of the current studio – The Kaffe Fassett Collective – with fellow designers Brandon Mably and Philip Jacobs is apt. Kaffe's work can also be said to collaborate with history and landscapes, while so much that he designs, whether patchwork, buttons or mosaics, are visual collaborations, juxtapositions of materials and shapes. The notion of collaboration equally resonates with his ability to commune with his followers, who themselves often partake in 'fabriculture', a 'whole range of practices usually defined as the "domestic arts": knitting, crocheting, scrapbooking, quilting, embroidery, sewing, doll-making'.[34] Referring to the recent popularisation and resurgence of interest in these crafts, especially among young women, Bratich and Brush, the originators of the term 'fabriculture', include in their definition 'the mainstream forms found in Martha Stewart Living as well as the more explicitly activist (or craftivist) versions such as Cast Off, Anarchist Knitting Circle, MicroRevolt, Anarchist Knitting Mob, Revolutionary Knitting Circle, and Craftivism. In addition, a whole range of cultural forms fall in between these poles, such as the virtual knitting circles and crafting blogs, as well as the association with (post)feminism in the pages of *Bitch* and *Bust* magazines.'[35]

As a ringmaster Kaffe's energy has become ever more impactful:

'The resurgence of craft is a profoundly collective phenomenon. Although it can take overtly political forms, like the knitting of protests signs or "yarn bombing" public spaces, craft is also inherently political because it is collective, and because it is slow. Scholars have argued that the communal nature of "craftivism" makes it an antidote to alienation within an information society. They note too that in protests where knitters are present,

they serve to remind us of the intrinsic value of building a cooperative project.'[36]

In such a long career, and with so much in print and digital media, it can be tempting to identify Kaffe's achievements as singular. The truth is more nuanced, depending as it does on the recognition – which Kaffe himself gives – of the consistent presence of collaborators. Some are often mentioned; others are not. This is the nature of the business, just as it was when Missoni did not reveal Kaffe's contribution to their early 1970s collections. Just one example is the use of the Liberty Archive, a source that – as we have seen – chimes with Kaffe's own aesthetic. In 2008–10 they consulted for a 2011 collection with archivist Anna Buruma, who recalls:

'Kaffe and Brandon came to the archive and I am sure I would have shown them some real things, but the designs were chosen from the database. They would probably have given me a brief and I would have made a selection of the kind of designs that might appeal to them, but I would also have been able to find other designs once we had sat together and have understood better their likes and dislikes … Some are pretty much directly transferred, maybe a different scale and certainly different colours, but there are also designs that they have transformed into something completely different. So it is pretty much as all design studios work, being "inspired by", "based on" and transforming.'[37]

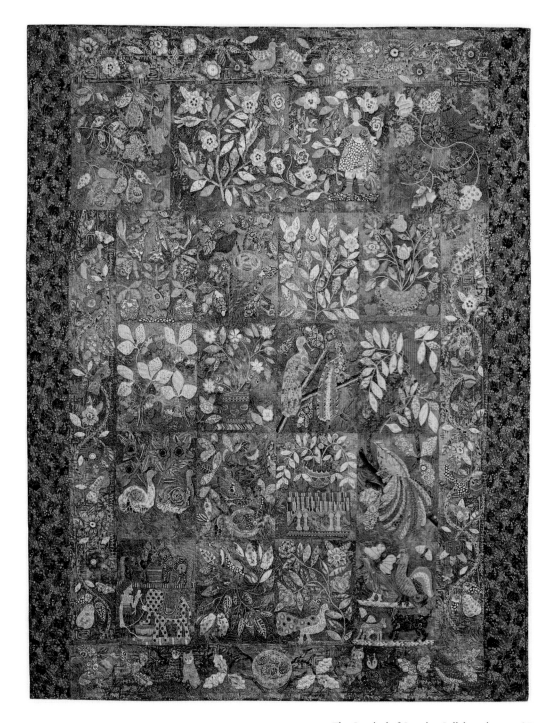

Civil War Bride quilt by Patty
Harants using Kaffe Fassett fabrics

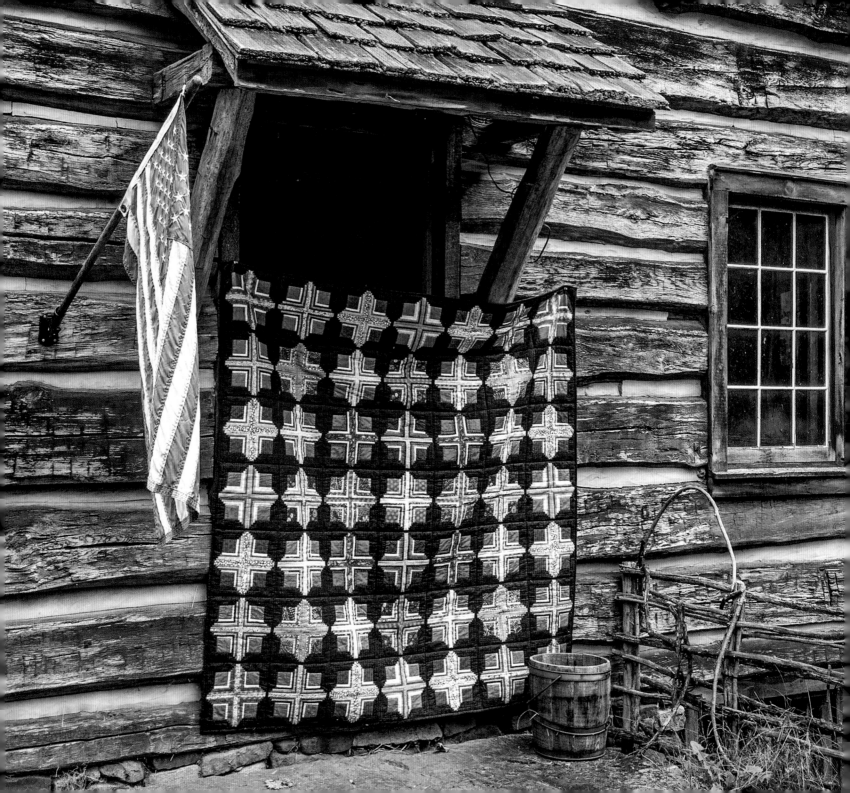

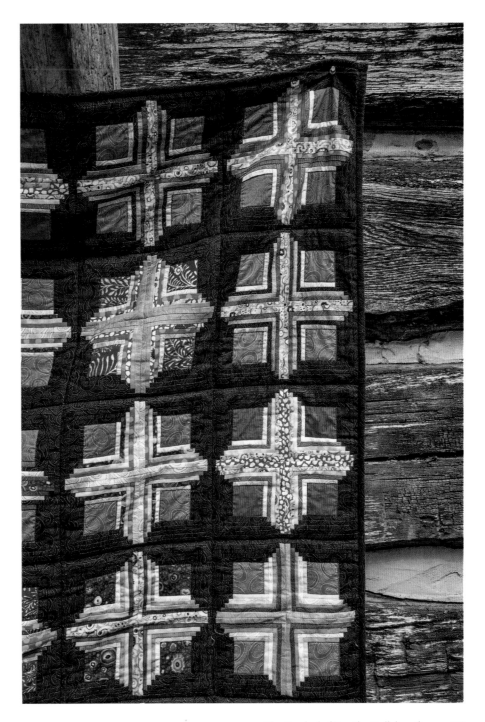

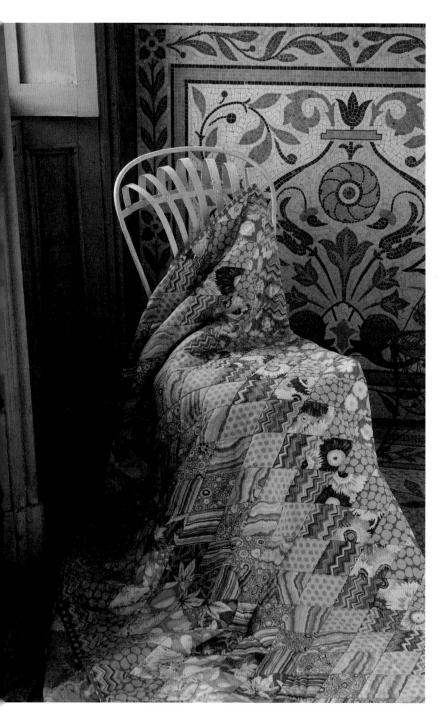

Green Diamonds quilt from *Quilts in Ireland*, 2017 (with detail)

Within their selection were two designs by Raymond Honeyman for Liberty, one of 1990, covered with small, brightly coloured 'tossed' teapots. A highly regarded designer known for his rhythmic interchanges of pattern and colour, Raymond reacted positively when this later use came to his attention,

'I was very flattered that Kaffe had chosen the "Teapots" design especially as Liberty had bought my designs but never told me when or if they were put into production … so when Anna told me that it had been in production and chosen by Kaffe who recoloured it, I was indeed thrilled. The fact that he and I both design for Ehrman is a nice link too.'[38]

Notes

1 Moore 1986.
2 Klein 1996.
3 See www.carmelart.org/about-us/ (accessed 13 February 2022).
4 Today owned by a family member, Nepenthe has its own Wikipedia page.
5 *Dreaming in Colour* 2012, pp. 26–7.
6 www.juliesrestaurant.com (accessed 10 February 2022).
7 *Dreaming in Colour* 2012, p. 86.
8 Bernard Nevill obituary, *The Guardian* online, 27 February 2019. (www.theguardian.com/artanddesign/2019/feb/27/bernard-nevill-obituary, accessed 10 February 2022).
9 V&A, inv. T.276-1990 (www.collections.vam.ac.uk/item/O83996/skirt-fratini-gina, accessed 10 February 2022).
10 See Schoeser 2020, p. 99.
11 See www.caa.org.uk/cvs/richard-womersley/ (accessed 10 February 2022).
12 Holstein 2002.
13 See *Crafts Magazine*, 15 (July–August 1975), pp. 28–33; Hinchcliffe and Jeffs 1977.
14 Linda Parry, email to the author, 24 February 2022; the piece she refers to was a gift to the Museum from Kaffe (Ginsburg 1971, no. 362).
15 Roscoe 1985, p. 171; the other two pieces were machine-knitted by Barbara Brown (1984) and Anne Fewlass (1979).
16 Mendes and Hinchcliffe 1987.
17 *Kaffe Fassett at the V&A* 1988.
18 Black 2012, p. 146.
19 Elian McCready, 'Patricia Roberts', in *Encyclopedia of Fashion* online (www.fashionencyclopedia.com/Pi-Ro/Roberts-Patricia.html, accessed 24 February 2022).
20 Hugh Ehrman, email to the author, 10 January 2022.
21 *Dreaming in Colour* 2012, p. 141.
22 Andrew Salmon, email to the author, 15 February 2022.
23 Ibid.
24 Ibid.
25 Dilys Blum, correspondence with the author, 11 February 2022.
26 The *All Things Bright and Beautiful* Design Council exhibition 1978 included Kaffe Fassett's 'Geranium', 'Pollo' chair by Robert Whiting Designs Ltd, and carpet by Greenwood & Coope Ltd.
27 Bevis Hiller, 'Designs on your home', *Sunday Telegraph* (6 January 1980), unpaginated (from the Designers Guild press books).
28 Guild 1979, p. 91.
29 Donald 1980.
30 Louise Bootes-Johns, 'Sticks and Styles: A guide by type for furniture-buyers in London and around the country', *Harpers and Queen*, 1981, unpaginated (from the Designers Guild press books).
31 Quora, www.quora.com/What-number-of-followers-is-considered-large-on-a-social-media-platform (accessed 10 February 2022).
32 Dilys Blum, correspondence with the author, 11 February 2022.
33 Jo Ann C. Stabb, telephone conversation with the author, 10 February 2022.
34 Bratich and Brush 2011, p. 234.
35 Ibid., p. 234.
36 Thanhauser 2022, p. 260.
37 Anna Buruma, email to the author, 8 February 2022.
38 Raymond Honeyman, email to the author, 12 February 2022. This captures the courtesies shared among professional designers – even though Raymond believes that 'to this day Kaffe probably doesn't know that it was my design'.

A WILD RIDE

Hugh Ehrman

I have been working with Kaffe for over forty years and his creative process never ceases to fascinate me. He works at speed, with tremendous enthusiasm, fuelled by an exhilarating American can-do spirit. I think it's this boundless enthusiasm I treasure most and what has made our collaboration such fun. He is always thinking bigger and imagining wider possibilities. Such ambition is very rare in a designer and has proved invaluable to the companies that have worked with Kaffe and have managed to harness this energy. It has been a wild ride at times with lots of laughs. I have enjoyed it immensely.

Kaffe is the most single-minded of all the designers I have worked with. He knows exactly what he wants to do but is always open to ideas. I must gain the trust of a designer before I can start making suggestions and with Kaffe I felt we were on the same wavelength from the start. I met Kaffe when I worked for Judy Brittain at *Vogue*. Judy was an early champion of Bill Gibb and Kaffe and had a wonderful eye for emerging talent. I learnt a lot from her and, when I stood in for Judy at *Vogue* later on, I improved my own eye and my critical appreciation of all the design talent from so many fields that came my way. It was a wonderful education. Starting with Kaffe set the tone for our business, which was always about trying something a little different and bringing his unique look to an industry that lacked design flair.

As businesses settle down, they develop a personality and discover what works. This can lead to complacency: flowers and animals sell so let's stick with those. There will always be safer, tried and tested subjects for needlepoint kits but a successful business needs more, and Kaffe has been the perfect partner to inject that element of surprise. If a business loses sight of what made it interesting to start with, it will fade over time. To avoid that you must take risks and some of Kaffe's designs have been complete gambles. Only some work commercially but the ones that do far outshine the others and give the range a fresh direction. It stops us all from getting bored – customer, designer and producer – and it keeps us relevant. Kaffe's confidence is the key. Not just with colour but with subject matter. We have produced more experimental designs with Kaffe than with anyone else but, at the same time, Kaffe never forgets his audience and always bears in mind that he is designing for stitchers, not composing one-off artworks for private clients. It is an interesting fact that Kaffe's kits often have fewer colours than our other designers use. He makes better use of a limited palette than anyone I know.

It has been a great privilege and a stroke of extraordinary luck to have linked up with Kaffe at the age of 25 and to be working with him 45 years later – the most consistent and important contributor to our collection every year, without a break. An amazing record.

KAFFE FASSETT AND DESIGNERS GUILD

Tricia Guild

I think it was in the early 1970s when I first became aware of Kaffe Fassett;
at one of his exhibitions I saw some of his knitwear and his tapestry work and
I was immediately smitten. I knew I had to have a piece of his. Kaffe and I
became great friends. I was – and remain – an ardent fan of his.

There is a wonderful free expression within Kaffe's work, a love of colour
and an inherent ease in using it. The textures are also so vibrant and alive
– it is quite beautiful. I remember a large painting of a pot of geraniums

and on looking at it, I could see a fabric repeat. I talked to Kaffe about the possibilities of a fabric collection, and he was as thrilled as I was! It was an exciting time.

'Geranium' – our first collaboration– was very much based on Kaffe's work. It was layered and decorative, in soft, chalky colours that came to be extremely popular. I think in total we launched five collections with Kaffe over the years, and each one was a great success. Conveying the knitted texture in printed fabric was not always easy but we worked hard to achieve it and the result was collections that had a unique quality and handwriting.

Not only is Kaffe a wonderful person, but he is also an immense talent who has an infectious energy and an extraordinary gift.

Battenberg quilt from *Quilts in Ireland*, 2017 (with detail)

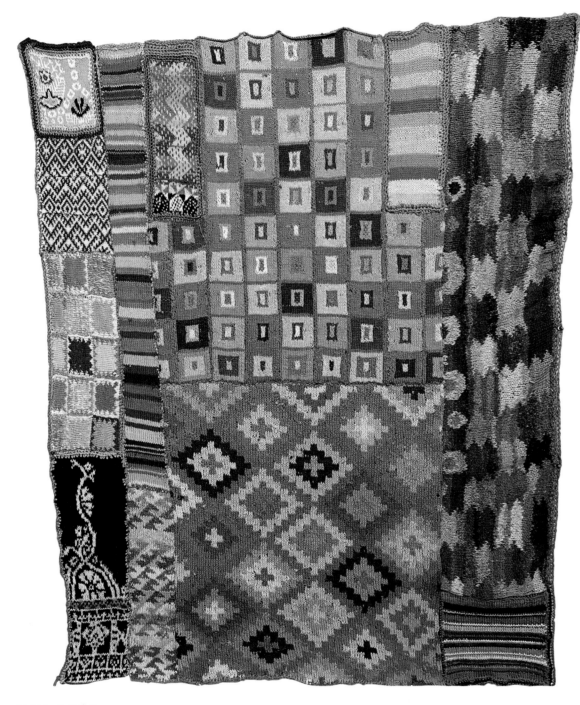

Bright Squares Blanket, knitted patchwork, 2021

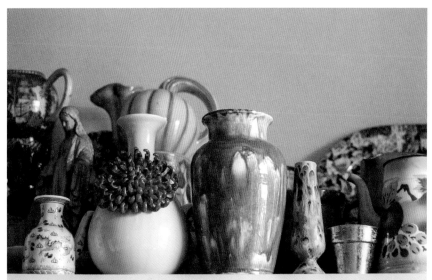

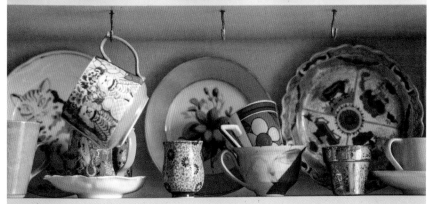

Garden mosaic with Rupert Spira
tiles

Fassett's kitchen shelving with a
selection from his china collection

Starburst quilt from *Quilts in America*, 2018 (with detail)

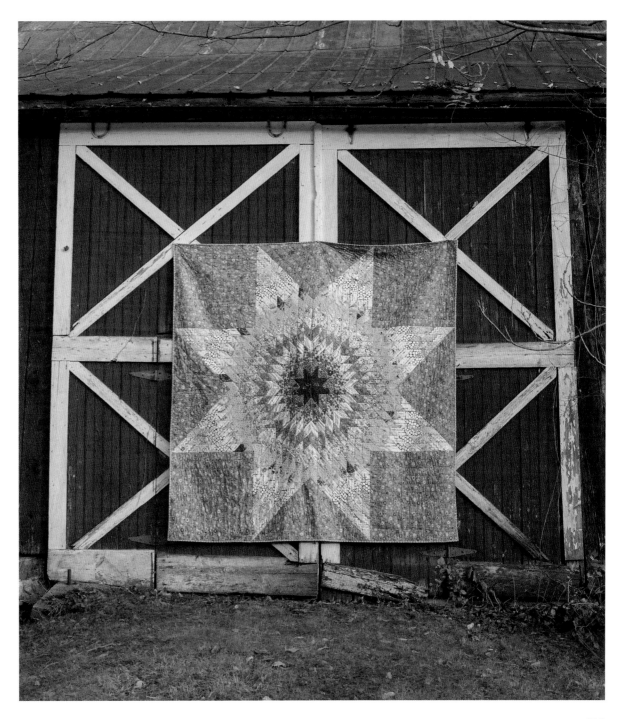

Location shot at Skansen from *Quilts in Sweden*, 2011

Detail of *Grey Gridlock* quilt from *Kaffe Quilts Again*, 2012

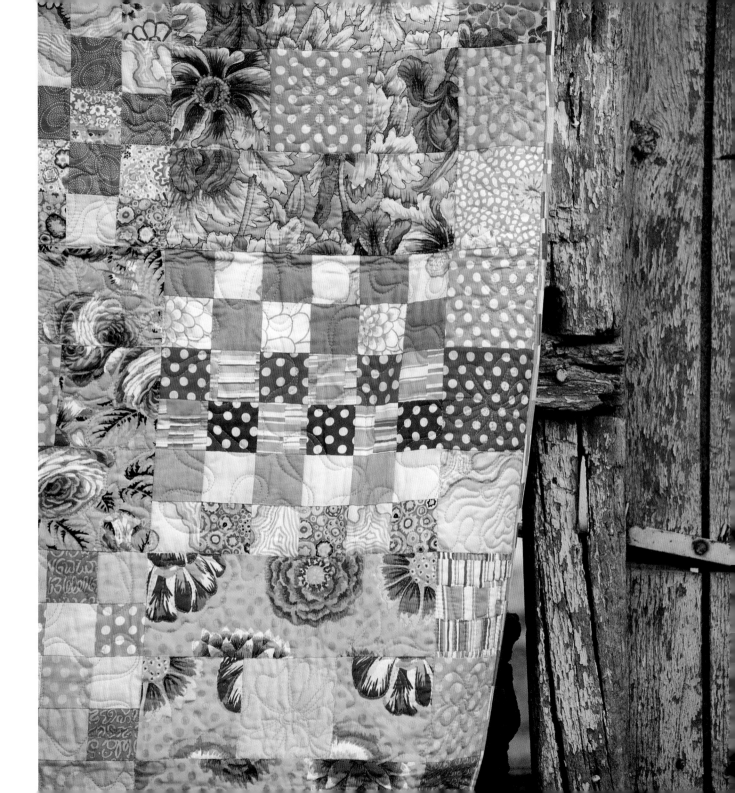

Maple Leaf Medallion quilt by Liza Prior Lucy from *Quilts in Ireland*, 2017

Location shot for *Quilts in Ireland*, 2017

Spring Boston Common quilt from *Simple Shapes: Spectacular Quilts*, 2010

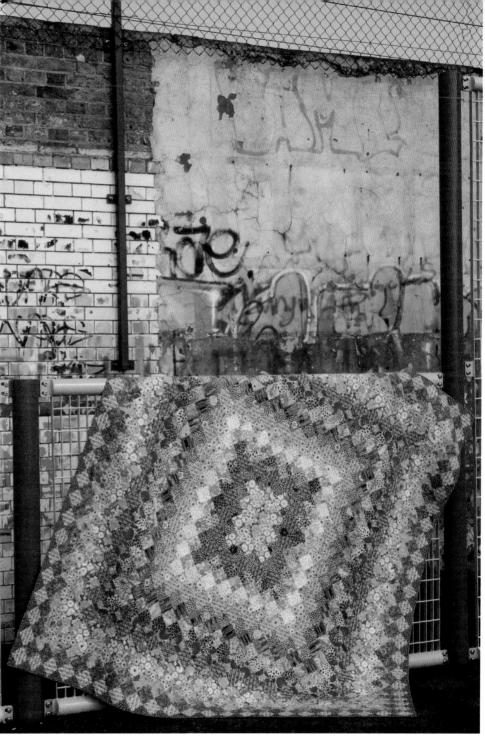

THROUGH A LENS: 30 YEARS OF PHOTOGRAPHY WITH KAFFE FASSETT AND BRANDON MABLY

Debbie Patterson

I wonder that the criteria for soft art being considered high art is that it should have an element of political or social commentary. I would suggest that Kaffe Fassett's vibrant legacy and vast, versatile body of work has influenced an important social evolution of colour within these media. I am not a critic or an academic, but what I can do is relate my experience of working alongside Kaffe and Brandon in my role as photographer and reflect on the connections that link one image to another.

Liberty's, London 1993

The central staircase of the Liberty's building creaks: its oak timbers are from ancient ships. On the top floor is the homes department, where you can buy Arts and Craft-influenced pieces. From here you can see all the way down through the heart of the building, as if from a minstrels' gallery. Fragments of conversation and bustle drift up. It feels like a Shakespearean stage.

I was there to meet painter and textile artist Kaffe Fassett, who was going to decide if he liked me enough to photograph for his new book, *Glorious Interiors*. He was having an event at Liberty's and the publishers, Ebury Press, had arranged for us to meet.

Craft was not my world at that time and I had not researched what Kaffe was doing then. However, I was aware of his name because I had bought a needlepoint kit that he had designed. It was one of his most famous cushion kits, the canvas overprinted with the image of a voluptuous winter cabbage. I had got stuck deciphering shades of cabbage and the kit was left unfinished, green wool threads dangling like an exodus of caterpillars.

Kaffe needed a new photographer after Steve Lovi had returned to the United States, having lived in London for many years. Steve was the photographer and muse with whom Kaffe had created the successful books *Family Album* (1989), *Glorious Needlepoint* (1987), *Glorious Colour* (1991) and *Kaffe Fassett at the V&A* (1988, cataloguing his one-man show at London's Victoria and Albert Museum). Together they produced intensely layered imagery, picking up on colour and texture, creating a photographic style that was highly distinctive and instantly recognisable.

I was unaware at the time, but Steve's departure had left a void. This shift in the creative team was a significant and disruptive moment for Kaffe. Eager to please, his publishers presented him with a selection of portfolios for him to assess. Kaffe remembers that it was a detail shot of garlic in a purple

net bag that I had taken that caught his eye among the portfolios he was assessing.

I had begun to make a name for myself photographing food and flowers in a style that was both evocative and had a sensitive sense of colour. I was one of a small group of female photographers who had broken free from the lighting-filled studios that were then the norm, and just used natural daylight to create images with a much more naturalistic look. I had been very influenced by the photography in *The Taste of France* (1993), a cookery book, by Robert Freson, who began his career assisting photographer Irving Penn in New York. Freson's images were painterly and evocative, capturing every sensory aspect of the classic French recipes, the region and the people.

I had purchased the cabbage needlepoint kit from Ehrman, a shop owned by Hugh Ehrman (for whom I would later photograph many needlepoint kits, including those by Kaffe). I recall that Kaffe's yellow wallpaper with blue pots (used for his 'Jug Plate' cushion published in *Glorious Colour*)[1] was papered on the walls. Looking at that cushion shot now, I am amused to see that Steve was not a fan of ironing the background fabric, something that Kaffe has resisted on my shoots too.

I was a frequent visitor to The Lacquer Chest nearby, which appeared from the street to be a small, cramped antiques shop selling country-style furniture. However, in the basement and upstairs floors the shop was racked high with the valuable and humble: china plates, glasses, silverware, fabrics and objects of whimsy. Film and photography stylists, including myself, squeezed past each other, gathering props for jobs they were working on. Kaffe's studio is another *Wunderkammer*, sharing synergy with The Lacquer Chest: it, too, has floors and drawers filled with eclectic treasure.

On the first day of shooting for *Glorious Interiors*, Kaffe and Brandon Mably (who at the time was managing the studio) were busy finalising the sets in the various rooms about the house. On the top floor, in a room that Kaffe now uses as his painting studio, the set was worked to resemble the corner of a tawny sitting room inspired by antique marquetry boxes. For this set I had brought along some of my own Provençal ochre-coloured pots, and on this occasion (and as I would do subsequently) I had also brought a large

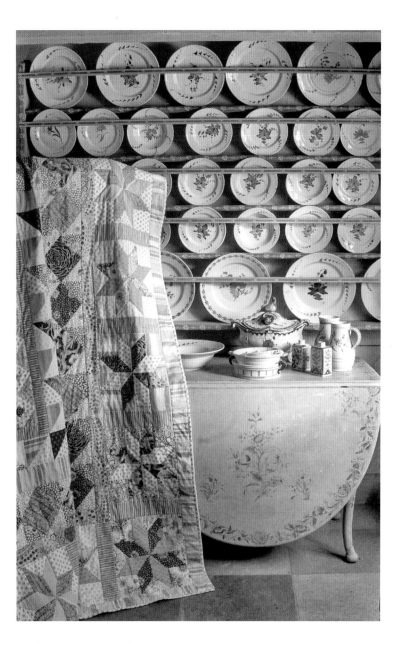

Imari Plate quilt from *Quilts in Sweden*, 2011

bunch of interesting foliage and flowers – felty yellow
monkey's paw and large, Van Gogh-style sunflower heads
– to excite Kaffe. He immediately started to pull the stems
out of the bucket I had brought them in and arrange them
informally. On that first shoot, bringing those appropriate
textures and tones confirmed my competence in the team.
Brandon and I share the same frivolous sense of humour,
which can help to lighten the intensity of the shoot. My
photography and sense of styling is also painterly: I seemed
to have a natural sense of colour that was evolving and an
ability to deal with composition, which Kaffe has always
acknowledged and encouraged. This generosity of spirit is
something that he gives freely. It is a marvellous boost when
you are validated in this way.

Workflow

On photo shoots, whether in the house or on location, Kaffe
is focused from the minute I arrive, even after a long journey.
He propels me to the first set-up, which he has already
organised and styled. There is an urgency and need to start
the flow of the day, and a determination to realise his vision
of each shot. Kaffe wants the photographer to capture what
he is seeing in his mind's eye and to convert his vision into
a usable inage that can be reproduced, usually in a book or
a magazine piece. My method of working with Kaffe is to
follow his direction but to be present and observant, pointing
out other possibilities along the way. He is sometimes
receptive to feedback and the odd suggestion from time
to time, and also appreciates Brandon casting an eye over
the final shot. Kaffe can be impatient when the process is
interrupted by, for example, changing lenses or setting up
reflectors. In his mind, once he is happy with the set-up the
shot is in the bag and he is ready to move on to the next one;
everything else is just wasting valuable creative time.

Glorious Interiors was crammed with ideas, rooms in the
house were reinvented wall by wall, corner by corner. There
was no minimalism employed here: it was as if we used every
item in the house, layering colour and textures, building up
detail on detail, some of the finished pages feeling almost
too small to contain the densely designed imagery. The
sepia-toned dining room is the only room that has remained
intact over the years; it is sometimes used for entertaining
and was decorated and photographed at Christmas one year,

Garden at Hidcote, on location
for *Quilts in the Cotswolds*, 2019

Sunny Zig Zag quilt detail from
Quilts in the Cotswolds, 2019

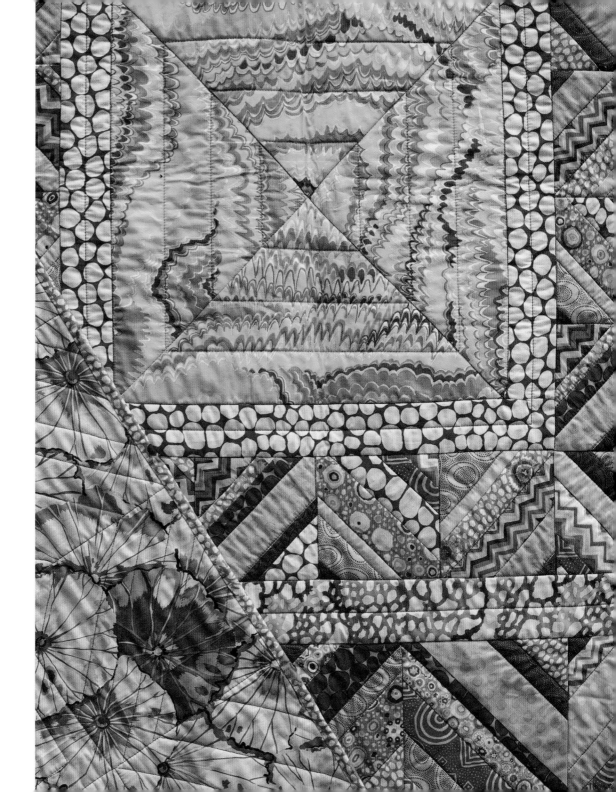

Assorted wools in Fassett's studio

Fassett's sitting room with
Chinese Ancestors painting from
Fassett's personal collection and
Schoolhouse quilt from *Welcome
Home* new edition, 2017

looking sumptuous. Some of the pieces that Kaffe designs, such as the stamp-covered lampshade, can be related to recurring motifs – in this case a spread in *Glorious Colour* showing stamp-covered boxes, where Kaffe talks about the satisfaction of the square shape and makes mention of board games. Indeed, one mainstay quilt design is his 'Chequerboard', which we have photographed over the years, one of my favourite examples being the *Blue Chequerboard* quilt shot against a fading mural in Rousillon, France (p. 148).

On the basis of a contented Kaffe, I was commissioned to shoot other books, including *Mosaics*, a collaboration with American Lebanese artist Candace Bahouth published in 1999. For this Kaffe transformed the entrance of his house with huge mosaic panels of hollyhocks on one side and coloured diamonds on the other. Inspired by quintessential English cottage gardens, the tall hollyhocks on the left reach high into the blue sky: Kaffe knew that the design would work to fill the tall, narrow space. He explains that variations in the size of tesserae in this panel give 'vitality and movement to the design'. I know these panels well, having photographed their step-by-step installation. The designs were first sketched out directly onto the wall in black

chalk: Kaffe's sure drawing hand is clear to see. The rather crudely snipped tile pieces might suggest that this was a project spontaneously created on the go, but in fact Kaffe has acutely observed the leaves, carefully detailing veining, shadows and light, illumination falling on the leaves and even tonality in the sky parts to create a meticulously subtle effect. On the right side of the door is a geometric design by Brandon Mably, comprised of diamonds filled with rich, glossy contrasting colours (p. 161).

During this period the ground floor of the house was for weeks a jumble of plastic buckets filled with broken china sorted into colours, dusty open bags of cement and grout, rags and scattered tools. In the same way, when rag rugs were being made for *Glorious Interiors* there were piles of old T-shirts and other clothing cut and ripped into mounds of colour everywhere.

In the hall is another mosaic project, a high table covered with mosaic pieces created from transferware. This type of English pottery, which originated in Staffordshire in the early nineteenth century, features surface printing in a single colour. Cobalt blue and white designs were the most common, notably 'Willow Pattern', with green, brown and

Garden mosaic

Fassett's entryway with mosaics

Graphite Medallion quilt by
Liza Prior Lucy from *Quilts in
the Cotswolds*, 2019

pink designs later becoming popular. For the table Kaffe used both antique china and contemporary reproductions, much of it collected from car boot sales and junk shops. Kaffe's mosaic-covered chimney pots were part of his Chelsea Flower Show garden design for Hillier in 1998, which won a gold medal. Diamond-shaped sections were filled with succulents and there were shell-covered mirrors and cement swans covered in shards of white china and pearls.

Although *Glorious Interiors* was shot in and around the house, we had begun to venture out on location to photograph the books. For his *Hat Boxes* quilt Kaffe used the fabric equivalent of transferware, Toile de Jouy – some of the vintage French fabrics having been collected by Liza Prior Lucy. We photographed this at the Shropshire home of Rupert Spira, a notable studio potter and maker of the tiles Kaffe has used in his house. Rupert's house had a sparse integrity in its decor, a kind of refined minimalism with texture – lime-washed, bumpy plaster and old beams – but not fussy or cluttered. I remember Brandon, Kaffe and myself sitting at the kitchen table while Rupert roughly scrubbed a huge pile of earthy carrots, then juiced them into raw energy and goodness for us. We went on to photograph some of

Glorious Patchwork (1997) at a pale blue weatherboarded house in Whitstable, known as The Battery, a former Sea Scout hut, sensitively preserved and enhanced by its craft loving owner. *Passionate Patchwork* (2001) soon followed.

The fabric designs for use in patchwork gathered momentum quickly and the 'P&Q books' (as we knew them) were published by Rowan every season to promote the latest fabrics. Kaffe was driven by design possibilities, producing quilt designs incorporating patterns inspired by the past and his own reinventions. We went further afield, to locations such as Portmeirion in Wales, a quirky Italianate vision of a seaside village with buildings in ice-cream pastel colours. Built in 1925-39, the village was the creation of Sir Clough Williams-Ellis, who wrote evocatively: 'An architect has strange pleasures. He will lie awake listening to the storm in the night and think how the rain is beating on his roofs, he will see the sun return and will think that it was for just such sunshine that his shadow-throwing mouldings were made.'[2] I can relate that to our shoots, some locations were made for these quilts and some quilts were made for these locations.

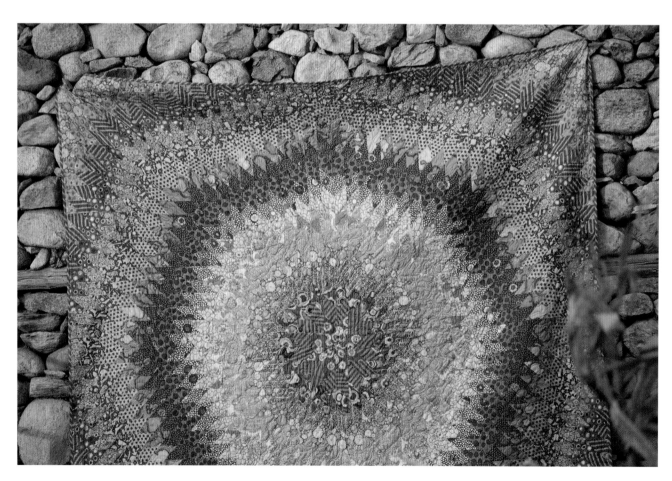

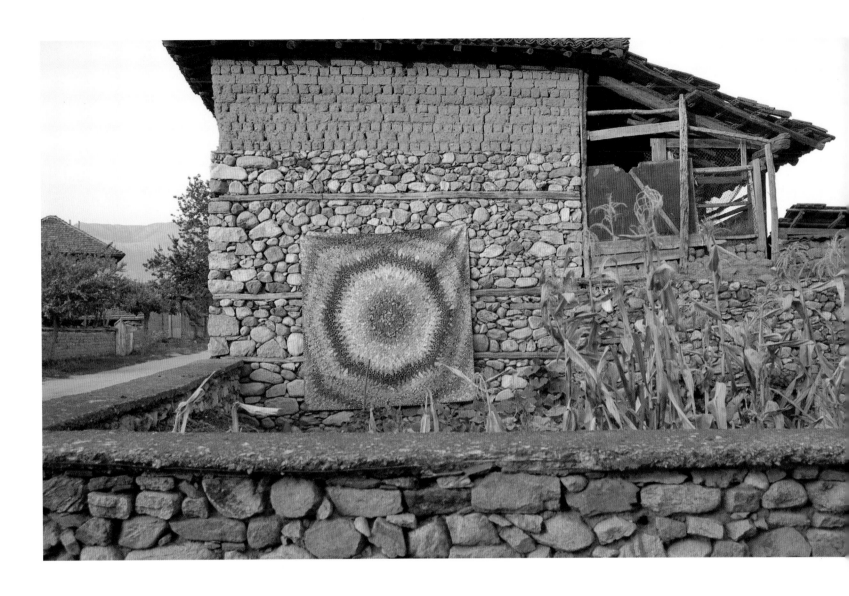

Earthy Big Bang quilt from *Kaffe Quilts Again*, 2012 (with detail)

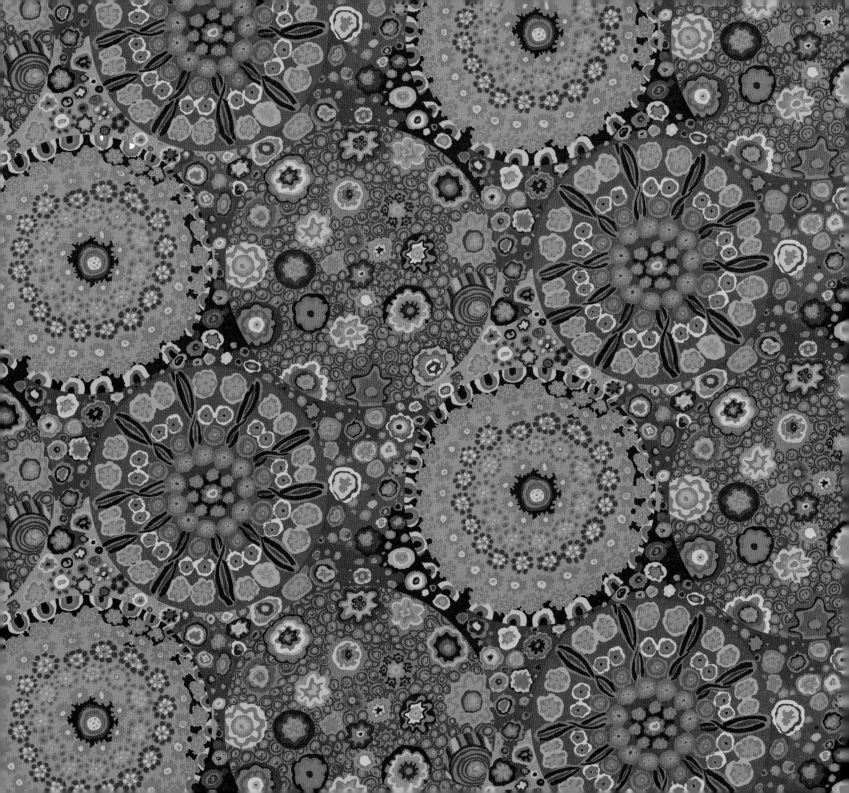

'Millefiore' fabric in tomato

Malta 2005

I don't intend to travelogue every book we have created but just touch on a few highlights. In 2007 we travelled to Malta for *Kaleidoscope of Quilts*, to the incredible castellated Bubaqra Tower owned by the Fry family, with whom Kaffe has a seminal connection.[3] Kaffe had been to Malta before to photograph his knitting designs. We entered the garden through a gate into a courtyard of large, mellow slabs under foot, the walls enveloping us in square blocks like enormous caramel sugar cubes balanced one on the other. These walls feature in the shot of the *Victorian Fans* quilt. Huge subtropical aloes in glaucous greys arched firmly over the edge of the borders and there was a small orange grove with windfalls of dessicating oranges lying on the terracotta earth. A thick bower of brilliant pink bougainvillea framed a walkway. Malta was easy to navigate in our hire car and no one bothered us: we sought out fishing villages with brightly painted boats. A fisherman cheerfully let us use his boat interior as a backdrop. The window shutters and doorways were charming and there is nothing we liked more than flaking colour. The softly coloured verandas of the capital, Valetta, complemented Liza Prior Lucy's *New Orleans Star* quilt, its subtlety being

the key to its desirability. One of the locations we used in Valetta was a vast cemetery, where some of the monuments and family mausoleums were carved into miniature follies such as mini reproductions of the pyramids. Publishers tend to be reluctant to allow us to use such locations, although Kaffe is often drawn to them (as also to churches): they often feature impressive stonework and wonderfully carved statues, offering an opportunity to celebrate such craftsmanship. We later photographed some quilts for *Simple Shapes: Spectacular Quilts* (2010) at Kensal Green Cemetery.[4]

Over the years these books have become a rich record of designs and places, of colours and textures. The locations are often chosen because Kaffe has a memory of them, having spent time there in the past. He talks of travelling through Syria, Turkey and Afghanistan in his twenties, and trips such as these have imprinted a large bank of design references on his memory. Brandon and he usually have a notion for somewhere, then make a preparatory trip. The location is a vital piece of the picture: it is not only a backdrop but for me it often infuses the images with a sense of perfume, colour, light and sound, from the delicacy of an English flower garden to the narrow, sun-baked stone streets of Morocco.

Fez 2013

Bab Boujoud – the blue gate. We leave our cab and enter the ancient city. It is dark and we are met by two slight Moroccan men who speak no English. They load all our luggage onto their wooden cart and we pass into the largest extant Islamic walled city in the world, Fez.

We follow the handcart as it bumps down wide, sand-coloured stone steps, twisting and turning along narrow lanes with tight corners. Fez is a city with no cars and more than 90,000 steps; almost every doorway is home to a skinny, nonchalant cat. Through one small doorway we see a tailor stitching a brightly patterned *djellaba*; through another is a shop with a small glass-fronted counter displaying a few cakes and some familiar-looking chocolate bars with unfamiliar names. Cats hiss at each other over scraps of food. A boy brushes past us with a tray on his shoulder: he is carrying flatbread (*meloui*) home to his family from the communal bakery. His mother would have made the dough earlier and sent him to the bakery for baking, as has happened for centuries: the fire is never allowed to go out. With every step down through the city we leave the twenty-first century further behind.

Our *riad* – Moroccan house – has a discreet entrance but inside is full of pattern, hand-painted doors and furniture. Hand-made *zelige* tiles are arranged in traditional patterns and designs: these are so complex and varied that they have been studied by mathematicians, computer scientists and engineers. My room is on the ground floor, its vast painted wooden doors opening on to the courtyard with an amazing *zellige* floor (on which we lay the *Carnaby* quilt the next day). The courtyard is in the middle of the house and open to the sky. The ceiling above my bed must be 30 feet high, from which hangs a pierced lantern on a long chain, its light too dim for me to read.

The three of us head out early the next morning into the medina. The sharp sun is up but the day is not yet hot. The medina spreads across a labyrinth of narrow streets. There are quarters selling oils, henna, saffron, hand-made pans and carpets, beads, lanterns, shoes and bright geometric-patterned leather footstools. Fez is a city of crafts. A shopkeeper holds out a bunch of fresh mint to us, which we take, and then he beckons us into his shop to view his leather goods, mainly bags and belts. In Fez a small entrance usually means a cavernous inside space, just like our *riad*.

Location shots from *Quilts in Morocco*, 2013

Rouge quilt from *Quilts in Morocco*, 2013

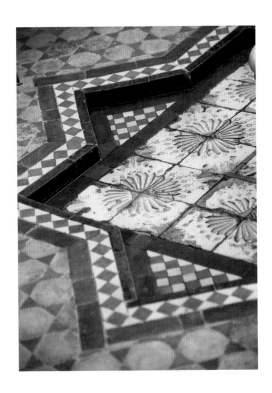

Location shots for *Quilts in Morocco*, 2013

Strata quilt from *Quilts in Morocco*, 2013

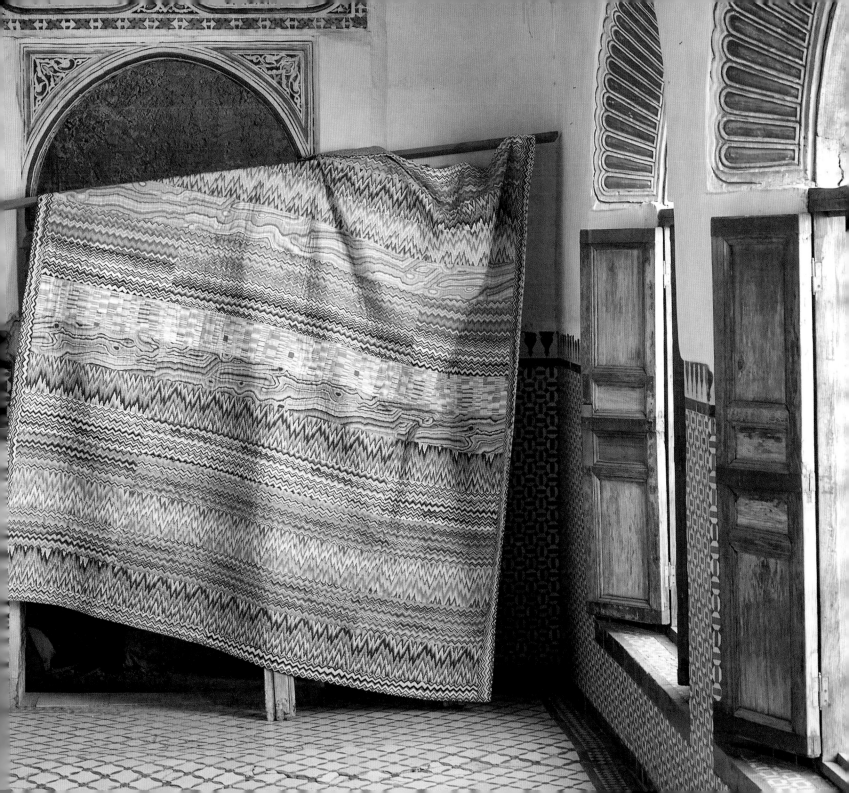

Cayenne quilt by Corienne Kramer from *Quilts in Morocco*, 2013

Market stall in Fez, for *Quilts in Morocco*, 2013

Shuttles quilt from *Quilts in Morocco*, 2013

Jewel-coloured leather goods fill every shelf and hang everywhere in the shop, which smells like goat. The shopkeeper keeps beckoning us and leads up a flight of stairs to a balcony; he motions us to hold the bunch of mint to our nose and come forward to the edge of the balcony. We look over a wide area of large round stone vats: the famous tanneries of Fez. The smell is indescribable, as urine and pigeon droppings are used in the tanning process. I bruise the mint harder between my thumb and forefinger, squeezing every drop of essence from it. Some of the vats are tiled in patches on the inside and contain various coloured dyes: I can see a deep aubergine colour in one, chalky white tones in another. Men with their trousers rolled up stand in the vats and move from one to another, hauling out and agitating the stinking sheepskins from which the fleece has already been removed. The almost biblical image of this ancient process among the centuries-old stone houses of Fez has stayed with me: it was like an out of body experience.

Stopping to take a photo anywhere in the medina holds up purposeful human traffic and is not very welcome, especially when I splay the tripod legs for stability – although somehow most tolerate me.

In one of the narrow alleys we halt at the stall of a slipper seller. I position myself flat against the opposite wall to get back as far as I can, while Brandon holds out the small *Shuttles* quilt. People still walk past and we snap pictures between figures blurring through my viewfinder. The ends of the slippers displayed on the wire rack reflect not only the shapes and colours of the lozenges in the quilt but the fabrics themselves, including 'Roman Glass' and 'Ribbon Stripes'. It is incredible that Kaffe's inspiration for this quilt should have been an early American quilt that he saw in a book when it sits so comfortably here in the medina. The serendipitous shot is chosen for the book cover.

At the top of the medina are food stalls and cafés, the food quarter. As we walk through, there is a still life everywhere I look: I take a shot of a simple cart piled up with a dusty lilac grape harvest; a small wooden table of pomegranates, one split open, its carmine seeds oozing out; a basket of limes; figs placed on fig leaves. The food here is not vibrant and bright as at home but appears as if brushed with dust from the desert, the colours like pastel chalks. Kaffe throws his *Sunny Snowballs* quilt over a corner of a stall of peaches with round plastic baskets piled up; I shoot it and we move on.

Location shot in Cinque Terre for
Quilts in Italy, 2015

Location shot for *Quilts in Sweden*, 2010

Dark Windows quilt from *Quilts in Sweden*, 2011

Blue and White quilt location shot, Cinque Terre, from *Quilts in Italy*, 2015 (with detail)

We have arranged to use the Jardin des Biehn and Café Fez as a backdrop. Once the summer palace for a Pasha, the hotel is a lush green oasis in the heat of the city, again hidden behind walls. Here we make good use of the bright blue walls, the patterned stair treads, the fretwork, the tiled paths and the spectacular interiors, which are otherworldly.

On the way back to the airport we urge the taxi driver to stop so that we can take a shot of Kaffe in front of a wall-sized tiled design on the side of a supermarket. Such indulgence is increasingly rare on modern buildings.

Italy 2015 and 2019

Italy is such a joy, the hospitality and energy of its people and its language are invigorating. In Cinque Terre on the coast of Liguria, after a mix-up over our accommodation that sees us running round the town of Monterosso al Mare while our taxi waits with all the quilts and equipment, we squeeze into a modest seafront hotel. Kaffe and Brandon carried out their recce trip out of season and are dismayed to see that the place is heaving with summer tourists. However, one advantage is that the beaches are filled with stripy parasols, which otherwise would be packed away – and we always start almost as soon as it is light, before the crowds arrive. Here we get some fabulous shots of the *Chiaroscuro* quilt.

Cinque Terre is a chain of steep towns stretched like fishing nets across the cliffs, with a frill of vigorous sea below. We have not hired a car: the towns are joined by rail and we intend to travel by train with the quilts over a few days. Our plan is somewhat thrown by a timetable that means we have many minutes to wait between connections and the trains are hot and busy. The break in creative flow is frustrating for us all. We utilise the stripy stonework of a church, the pebble mosaics and the simple green tilework for Kaffe's *Tussie Mussie* quilt. The playfulness of Cinque Terre is encapsulated in the shots of the aptly named *Losing my Marbles* quilt

designed by Julie Stockler, alongside bright bracelets and sunglasses at a kiosk.

We return to Italy in 2019, to the colourful island of Burano; none of us forsees the pandemic just around the corner. This island is pure Kaffe, almost as if he painted it himself, in his own palette. Burano has a daily rhythm: a ferry brings day trippers around 10am and the tiny island is filled with camera-wielding tourists until around 7pm, when the ferry leaves again. We are staying in the middle of the island, so have the place almost to ourselves outside these hours. Bliss.

The Japanese have a particular way of exploiting a location such as this, as perhaps the ultimate Instagram Italian backdrop. They pose for each other as models would, they dress in quite formal and eccentric ways with hats and props, they appear to go from one door to the next, pose in several Insta poses, take the photo then reciprocate for their companion, then move on to the next door. It is quite extraordinary. Some groups are dressed as if for a wedding, like a full-on fashion shoot. The lovely people of Burano are so gracious, they see this day in, day out; and now we arrive with our quilts, which they allow us to peg out on their washing lines.

The Burano trip would be our last foreign shoot for a while, thanks to Covid 19. We would for the time being certainly miss the light, warmth, spice and variety that other cultures give our books.

Notes
1 *Glorious Colour* 1988, p. 152.
2 Clough Williams-Ellis 1924 (www.portmeirion.wales/about/history-of-portmeirion).
3 See p. 47 above and *Dreaming in Colour* 2012, pp. 65, 69–76, 138, 181.
4 *Simple Shapes: Spectacular Quilts* 2010, pp. 43, 67, 85, 94.

Location shot in Cinque Terre for
Quilts in Italy, 2015

Fassett on shoot with *Chiaroscuro*
quilt from *Quilts in Italy*, 2015

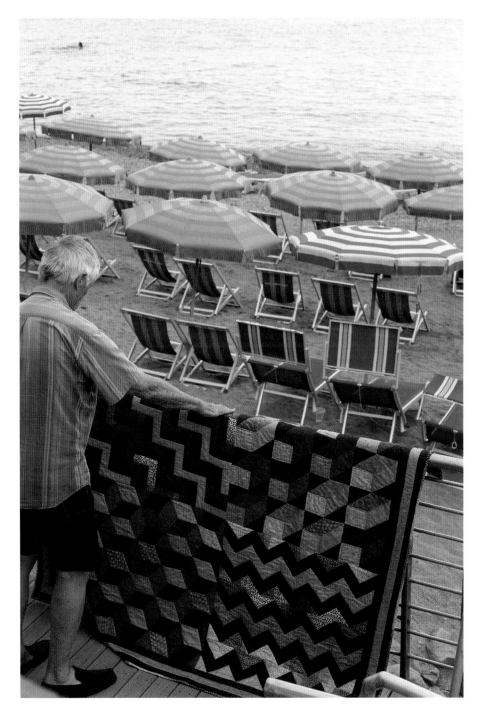
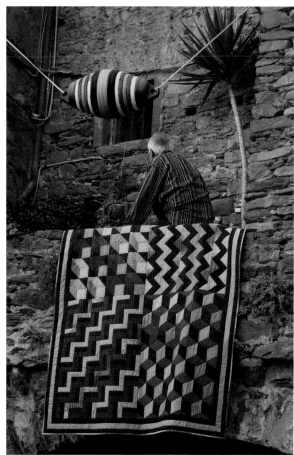

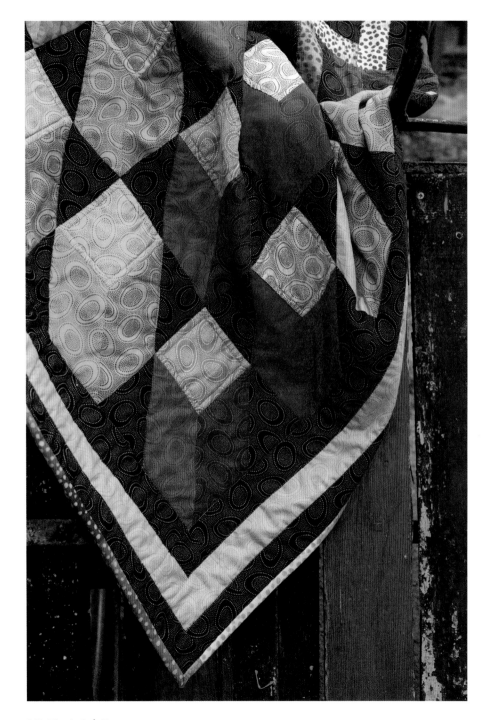

Chiaroscuro quilt from *Quilts in Italy*, 2016

Market stall from *Quilts en Provence*, 2010

Location shot in Cinque Terre for
Quilts in Italy, 2015

Cool Zig Zag quilt from *Quilts in
Italy*, 2015

Green tiles from
Quilts in Sweden, 2011

Shop window from
Quilts en Provence, 2010

Cool Zig Zag quilt from
Quilts in Italy, 2016

Location shots for *Quilts in Italy*,
2015

Blue Chequerboard quilt by Liza
Prior Lucy, *Quilts en Provence*,
2010

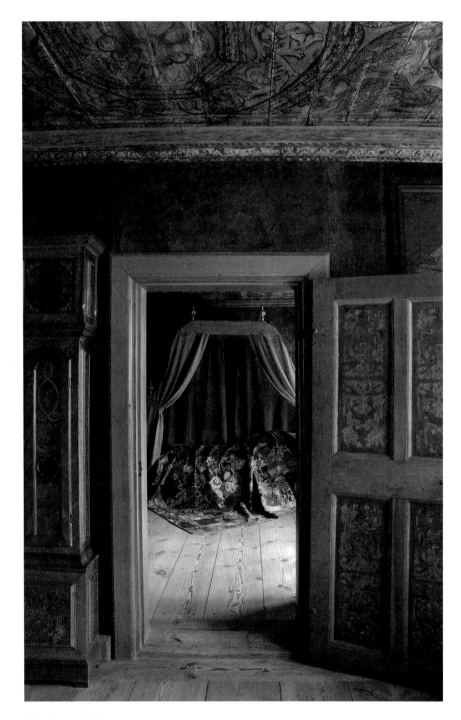

Sunlight in the Forest quilt
from *Quilts in Sweden*, 2011
(with detail)

Garden Chintz quilt from
Kaffe Quilts Again, 2012

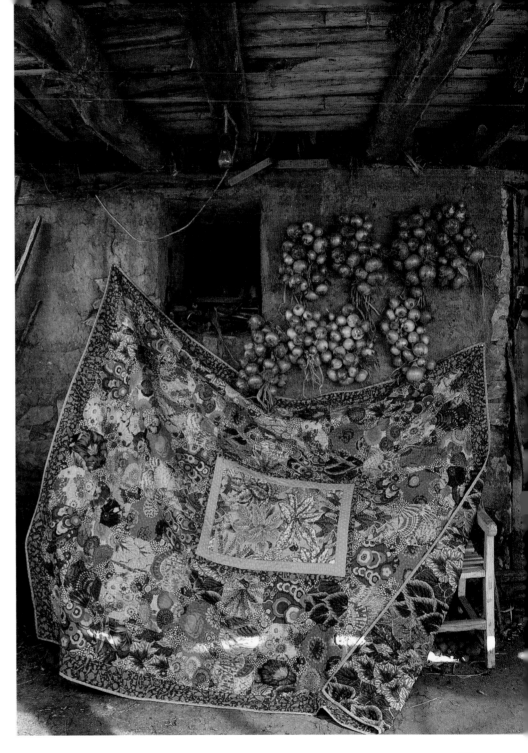

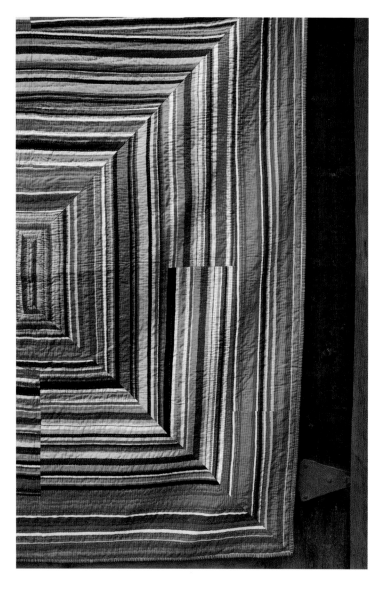

Striped City quilt from *Quilts in Sweden*, 2011 (with detail)

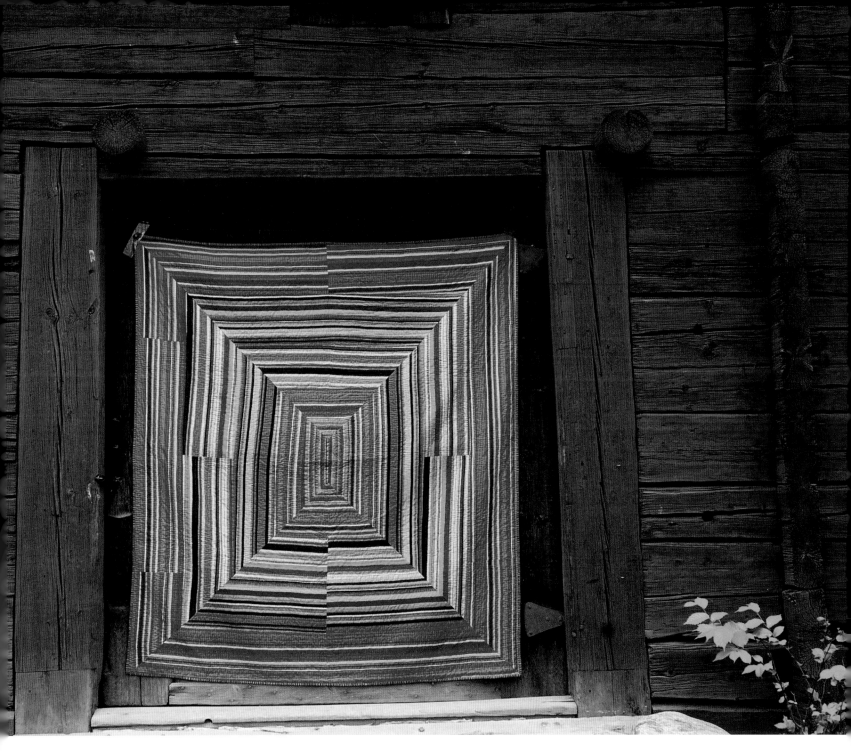

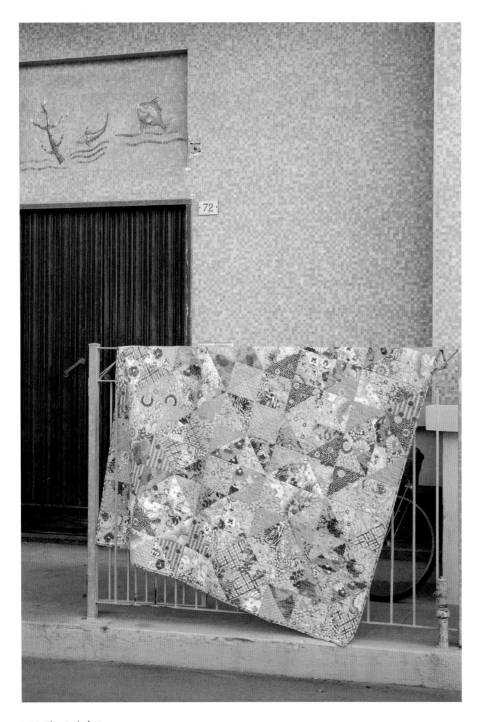

Tussie Mussie quilt from *Quilts in Italy*, 2015 (with detail)

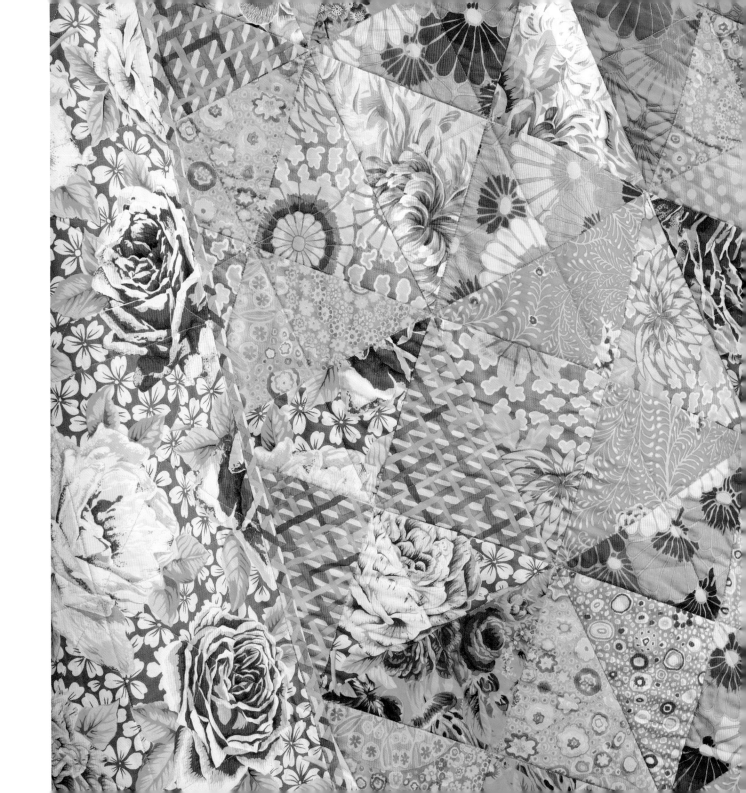

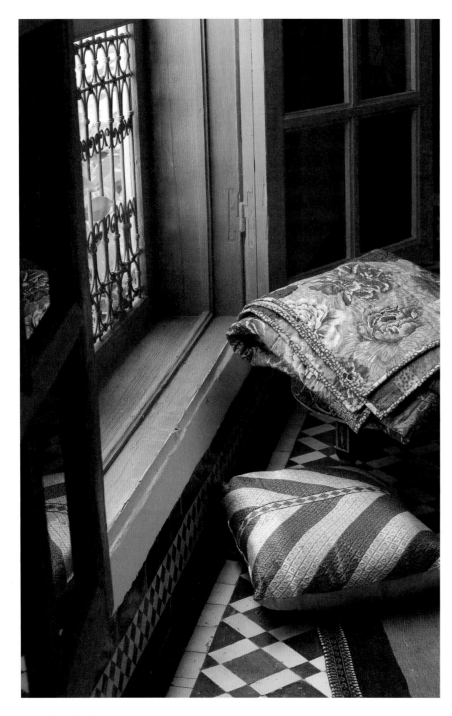

Rouge quilt from *Quilts in Morocco*, 2013

Details of *Barcode* quilt from *Quilts in Sweden*, 2011

IN CONVERSATION: DENNIS NOTHDRUFT WITH KAFFE FASSETT AND BRANDON MABLY

In preparation for the Fashion and Textile Museum's new exhibition, Kaffe Fassett: The Power of Pattern, *in September 2022, I sat down with the artist for a wide-ranging conversation on his life and career. What struck me was the passion that Fassett still brings every day to his work: an enthusiasm for colour, pattern and making that is infectious.*

Dennis Nothdruft

I want to just start at the beginning. Reading *Dreaming in Colour* again, and looking back through your work and career, I am really interested in where some of the impetus comes from. A lot of the work that we see today – the quilting, textile design and needlepoint – seems to have its genesis in some of those really early artworks.

I was thinking of the pen and ink drawings; they were so rich in detail. Or the still lifes, starting to put those collections together and to show all the variety, just of the white things. Where do some of those early ideas come from, and is there a point at which you felt something 'clicked' when you started to do those works?

Kaffe Fassett

I would say early influences as a child, growing up in a log cabin in the middle of the country with very little stimulation except for what my mother provided. She used to make scrapbooks. If she saw anything colourful or artistic in a magazine, she would rip it out, so we had these scrapbooks full of old paintings and tapestries and puppets, things that would intrigue her and she thought would stimulate us – which they did.

So, all of that was in my background, you know, the love of rich pattern from the past. When I first started painting still lifes, I was going to charity shops and finding old patchwork quilts and things, putting them on a table and arranging things on top – so that was an influence. I would say when I came to England it was exciting to me to be in Europe and all of its history, so these were more influences. When I was doing my still lifes, I was placing a lovely flowery English teapot on top of an Indian bedspread print or a patchwork quilt that I found in the market, or something African, or something embroidered from Scandinavia – or whatever.

I think as I was painting my still lifes, I was thinking more and more about the world, or these European patterns and the decorative arts of these rich cultures. You, know it's very funny but the first thing NJ [Stevenson] asked me was why did you leave colourful California to come to grey old England? Well to me it wasn't grey old England – it was this fabulous new

land that was on the outskirts of all these fabulous cultures, Russia and Scandinavia and France, Spain and Poland, and all these places that were full of people who embroidered and made gorgeous things, so that was an influence. I suppose doing the drawings and the paintings was a way of seeing those things in the round: getting things from the flea market and putting them on my table and staring at them and thinking about how they were made.

DN I think the thing that always strikes me from these very early artworks is that you were so intrigued by, and wanting to share, all these things that you were discovering. There's a real love of decoration and pattern. That's interesting that NJ had that comment about 'grey England', as it was a later question I had. We can talk about it now. You did those early first knits coming out of Scotland, and you were clearly so impressed by the landscape. The landscape in Scotland is very subtle – all the shades of greys and browns, the mosses and heather. You were really capturing that when you created those early stripes: you have all of those colours in the landscape in these knits. I mean it is very, very sophisticated but it obviously resonated with you.

KF Oh yeah. Part of my childhood was being raised on classic Irish mythology. There was a wonderful old woman who would come down to us. She had a jewel in the middle of her forehead and she had big, strange, bun-like hair; she would sweep into the room – she was a bit like Edith Sitwell – and she would tell us great stories of Finn McCool and Cuhullin. All of these characters were out of Irish mythology, which I was visualising as a child, in the landscape that I saw when I went to Scotland. There were these kinds of hillocks of mossy green and grassy slopes and things, all of the things that I had imagined as a child when this woman was telling these stories.

DN I think you could see all that multiplicity of colour and texture, when most people taking a train through the Highlands would just see rocks and heather. You see

Kaffe Fassett with mosaics outside the front door of his studio

Overleaf: Kaffe Fassett Collective fabrics in Fassett's studio

all those shades and I think that – to me – relates to the early still life paintings, like the creamware paintings where you're showing us all the different shades of white. For most people it's just a white pot but you're showing us every shade of white that's possible.

KF It was great. You couldn't find a subject matter that was more focused on just that, of looking for the slight differences in the shades of white in the cloth and then the pottery and then sometimes eggs, or folded paper, or something like that would come into it as well. Yes, it was just centering on that world of light or reflected light and shadow, you know, very subtle shadows.

DN I think that's one thing that for me always informs your work: from the beginning to now, it's all the colours that exist out there in the world and your ability to differentiate them and to see them, and to get us to see them. Because I don't think most people stop and look, really look, at things. I think that's something that comes across in your work from the very beginning through to what you are doing today – you are showing so many options of colours and how they can all sit together.

KF It's also trying to get people to appreciate their history and their culture. When I first started making fabric patterns, I was convinced I couldn't do it – it was technically difficult because you had to make things in total, exact repeat and so forth. So that seemed beyond me because I'm not an exact type of person, so I hired Susan Collier. Susan was the wonderful textile designer for Liberty and Co. I would be telling her the things that I wanted in the patterns and she would say, 'like this old Romanian carpet design?' And as she was painting it out she said, 'you realise, Kaffe, what we're doing is giving people back their history. We're celebrating these wonderful things from the past and we're making a fabric. They can take that fabric and it can be used now as an echo of what went on in their past.' So we're giving people back their past and I love that.

DN That's a good point, and I hadn't appreciated your work with Susan – she was such a talent.

KF I called her up one day and said 'Susan, I'm so excited by watching you paint fabrics, I've decided I am going to start painting fabrics'. She said: 'Kaffe, stick to your knitting! Leave that to us!'

DN I think when you saw Susan working, or her sister Sarah, who is a brilliant painter as well – when you watch her working it's inspiring, it does make you want to paint out designs!

Now going a little bit back to your childhood, I think that you had a really magical childhood in a place like Big Sur, surrounded by what was quite clearly an artistic family and an artistic community, completely alien to my experience growing up in the Midwest of America. In Three Rivers, where I was raised, everybody did the same thing. So for you it must have been quite an experience coming out of all of that creativity and then finding a channel for it. When you started working in art and painting, what you were doing was going against the prevailing trends in contemporary art, which would have been post-expressionist, expressionist, abstract painting, minimalism.

KF It was de Kooning and Franz Kline and Pollock. You know – *splat, splat* – action painting, and here was I painting teacups and oriental bowls of oranges and things because my hero at that time was Bonnard.

DN Yes, you can definitely see Bonnard as an early influence.

KF Yeah, because he dazzled the world with colour. It was so fabulous. When I got into colour it was through the eyes of Bonnard.

DN Some of your early things, or some of your use of print, remind me of Vuillard as well.

KF Yes, I love Vuillard. If I have any subtlety in my work it comes from Vuillard because, as somebody said,

he loved his shades of grey and there was something so gorgeous in his work. But he also loved pattern; he was a master of putting a woman in a flowery dress and against a piano with a wonderful oriental shawl covered with flowers and then the whole wall was wallpapered. The entire scene was all flowers. I mean those works absolutely staggered me – I want to get that kind of excitement into our exhibition.

DN I'm sure we will! I think your work does have that excitement. I think you open people's eyes to the possibilities of putting things together, and that's quite exciting.

 If we talk about the knitwear for a minute, when you began to knit, and reading and talking to you about it, to me it seems that it was something that came very naturally to you once you got going. I have tried to knit, and it wasn't very good. Learning to knit obviously unlocked something within you. So, as you were learning to knit what were your thoughts? What were you trying to get across, because to me you are putting so much into those early knits?

KF Yes, well, it was organising the tsunami of inspiration that flows through my head all the time. Lots and lots of ideas, and then by knitting you sat down and took one stripe of colour, you then added it to another stripe. In this way you began to organise this thing, it was like building a mosaic or a collage or something. You started to manifest the relationships of one colour against another.

 I remember one day with an artist friend of mine, Lilian Delevoryas – she was wonderful. One of the things she said to me as we were talking about how fabulous music is – singing, theatre and things – and she said, 'yes, but you know that painting is about one colour meeting another colour'. This was such a revelation to me: colours meeting with rough edges, or are they going to be very smooth and sharp? It just put it in context and broke it down. Yes, as artists we are putting one colour against another. Bonnard said that a good painting is first and foremost an arrangement of colours. When you see those ideas that seem utterly simple to a lot of people, they are actually very profound. It makes you think that first and foremost this has got to be a good colour composition – or else why bother?

DN I think that is a really good way of putting it. One of the things that is so exciting about what you have done – and will continue to do – is this amazing use and exploration of colour. The thing that I think is exciting is that you and your work with Brandon, and the Kaffe Fassett Collective, you see the world around you and you put together colours that people don't even think can exist together, and it's exciting.

 I've seen when you give your lectures that they're a visceral experience for the audience. People respond to your work and it goes on to inspire them because you are showing them things they didn't know existed or haven't really looked at. I think that is a key to what you do and is such an important part of what you do.

KF Well, you see, I had so many wonderful artists in my life that did that for me when I was a child. I can remember the great Henry Miller – the writer of wild, sexy books – coming over. He lived in our neighbourhood, in fact he used to live in the house that I was living in at that time. He came down one day and he looked at my paintings and he just said 'you know, they're just joyous'. And he wrote a book called *To Paint is to Love Again*, which again is that spirit of optimism.

 When I came to England, so many people said to me 'England is so grey' and they said, 'you're going to be so disappointed when you get to England because it is so grey, and the weather is terrible'. Well, when I first arrived we were having an Indian summer that just went on and on and on. In the late autumn we had these beautiful, golden days. I was so prepared for horrible, depressing weather that I was celebrating it – and I was celebrating so many things that I found in England.

 What I loved, which was strange, was that the love of colour and pattern came out but in a restrained way: you didn't pull out all the stops and have a Russian Circus, you had a very elegant way of expressing it, but still full of pattern and colour.

DN It may be that it takes somebody coming in from the outside to appreciate that. Even if you look at the great country houses of England, they are rich in colour and pattern.

KF Yeah! Wonderful, wonderful influences from all the rich histories of the decorative arts in those houses.

DN And some of them have these amazing spaces with prints and patterns but they are quite old and aged – something you have picked up in your work as well. These spaces get to be lived in and evolve so that layer of other colours comes through with time, the subtleties coming through things as they fade or darken.

KF And that was something that was missing from my American experience of seeing rich people's houses, because rich people's houses in America at that time were NEW, NEW, NEW! Everything was clean and sharp, white underpants and all. It was very, very proper and the idea of having old, falling-apart things was just not going to happen, at least the houses that I saw. So that's the thing. I loved it here, where you'd have these old leather couches that were just about falling to pieces, full of holes, completely faded and worn and then the old carpets and the old wallpaper falling off the walls and stains of the rain coming in – wonderful! – and of course all of that is a natural patina, which has great charm, which was recognised by these wonderful aristocratic people.

DN If we look at some of those works from your earlier period in England it reflects those colour stories very much. You are celebrating the subtleties and the restraint.

KF When I do my fabrics, I always try to include a colourway that is very soft and pastel with grey tones and a lovely kind of English watercolour palette...

DN Your colours are interesting because you embrace all sorts of them in your work. You're not afraid of grey colours or light colours, pastels or these bright colours –

they are all available, they can co-exist.

For me, the understanding of colour in what you do is very important. I think that it's something that people don't normally have, it is not an innate skill but I think that you do have it, and that you can share it. Once somebody does it for you, and lays it out, it is quite an eye-opening experience to start looking at colour and patterns. I think that is something you very much do.

Your practice is very much of making, of craft. Do you feel you have helped make handcraft more accessible? Something that's more inspirational and aspirational in the sense that you have encouraged others to have a go?

KF Yes, and that's why I court museums. I don't want to spend my energy creating something that is going into a rich person's house and the door is going to be slammed and locked against the world. I remember having that experience. We made a fabulous big tapestry in needlepoint, all in tent stitch, and it was very, very fine and detailed. A very rich person bought it. When I asked the woman who was in charge of their great estate what had happened to that tapestry, she said, 'Oh it's in storage'! I was furious. I just couldn't believe it: all the work we had put into it and it wasn't going to be seen by anyone – then eventually it would come out of storage and be only seen by the guests of that house.

That's why I love coming to people like you and having an exhibition where everybody is invited, and it's a great party and everybody can come and be turned on, in the way I've been turned on by other exhibitions I've seen.

DN When we did our first exhibition at the Fashion and Textile Museum with you, just being in the gallery when it was open and watching people in the space was really an eye-opening experience. The people who came were wearing things that they had knitted from a Kaffe Fassett pattern or talking about the Kaffe quilts they had made. There were lots of dutiful husbands who came wearing Kaffe Fassett things that their wives had knitted for them. That was the power of that

exhibition for us: that people came and they either had made things or they felt that they could make things, that they could be inspired. They were just soaking it up and you could tell that they were so excited to be there.

KF This is one of the reasons why I finally gave in and stopped fighting the idea of working in the crafts field. It was 'Oh, as a Fine Artist do you really want to be dabbling in the crafts?' But what I loved about crafts was that everybody could join me. They could and they did, it's not a mystery to them. It's not fine poetry, or great music from which most people are excluded from understanding, or painting. Quite a lot of people don't know how to look at a painting: they're often very nervous when they're in a room full of paintings and the painter is there, and what do they say to them? But when it comes to a knitted sweater or a needlepoint cushion or a patchwork quilt, everybody can do that, so they can enter on a totally different level and go home and try it themselves – and that's what I love about it.

DN Yes, the knitting patterns and then the needlepoint books were a revelation when they came out, because people had just not thought of it in that way. I think it probably didn't hurt that you were tall, with movie star good looks, and you came out as a man producing the most colourful, extraordinary in-depth work. It was a revelation: initially people didn't know what to think.

KF I know, it is interesting. I did those little Victorian heads as cushions, little portraits of girls. A woman came up to me after a talk and said to me: 'I desperately want the pattern for those Victorian heads.' I said I'd never do that because there are hundreds of colours in it. I said, 'have you got children?' and she said 'yes'. 'Well', I said, 'do portraits of your children.' About a year later I met her at another event and she brought out of a bag these portraits she had done of her children and they were fabulous. She had taken the courage from just looking at those cushions I had made to do her own.

DN You definitely give people the permission to try. I think that is a most important thing: so many people have picked up needles, canvas, or fabrics to create something.

The other thing I was interested in was the quite strong parallels between some of your ideas and what you were producing, and the work of the Pattern and Decoration movement artists in America in the 1970s and '80s. Again, they were very much gallery-based but what they did try to do was establish the importance of the decorative arts, or craft skills, as a medium for fine art.

You have touched on that – that craft was not seen in a fine art context, or decorative arts were always viewed as the second tier to the fine arts. Art history has not always been kind to the decorative arts; so here you had a group of artists trying to reclaim that place, and you were doing a similar thing. How do you think of your work in the narrative of art history? Do you see it sitting within the context of what other artists were doing at the time or do you see it as an applied art form?

KF There weren't that many people that I could think of who were doing what I was doing, except that I was coming out with all the knitting and the needlepoint at the time of the hippy revolution. We were groups of people sitting around in rooms, around a fireplace, with beautiful music – usually stoned out of our heads smoking joints – but communal. Somebody would be sewing beads on some wonderful leather trousers, somebody else would be crocheting and somebody else doing whatever. It was all about working TOGETHER. That was very similar to the quilting bees that used to happen in Victorian times in America. There were households full of the old aunts and the daughters sitting around quilting together and gossiping, having gingerbread and tea, all of that. That lovely, happy, constructive time together, of being creative and useful.

DN What's interesting is that I feel, as a design historian, your work should sit within the context of applications of fine art because your concepts definitely sit within

Swatches and samples in Kaffe
Fassett's studio

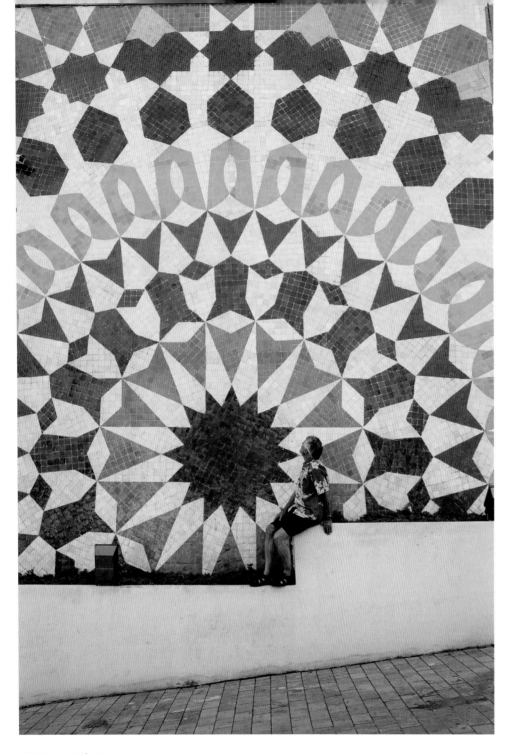

Kaffe Fassett on location in Fez
for *Quilts in Morocco*, 2013

those movements, coming out of that late 1960s era and trying to reclaim a place for making. Some of the applied artists were feminists but reclaiming what would be considered 'women's crafts', putting them into the context of a hierarchical framework that favoured male artists.

It is an interesting discussion because it feels now that making and doing things has far more relevance again than it has had for quite a long time.

KF Yeah, I think so. Look at Tracey Emin, who is incredible: she burst on the scene with her story of feminism, sexual liberation, and all of that but a lot of the expression of that was through patchwork and making textiles. So, she did a lot to help by bringing that into the arena. Grayson Perry's another example, with his tapestries. I watch all of that with great fascination.

DN I think textiles and fabric arts are far more accepted now in the sphere of fine arts, through people like Grayson Perry or Sheila Hicks. There is movement: the boundaries that for so long have been established by art history are starting to blur quite a bit.

KF And patchwork quilts in America, as you know, fetch enormous prices.

DN Exactly so. Then when we look at those fantastic pieces coming in for the new exhibition – the skill that goes into creating these quilts is unreal. I think that it will inspire lots of people.

Then you had a real impact in fashion in the late 1960s and '70s, with your knitwear designs for Bill Gibb and Missoni. Now you've had recent collaborations with companies like Coach New York. Where do you see your work today in the context of contemporary style? Do you feel that people in fashion design and contemporary design are looking at your work, getting in touch, referencing what you do?

KF Yeah, I do I think that. I was just walking down the street the other day and I saw a woman sitting in a

The artist at home

café with one of my jackets on. I rushed up to her and said, 'Where did you get your jacket?'. And she said it was designed by an English knitter, but it was totally influenced by my designs, it was so close to one of my designs for Peruvian Connection. I think that there are only so many ways that you can actually play with the art of knitting and pattern and colour, and I have explored a lot of those. When people go to knitting patterns they stumble across a lot of the influences I had, or use me as an influence, for sure.

DN Alongside that there is also increased interest in the idea of 'slow fashion', of making and sustainability around what we wear. For me, you have always advocated making and the idea of the handmade. Do you think people's idea of craft and making have changed?

KF I think they are certainly going to now: it's a great sin to go out and buy clothes now! What are we going to do – just all stop? No, what we are going to do is rent an outfit and then give it back to the source where it came from and so forth, instead of all this buying 'new, new, new' all the time. I think into that concept will come refurbishing and taking wonderful old garments from the past and joshing them up and making them up for you, and then adding a knitted edge or a needlepoint border or whatever. Fabulous shoes can be made of needlepoint!

DN Exactly! We've also had this enforced period of two years when we've all been in our homes. And again, plenty of people have started to explore things like knitting or weaving or needlepoint because – suddenly – they are not going anywhere.

FK That's part of the reason why I've felt embarrassed about what we are doing, because all those people at home have been buying our fabrics and books and things. It has been very good for us.

DN Yes, it has been an interesting experience. I think it was an interesting thing for society to reset things. I think it was getting out of control.

There are a lot of ideas which have always been part of your practice that are really relevant, or even more relevant today. People are having the same thoughts about things that you have been promoting all along. You've had a long and amazing career of making things, of creating: it must be interesting to look back and reflect on all the things you've done, and are doing now, and how society is now catching up with it.

KF Yes, I do think about it. There was a jazz musician who was completely loved in South Africa and they made him a hero but he didn't know it. He was completely finished in America – everybody had moved on to other stars. They brought this guy out to South Africa, where he was practically carried from town to town, and they loved him. I sort of feel that is happening to me now, with people beginning to realise how pertinent to their own lives what I'm doing can be. And that's a nice thing.

DN It is a very nice thing, and I think that will continue. I see that only increasing, particularly the work with the Kaffe Fassett Collective with all these designs being produced that people can relate to and engage with. I think you can see they are popular, and people respond to what you and the Collective are doing.

KF And that's why I love the chance we are getting to celebrate and just syphon that off from the crazy circus of everything that goes on in this house, to take that aspect of it and celebrate these patterns and how they've fired up these international quilt artists and so forth.

DN I think the exhibition is going to be amazing. When we first discussed the idea it was about giving you a space to curate something, and to look at something. We have been able to open it up and look at what other designers and makers produce when working with your patterns and prints. As we said it is the POWER OF PATTERN so...

KF There we go!

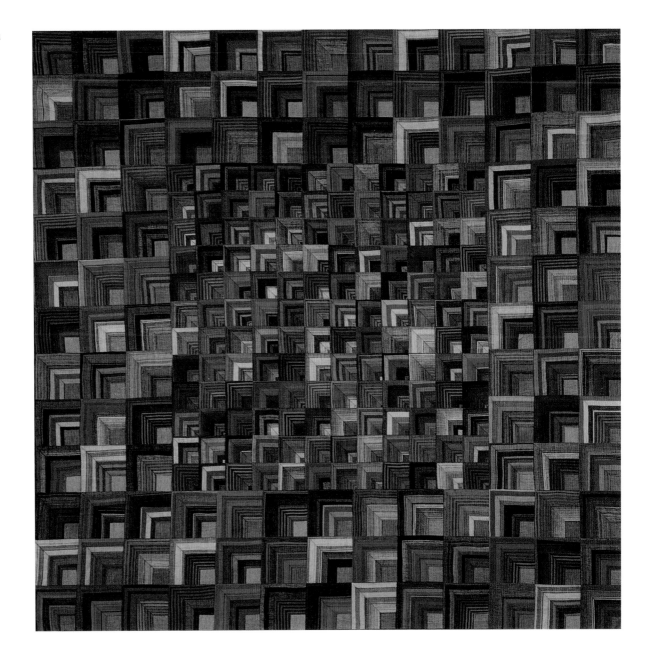

Handkerchief Corners quilt from *Passionate Patchwork*, 2001

After an initial conversation with Kaffe Fassett, I arranged a second interview, this time including Brandon Mably, Fassett's partner and a designer with the Kaffe Fassett Collective. With Fassett I wanted to discuss in more detail some of his approaches to the various disciplines he has worked in. Mably offered unique insight into the development of Fassett's studio and to their working relationship.

Dennis Nothdruft

Kaffe, I wanted to pick up again on some of those knitting points. You started knitting and then you started designing knitwear for the Bill Gibb collections. How did that process work, because you weren't a knitwear designer at the time? How were you coming up with the ideas and working through it with Bill?

Kaffe Fassett

It was very, very interesting because I thought 'this will never get off the ground because I can't ever knit enough for a production ever'. So we found a woman who was going to help me do machine knitting. That was a hand machine at that point; then eventually we decided we had to go on to commercial machines to make it work at all.

We found some knitters in Leicester and I would knit a little swatch for them by hand. First of all I would always ask them 'what are my limitations?' They said 'Oh, you can do anything, you can use as many colours as you like, you can go as big as you like' – ridiculous! Then I would do something with, say, six colours and

they would say 'Do you think you could bring that down to three colours?' So I would ask them to just tell me at the beginning what's practical, then I could sit down and work out something they could cope with. I would do a stitch repeat that would fit the machine and didn't give anyone problems.

So really it was a learning process in that way, but I found that it made me very creative, given the limitations. I would think: 'now, what can I make that is really fabulous looking within this 24-stitch repeat and only using two colours or four colours or whatever?' I would then use space-dyed yarns. [*Space-dyed yarns are multi-coloured yarns that produce a variegated effect when knitted or woven. Knitted space-dyed textiles were a feature of the Missoni collections.*]

I remember one collection I did. I went to the Leicester workshop with an idea for black background knitting with great big discs of space-dyed yarn that had a lot of maroon and blue and ochre in it. When the first sample came off the machines it was funereal – really ugly! But I really loved the ochre, which was like a burnished old brass colour. I suggested we just

use that for the background and it was fabulous. It was like a khaki colour, it was just gorgeous – these great discs of space-dyed yarn in this old gold colour and that made the whole collection. It was just one of those split-second decisions on the machine.

DN You have an innate understanding of colour and your knitwear designs are not easy. The fact that you were able to find commercial knitters for very complicated ideas is amazing.

KF Yes, it is, and then to be discovered by the Missonis... Judy Brittain, who was working at *Vogue*, said to me in one of our meetings, 'one day you're going to be so famous as a designer, you're going to be designing for the Missonis' as if it was the greatest achievement ever. I said, 'who are they?!' I had no idea, and she told me they're the best knitters in the world, an Italian family.

Then my very first article came out in *Vogue* and I got a call: 'Hello. This is Rosita Missoni. We would like to come and visit you and see you and have you design for us', and I couldn't believe it. This was the very first step of my career and there they were, knocking at the door. They asked to see my spring collection: they came in, these beautiful people draped in gorgeous Italian knitwear, and they said, 'show us your collection'. I just showed them a shoebox I had with some gnarled pieces of knitting in it, and said it was all I had. Unfazed, they pushed it back and said, what 'we saw was our vision of the future with your beautiful patterns on that coat in *Vogue*'. So they had me come out and work with them.

They had the most fabulous line of coloured yarns that I had ever seen. If you asked for, say, an aubergine and an ochre, they would say, 'do you want that in boucle, silk, cotton, linen?' Anything. You know, they had the most fabulous yarns; it was a great pleasure to work for them. You were working with people who understood colour. When they looked at me, they understood what I was about. They knew exactly the sensibility I had.

DN And you obviously married up quite well with the Missoni aesthetic; you can really see how well the two visions work together. How did you design for them? Did you go and work at the factory?

KF Yes. I had to learn Italian because none of the girls in the factory spoke English. I had a sample maker, a little Italian girl with curly hair who didn't speak a word of English. I had to learn the word for a row of this, and different names for colours, and that's all I needed to know: I would ask for two lines of yellow and two lines of aubergine or whatever, and it was just wonderful. We would just keep working, just trying things and trying things to see what the machines could come up with. The Missonis absolutely got it, but they wouldn't put my name on the designs. They had all of these journalists and people who were constantly asking them: 'who is designing for you?' They didn't want it to distract from the Missoni brand!

So I didn't get much press but people found out, saying, 'there's this new designer in London called Kaffe Fassett – are you working with him?'

DN You did beautiful knits with Bill Gibb, and I always think about the 'Moon' and the 'Buddha' knit that I love.

KF I loved it too. I remember going to a party where there was a bald man wearing a poncho-style coat that I designed with the 'Buddha' design down the front. He looked like the most incredible Russian who had stepped straight out of the past with this great coat on. I said, 'That coat looks fabulous on a man!' He said, 'You mean it's not supposed to be for a man?' Someone just gave it to him, and he just loved it.

DN You burst his bubble! It was a great collection, I loved it.

So you did all that beautiful work for the Missonis, and then at the same time you were designing knits for private clients.

KF Yeah, absolutely. Barbra Streisand came and commissioned me to do a dress for her. That was really fun. It was amazing because she was just so humble, like an ordinary housewife out shopping. She came up to the studio, looked around at everything – she had a wonderful eye for what she wanted. Shirley MacLaine came as well, and then through an agent I designed for Lauren Bacall. There were some good old people on that list.

DN You had this amazing career, developing and making for private clients; you worked with the Missonis and Bill Gibb. Then you didn't produce knitting patterns and your books until the 1980s, so it wasn't really until you did *Glorious Knits* that you opened it up to other knitters to create from your patterns.

KF I worked with Zoë Hunt, who was a great knitter. She came to me and said: 'I would like to just apprentice myself to your studio for a while because I want to learn how to do business. I can knit fantastically but I need to know how to make a business out of it.' She came for a couple of weeks and ended up staying for years and became my right hand. We would just design things together and she could just work out a shape. I could just show her a shape in an ethnic look or a historical garment with wonderful leg of mutton sleeves, a peplum and so forth. She would work all of that out and she would knit it exquisitely. That was a wonderful collaboration.

DN Then it was really your first book, *Glorious Knits*, that changed everything. It was a new way of looking at knitting patterns and knitting books.

KF Yes! When I first proposed that book, they said 'this is not the way you do a knitting book'. All the publishers had their formula for how they did a knitting book. You had some black and white photographs of models in knitwear and then you had some patterns, and it was all very dull. I was thinking that Abrams had done a book called *The Dyer's Art* which I had seen. It was a book about Ikat weaving from Indonesia and it was

fabulous. Full page bleeds of fabric, and colour, just pools of colour. I said, 'THAT is what I want my book to look like!'

Steve Lovi had come over. He was a friend of mine and a genius from Chicago. He was smarter than any of us and became the brains of our tribe of artists working around the world. He would do crazy things like go to India for a couple of weeks and end up staying three years: he was his own person and very adventurous. I wanted to make him a sweater but couldn't think what would suit him because he had such particular taste. I said, 'if I send you a plane ticket will you come and see what I'm doing?' Steve arrived and said: 'forget that sweater you are going to make for me. I just absolutely love what you are doing and there is a book in this. We will go to publishers until we find the right one and here's what we are going to say, "We are going to want £25,000 down"'. Here I was thinking if I got £100, I would be happy. I had no idea of the scale this thing would have to be to make a success of it, to get all the garments made and then to fly to places like Malta to photograph them in beautiful locations. Steve had the whole plan in his head and would tell me things like: 'I want you to make a wonderful sweater that's got yellow with a bit of pink and a bit of blue in it because there are these wonderful gardens at the edge of Kew Gardens. Kew has these fantastic yellow flowering trees – you have to have this ready by April, by the middle of April.' So he scheduled me. He also had this incredible critic's eye: he would know when I was on to a good thing; he really encouraged me. It was a huge beneficial thing in my life to come across this genius seer and also a fantastic photographer.

DN It must have been an amazing experience when this book arrived, and people went mad for it. It revolutionised people's view of knitting patterns.

KF Oh, totally. First, they said to me 'Don't look on the bestseller list for your book because it never happens with "How To" books'. Well, we sold out 40,000 copies in two weeks! When I tell that to people now, they say it's impossible, that doesn't happen in

publishing circles except with very famous authors or some controversial thing that has been banned. It just doesn't happen, and I said it did happen and by Christmas we had no books left. They had to reprint and reprint and reprint and that book sold millions of copies – just amazing.

DN It does give you a sense of just how ground-breaking it was, how innovative and how people were ready to look at something like knitting in that way – as an art form – taken out of the context of the home journal-type knitting pattern to that of an art book.

It's a beautiful book – and the knits are still beautiful. Those amazing photographs are so good. After you did *Glorious Knits*, the knitting books started, then needlepoint. Did somebody suggest you try needlepoint, or had you been interested in it because that's a whole new discipline?

KF I had been interested but I thought I could never do it, that it was the kind of thing that nuns went blind stitching. Those little coin purses decorated with roses: it just seemed impossible. Then Judy Brittain's sister was stitching a little tiny picture. I said, 'Can I have a go at that?' I started doing a few stitches and I loved it.

Then Pamela, Lady Harlech asked me to design a cushion that she could stitch in needlepoint, and I painted the whole of the design for her on the canvas. Then I sat down and started filling in some of the colours, just to show her what colours should go where, and before I knew it, I had finished it! I thought it would take a lifetime but in a couple of weeks I had finished the whole cushion. Then I just went to town and did the book, *Glorious Needlepoint*, which became an even bigger seller than the knitting book had been.

DN What is interesting to me is that your knitwear designs are all patterns, colours and stripes. Then needlepoint is very pictorial and for these you're creating these beautiful pictures, probably not unrelated to your paintings.

KF That's it. With needlepoint my ability to draw and to paint with colour came out and I began to paint with wools. I felt it was a great means of expression for me. Of course, I had that fabulous genius, Steve, on my shoulder, guiding me, telling me 'OK, now try this, now try that, now we need a pair of slippers or something unusual to really make it fabulous'. It was very exciting working with him.

DN When you look at *Glorious Needlepoint* it is so... I don't want to say 'over the top' but it is so lush and so baroque. There's so much in your needlepoint, with a level of detail very similar to your paintings. Zandra [Rhodes] was saying how she was always impressed with what a good draughtsman you are: your beautiful drawings and paintings show skills that particularly translate into things like needlepoint.

KF I found it very exciting being able to make a textile that was so figurative and could work with all the nuances, reflected light and features of people's faces and all of that.

DN You really can see that in the needlepoint. Another medium you've worked in is mosaic: when did you pick that up?

KF That was when I met Candace Bahouth, an amazing American who has settled in the West Country. I went to visit her and all her furniture was covered in this fine mosaic. There was mosaic around her bathroom sink and I absolutely loved it. I have always loved mosaic, after discovering Gaudí in the late 1960s and '70s: and as you travel around the world it's one of the wonderful flights of fancy you would see. Even in drab or very formal cities you might suddenly see a little mosaic that was just divine, or something wonderful made with tiles in Spain or Holland, and that always attracted me. The porcelain and the images you could make and then put into combinations. So Candace showed me how to make mosaic and I was off – and did a book with her called *Mosaics*.

DN Again, they feature in your house, where there are some really lovely mosaics.

KF That's why I feel the house is a laboratory for colour and pattern in all types of different media, mixing rag rug-making and patchwork; it is all about dealing with colour and pattern arrangements.

DN And you embrace ornament and decoration, often perhaps going against the prevailing trends in terms of style. When people are into minimalism, or whatever is the current style, you are willing to explore ideas of ornament when fashionable types wouldn't necessarily go for it. I think people have always responded to that: as humans, we like adornment.

KF I saw a documentary just the other night on the Art Nouveau movement. It was about the whole notion of making wonderful sprays of flowers on buildings in the Art Nouveau era, the gracefulness and beautiful lines, the nude bodies and the curve of the breast and the hips and all of that sexuality – I loved it, loved it, loved it. Then this new movement came in and NO DECORATION ON ANYTHING, just clean and cold.

DN Exactly. It was all swept away. What's interesting about Art Nouveau is that it is rediscovered in the 1960s, because it just wasn't that fashionable. But it is embraced again, and even psychedelia comes out of it; it influences a whole new generation of artists and designers.

KF There is the most wonderful story about Art Nouveau. There was a famous antique dealer who went to New York with a suitcase full of Art Nouveau glass. These beautiful little vases that were so fabulous, and he knew that everybody was just rediscovering Art Nouveau – this was the late '70s – and people in the know were buying up anything they could find. Anyway, he sold out. He opened his suitcase, and the antique dealers bought everything. He thought it was going to take a few weeks to get rid of this stuff but in the first day it was all gone. He had time to spare as he had bought his ticket for a week away, so he took a walk down 6th Avenue, where he found all these incredible junk shops FULL of Art Nouveau glass. People simply did not know about it, so filled another suitcase, then he called around and said, 'I've just gone home and got more...' – and sold them at collector's prices! I just love that story.

Brandon Mably joined the conversation at this point.

DN Hello Brandon, always great to see you. I wanted to ask that when you first met Kaffe what did you think? When you saw all of his work and all of these things that he did? It must have been rather extraordinary.

Brandon Mably
I'm originally from a small seaside town in Wales. My only city exposure was Cardiff, if anything. London was a dream.

Prior to meeting Kaffe I had been working in America. I was at a bus stop and this tall American – Kaffe – was there. We got talking: what does he do? He's an author and designer, and of course curiosity kicked in. He said his studio was only a couple of blocks away, so when I'm passing by I should just look through the window because he's working on this tapestry. And I thought, 'to hell with that, I'll ring the doorbell'.

My background was in the catering industry, so my initial reaction when I first walked into the studio was that it was like Aladdin's Cave. Everything was out, everything was patterned; there wasn't a plain wall in sight. I hadn't seen that before: the home where I was brought up, in Wales, had brown interior walls; beige, you know, that was the trend back then in the 1970s and '80s. When I came here in 1990 there were carpets piled up, one on another; there were carpets running up the stairs; there were paintings on the walls; pillows stacked up. To me it was a mess!

My initial reaction was that I could make myself useful here and create order. That was my instinct, and because I did not have any clue about Kaffe's history or his experience, I just spoke my opinion and said, 'why don't you try this, why don't you do that?' and he, of course, thought, 'Who is this cheeky guy?'

Everyone else was intimidated but I wasn't. I started to come around on my days off, for about three months, and finally I said 'Can I have a job?' Kaffe said 'I do all the designing – you don't even knit, but I can see that you could be useful, so start on Monday and we'll see what happens'. I thought 'Hmmm, maybe I don't fit in here', but I did – and that was 31 years ago.

DN I imagine your input was in structuring the business and tightening up studio operations?

BM Kaffe had had big years – the TV series, one museum show after another – and I came in at the tail end of that. He wasn't travelling as much as he had been – which was nearly every weekend. In the studio we had four people full time and part-time people coming and going. So what I would do was 'take away': admin, things like shipping and receiving, packaging, just general dogsbody jobs, and gradually did more and more. Then Kaffe stopped teaching his classes, so his travel schedule was open. When an invitation came in from Australia, he said, 'well, if I can take an assistant I'll go' – and to me, 'do you want to go to Australia?'

It was the first time I had taught with Kaffe and he could see that I was a people person. Then we started teaching classes together and it sort of took off. Really running the workshops has been a great part of both our educations, because we learn so much from doing those classes.

DN The connection that you and Kaffe make with people, and what they end up producing in the workshops, is amazing. I think that they probably surprise themselves.

BM Psychologically, it just opens them up. They are totally amazed with what they have achieved but what we are doing is helping them get past the 'NO'.

DN Exactly! Don't you think that through people's whole life they are taught what they can't do, or the rules, or this is how you are supposed to do something? But if they break through that, it's amazing what people can do.

Kaffe Fassett and Brandon Mably on shoot in Fez for *Quilts in Morocco*, 2013

BM We start the class with a short introduction and I say to them: 'Now, you need to know that mistakes leave room for opportunities.' It is a good starting point: you are not allowed to say 'No' – leave yourself open to try.

DN That's a very good point.

You also knit and you've written knitting books yourself. And then you started designing textiles, of course, the quilting fabrics.

BM The fabrics came along through Oxfam. Kaffe and I went out to India to advise Oxfam on developing fabrics but they didn't really take the idea far enough. To cut a long story short, we took the idea to Rowan yarns – our distributors in America – and they took it and built it up.

For about the first four years I was enabling Kaffe to find his voice. The head of the company we were designing for in the US asked 'when are you going to do something, Brandon?' But I didn't feel Kaffe had found his footing yet. Eventually he invited [designer] Philip Jacobs to join us. Their two styles needed something between them, to give them a little bit of breathing space, so I became the 'funky' guy, the primitive. But it was needed: you put those two together and it becomes like an orchestra without a conductor.

DN Now with Philip and you there is a group of designers working under a collective umbrella to create great things, these prints that go into this amazing final product. Were you surprised by the success of the quilting?

BM I still am. I am absolutely astounded. We'll sit and create a piece of artwork; we'll hand-paint it out and it goes off into the ether. It comes back to us four or maybe six months later in fabric form. We then cut that up and put it into an arrangement.

You can't work that out in your head or on the computer: you must literally put that scale next to another scale and see how they speak to one another. Every time it's like creating a piece of abstract art. And then once that is sewn together, we'll take it out into the world and photograph it in a location like Burano in Venice, or Portmeirion in Wales, or Powys Castle, where we've just been. We'll see our artwork in a different environment and I don't feel as if I have anything to do with it!

This exhibition is going to be a celebration of other artists, how they take our work and use it in their own style or for their own creation, and to us that is the highest compliment. There is one lady's work you are going to see from Australia: it's mind-blowing what she does. I mean, honestly, I get a fizz when I see what she has created. She has taken a lot of my work – my designs are particularly appropriate for what she creates – and she cuts the fabric and sews the pieces down. She's a powerhouse living in Sydney: she has a huge business in Malaysia and creates these incredible patchworks just for a bit of relaxation.

DN It must be quite wonderful to create something that then inspires other people?

BM I'm humbled by it. We are planting the seeds, and then they grow their own tree, then their work inspires others: it is incredible. The great thing is that we're learning all the time. When we create a piece of artwork, we don't actually have an idea of where it's going to go. We'll also make one artwork but then create five different colourways.

It all moves so fast. The frustrating thing is being able to keep up with the pace that it is available. We are already working two years ahead.

DN Like all the great designers, you are going forward all the time. Even in the museum world we hope to be two years out for every exhibition: it's the process that takes time.

BM For us the rewarding thing is that we have the pleasure and enjoyment of creating the artwork, then we move on. We go and teach a workshop, we will see somebody and often they have no idea about colour. Although they may have used colour before, they are astounded by our approach. Quite often they are in tears by the end of the

class at what they have actually ended up producing –
it is their work. It can be a spiritual experience.

DN Something from Kaffe's early knits and his other work
is just that power to give people something that they
didn't know was missing, and to open their eyes to
things around them.

BM The other thing is that a lot of people think the word
'colour' is a bit like a swear word, or that colour is
like graffiti. They don't know how to use colour and
until they try their work is lots of shades of white. But
shades of grey can be beautiful. Colour doesn't have
to be something that is really offensive. Colour is
psychological, it affects you in so many different ways.

 We say we are missionaries for colour: our home is
a colour laboratory because we are constantly putting
together recipes, through our world. When Kaffe
started knitting, and coming from being an artist,
he was using yarn to paint with. His knitting looks
intimidating and difficult, but it was all about the
colour. We are very basic knitters: it is the colour that
makes our work look intriguing.

 And throughout his whole career Kaffe has
collaborated. He collaborated with Steve Lovi, he
collaborates with Zoë Hunt, he collaborates with me,
with Liza Prior Lucy. You know we love collaboration!

DN Well, it shows. I think that is also true in a wider sense.
I think the idea of collaboration is something that you
share with all the people who engage with what Kaffe
and you create. The world is lucky that they have Kaffe
and that they have you creating these wonderful works
that they can share.

Fassett on location in Fez for
Quilts in Morocco, 2013

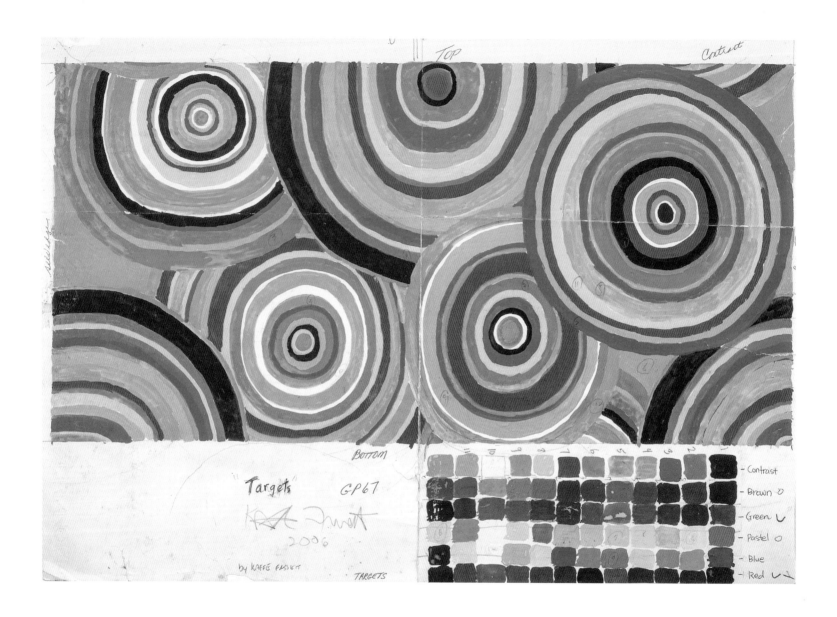

'Targets', original artwork in gouache with colourways

Right on Target quilt by Sally Davis from *Country Garden Quilts*, 2008

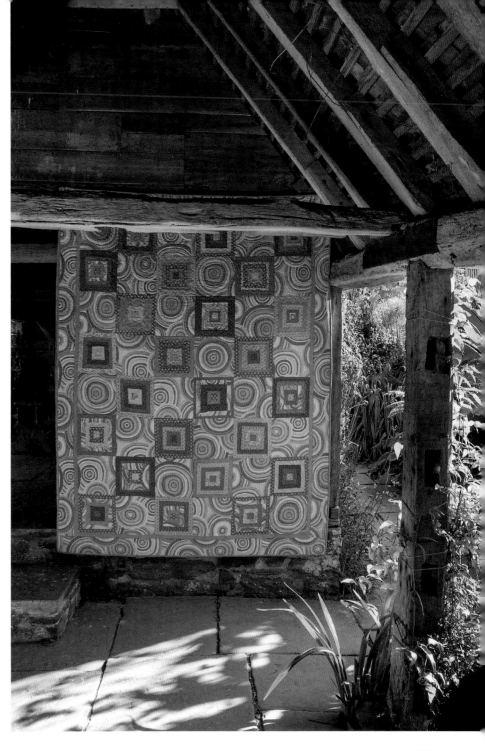

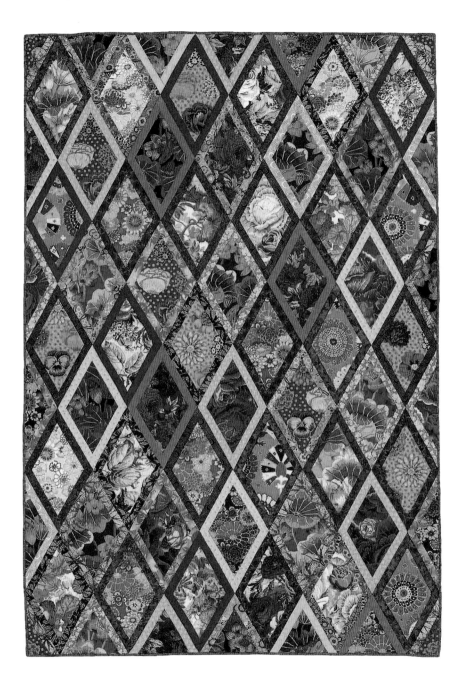

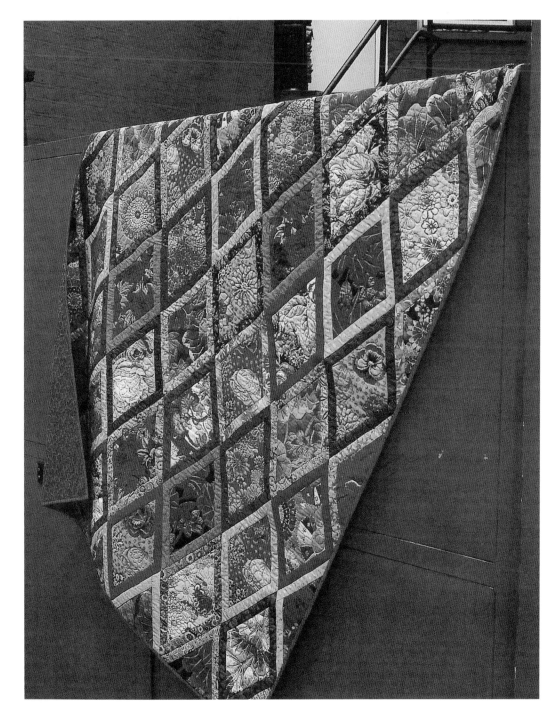

Bordered Diamonds quilt from
Simple Shapes: Spectacular Quilts,
2010 (with detail)

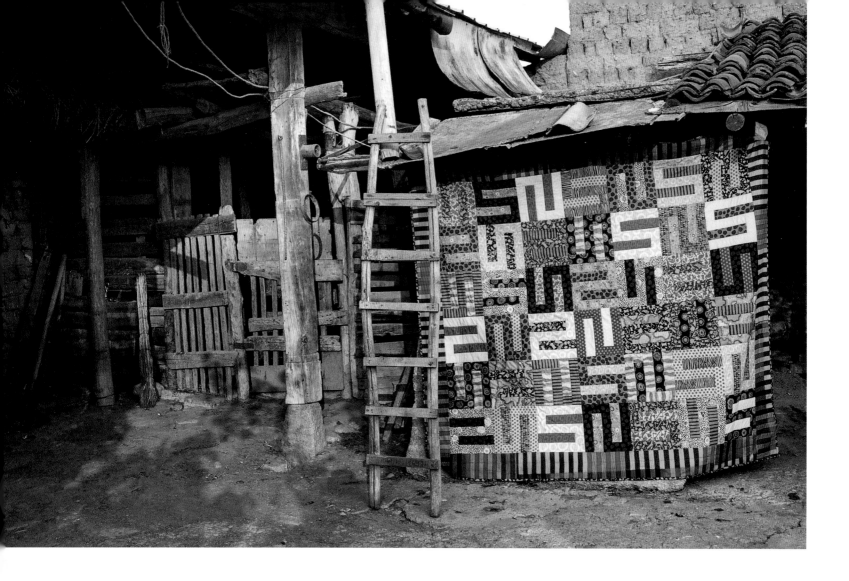

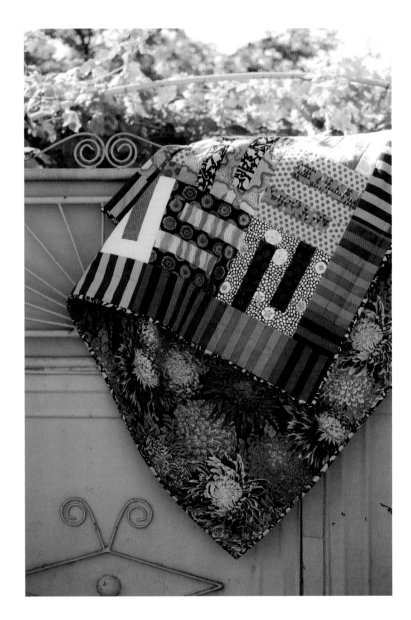

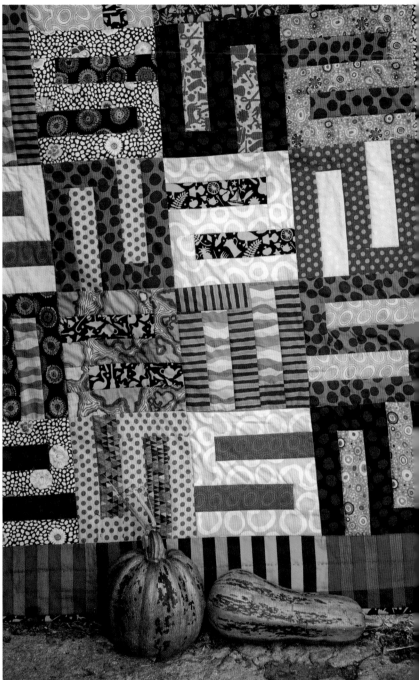

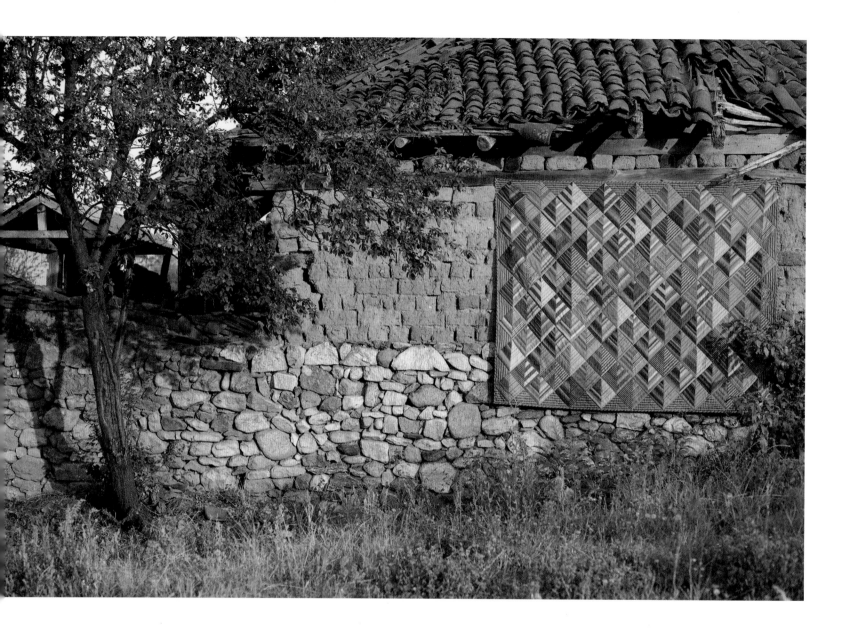

Rich Chevrons quilt from
Kaffe Quilts Again, 2012

Desert quilt from *Quilts in Italy*,
2015

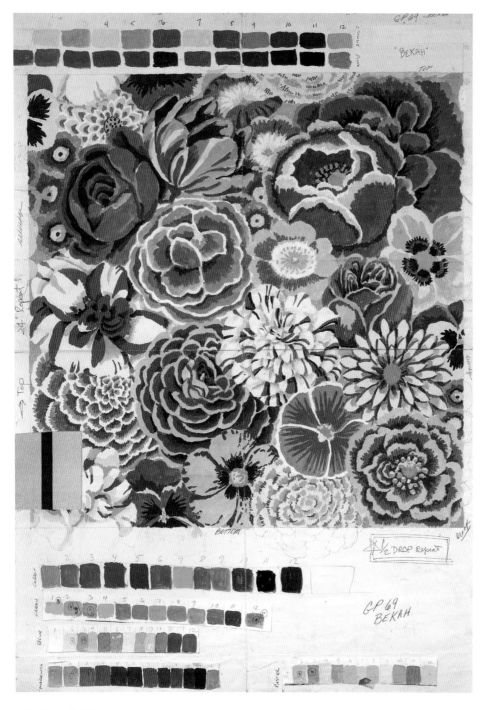

'Bekah', original artwork in gouache with colourways

'Bekah' fabric in violet, green and magenta

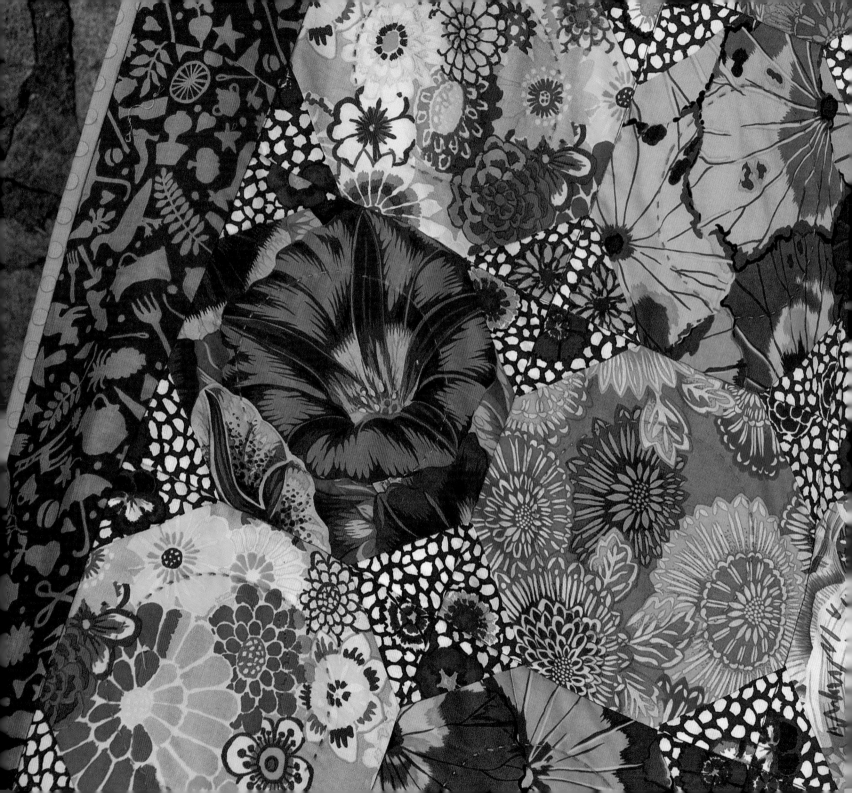

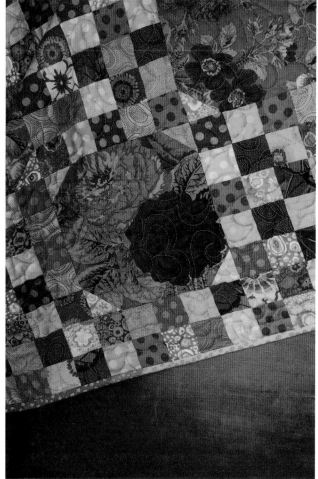

Detail of *Garden Chintz* quilt
from *Kaffe Quilts Again*, 2012

Detail of *Losing My Marbles* quilt
by Julie Stockler from *Quilts in
Italy*, 2015

Detail of *Marmalade* quilt from
Quilt Grandeur, 2013

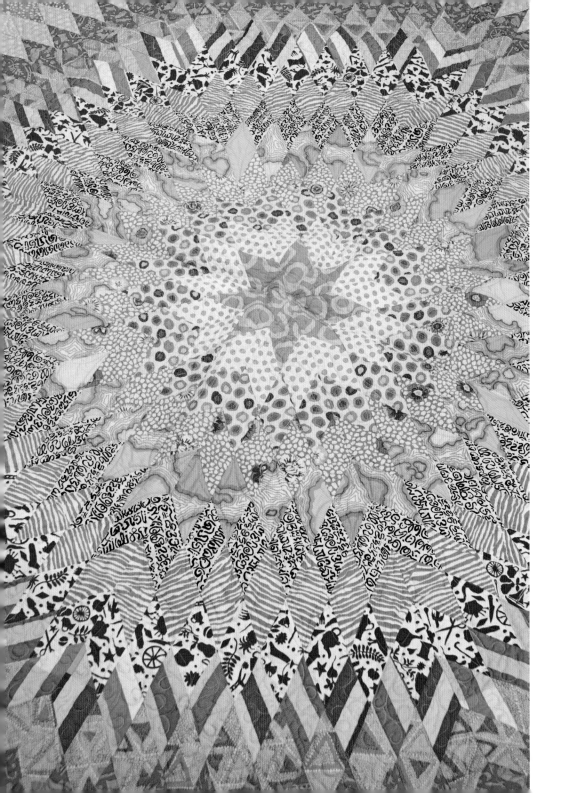

Pastel Big Bang quilt from
Kaffe Quilts Again, 2012

Vintage cloisonné vase from
Kaffe Fassett's personal collection

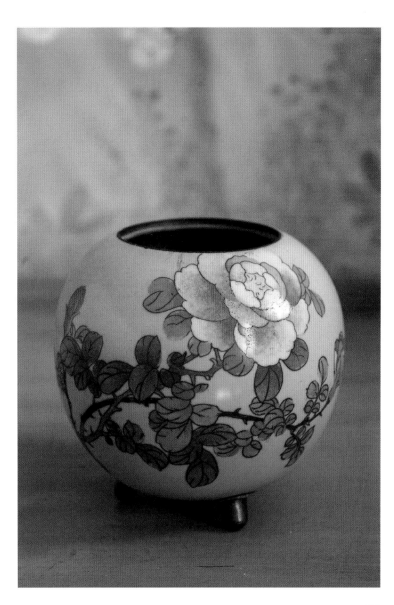

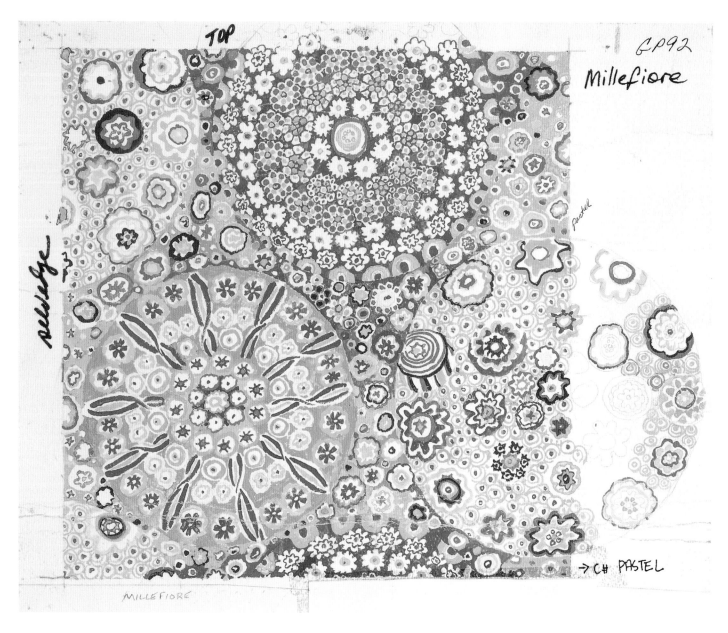

'Millefiore', original artwork
in gouache

'Millefiore' fabric in pastel

'Millefiore' fabric in various colourways

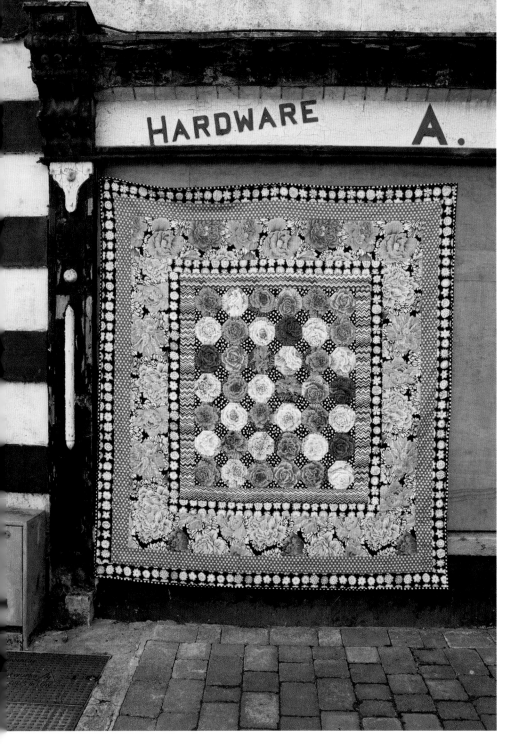

Contrast Brassica Snowball quilt from *Quilts in Ireland*, 2017

Mediterranean Hexagons quilt from *Quilts in Morocco*, 2013

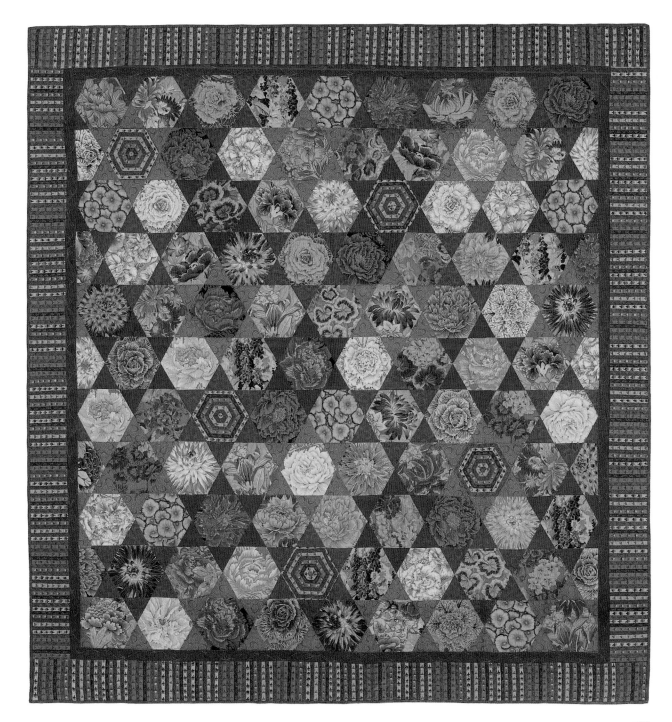

201

Location shot for *Quilts en Provence*, 2010

Lightning quilt from *Quilts en Provence*, 2010

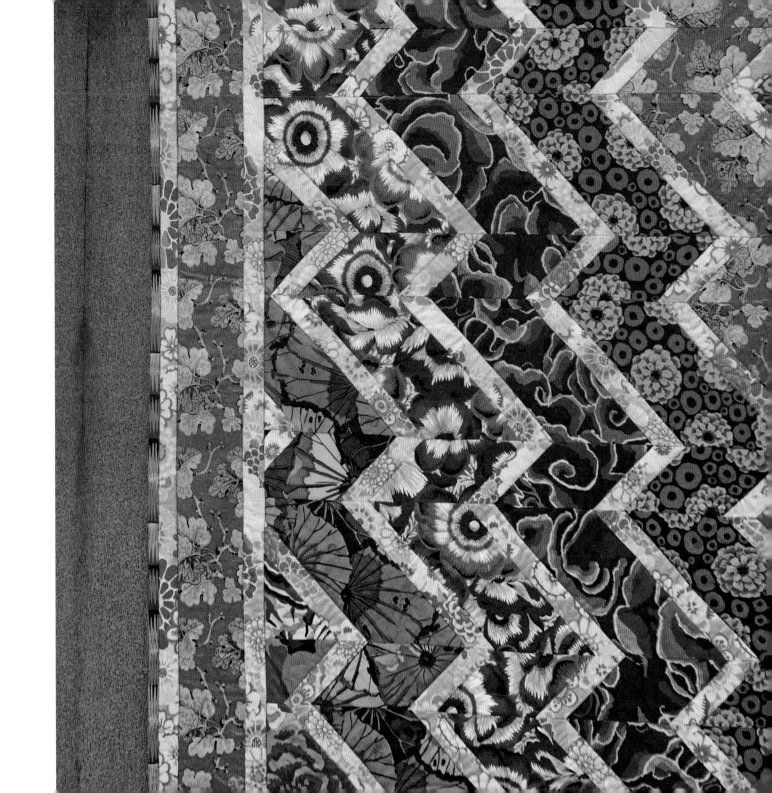

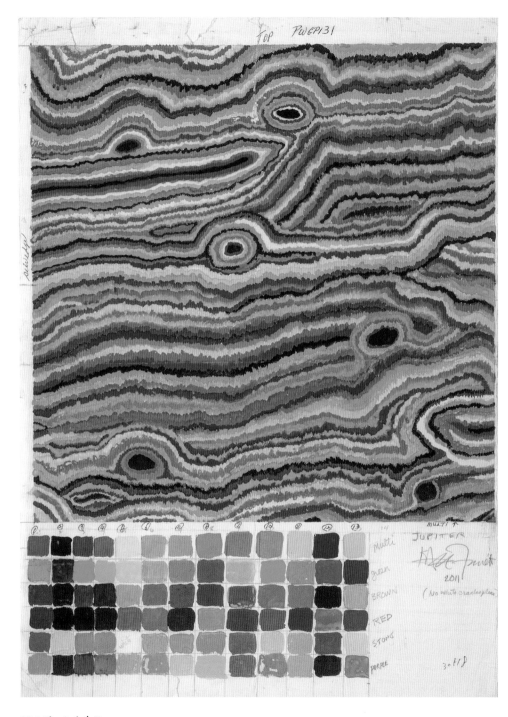

'Jupiter', original
artwork in gouache

'Jupiter' fabric in
various colourways

Location shots for *Quilts in Sweden*, 2011

Dark Windows quilt from *Quilts in Sweden*, 2011

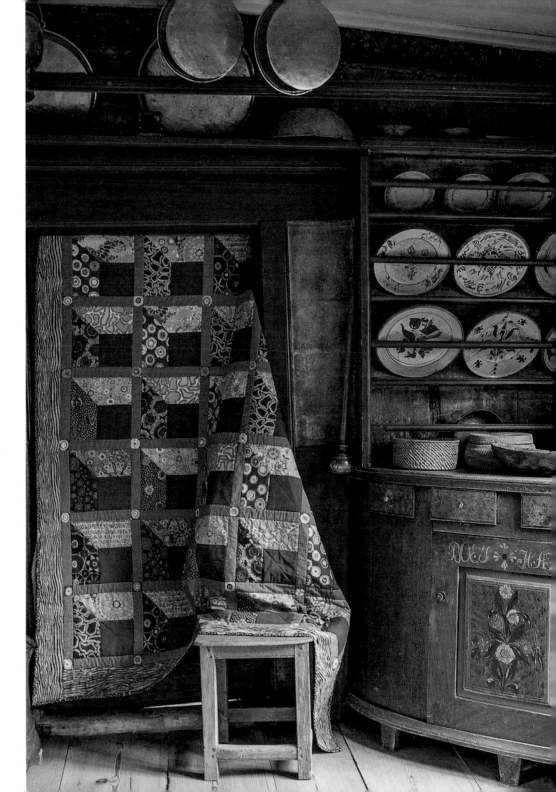

Market stall from *Quilts in Morocco*, 2014

Crosses quilt from *Quilts in Sweden*, 2011

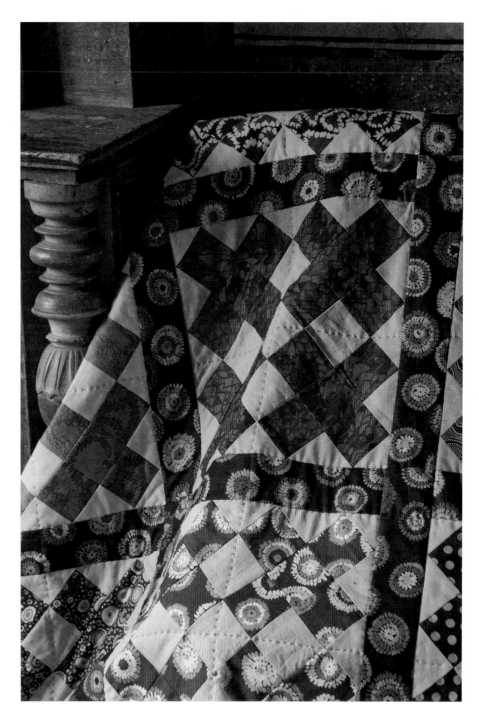

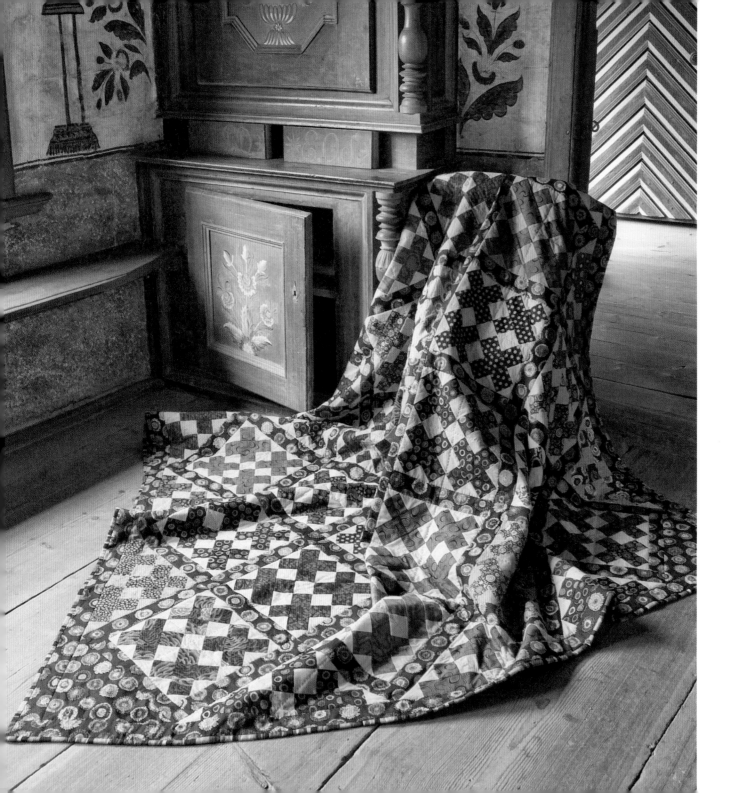

Crosses quilt from *Quilts in Sweden*, 2011 (with detail)

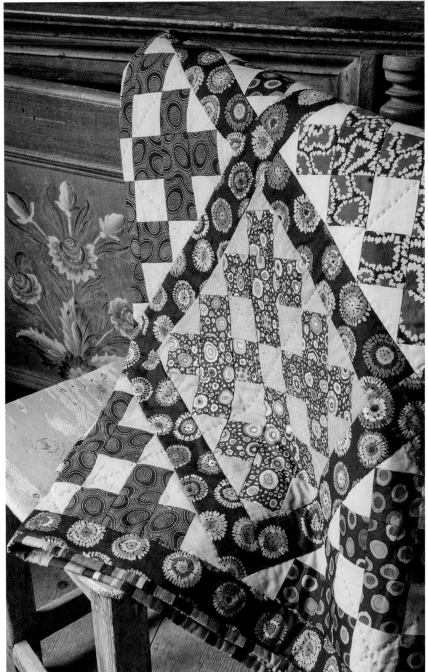

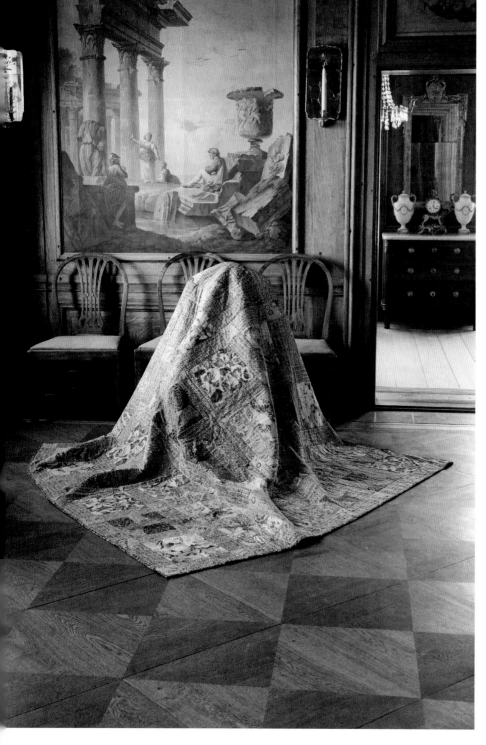

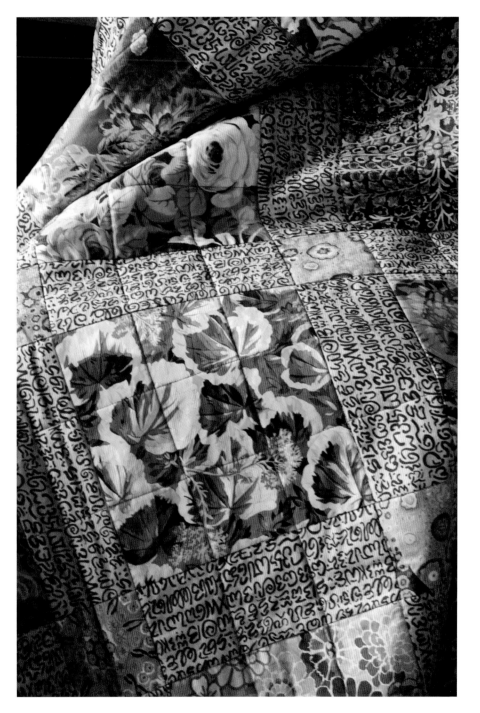

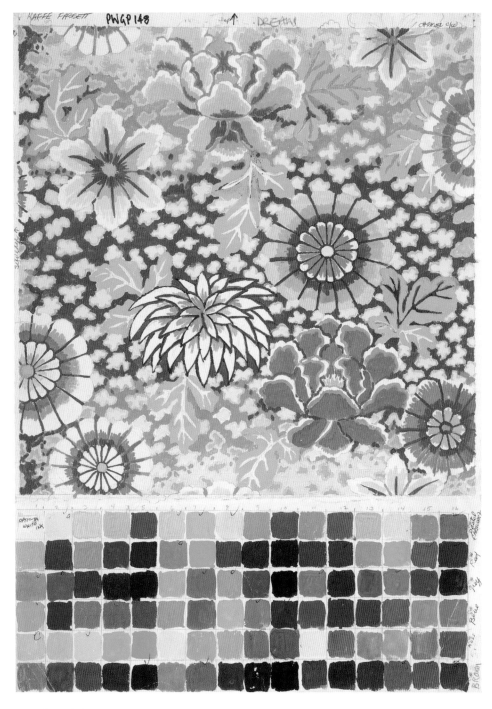

'Dream', original
artwork in gouache

'Dream' fabric in
various colourways

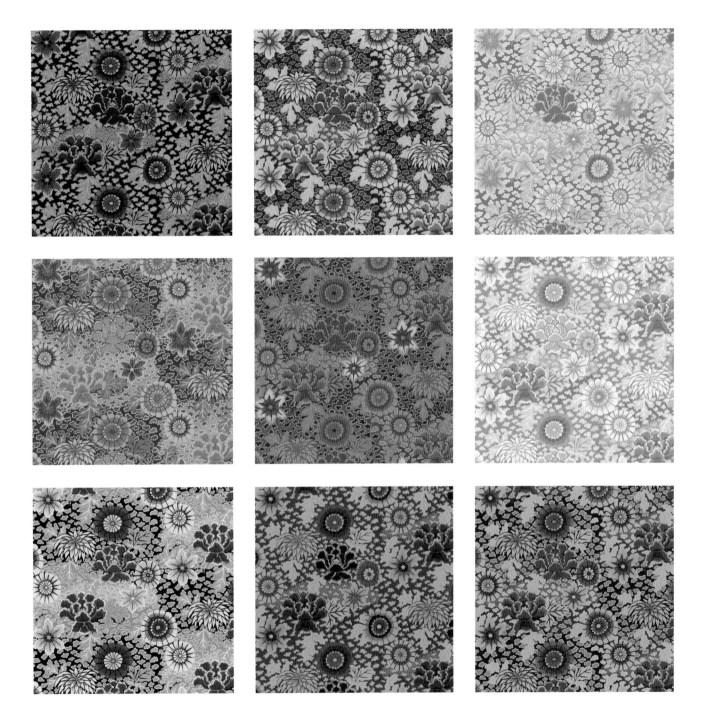

Location shot from *Quilts en Provence*, 2010

Fassett's dining room wallpaper: revival of a vintage Sanderson's wallpaper of a panorama of Kew Gardens

Diamonds quilt from *Welcome Home*, new edition, 2011

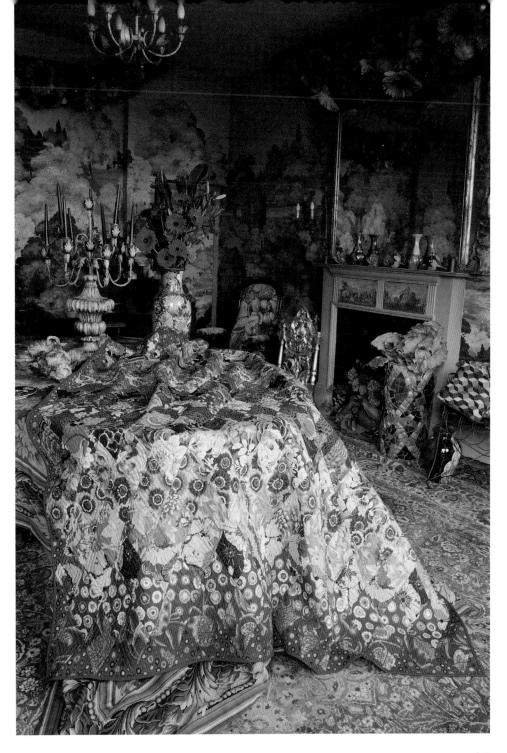

Detail of *Desert* quilt from
Quilts in Italy, 2015

Fassett hanging *Rust Squares*
quilt (with detail) for *Quilts in
Italy*, 2015

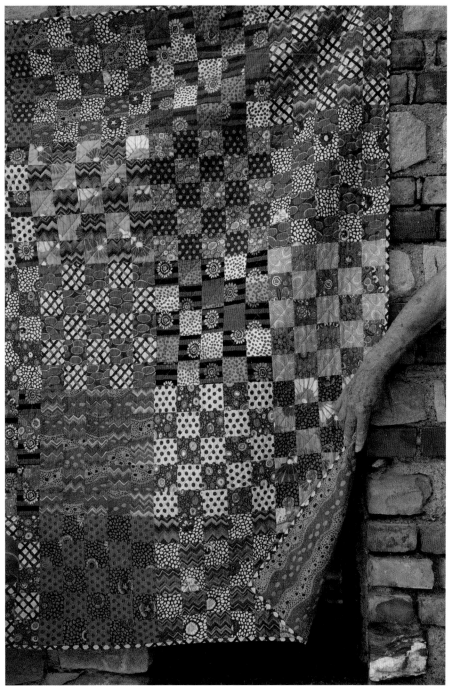

Mirror Squares quilt from
Quilt Grandeur, 2013

Cartwheel quilt by Liza Prior Lucy
from *Quilt Grandeur*, 2013

Sunny Zig Zag quilt from *Quilts in the Cotswolds*, 2019

Hidcote Gardens location shot for *Quilts in the Cotswolds*, 2019

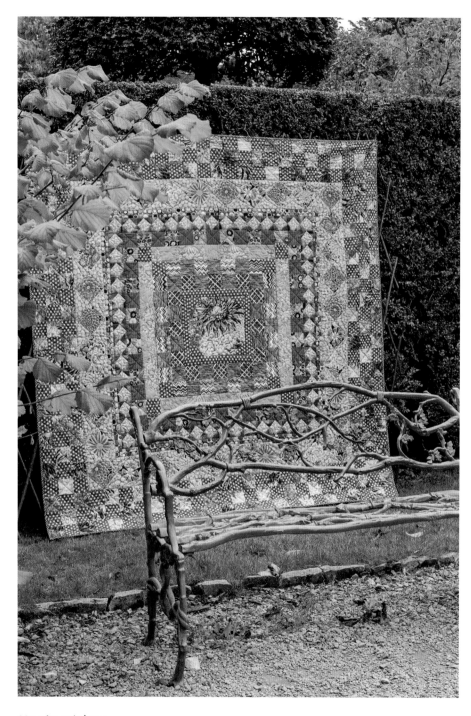

Graphite Medallion quilt by Liza Prior Lucy from *Quilts in the Cotswolds*, 2019

Flowery Jar quilt from *Quilts in the Cotswolds*, 2019

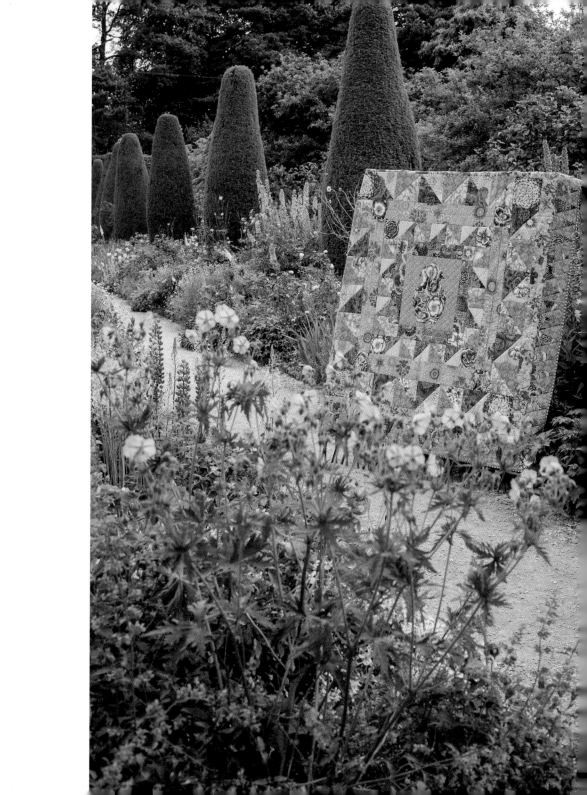

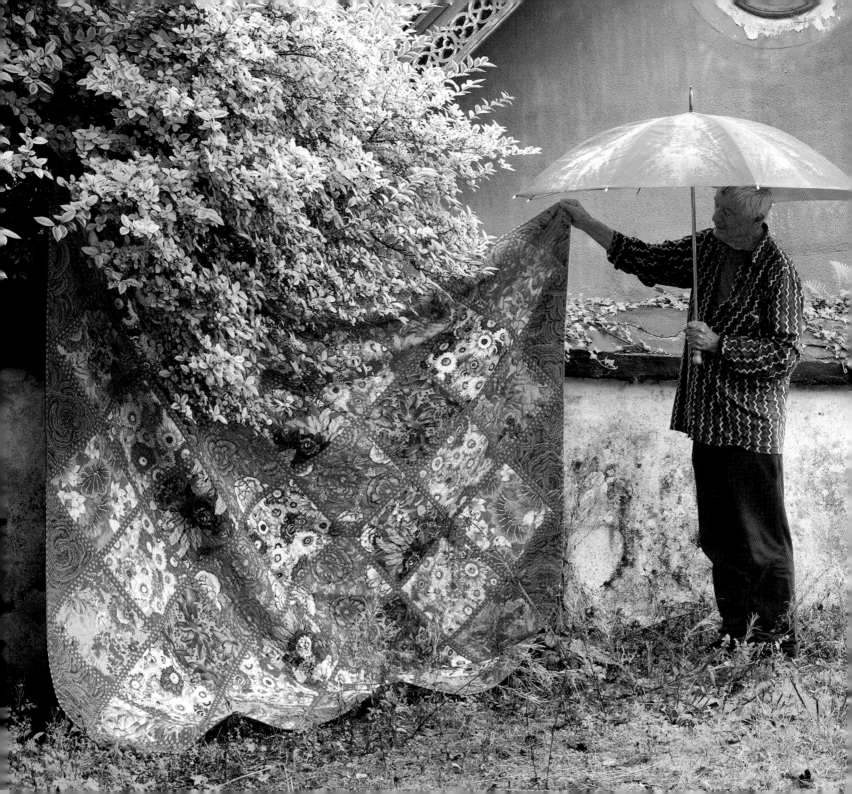

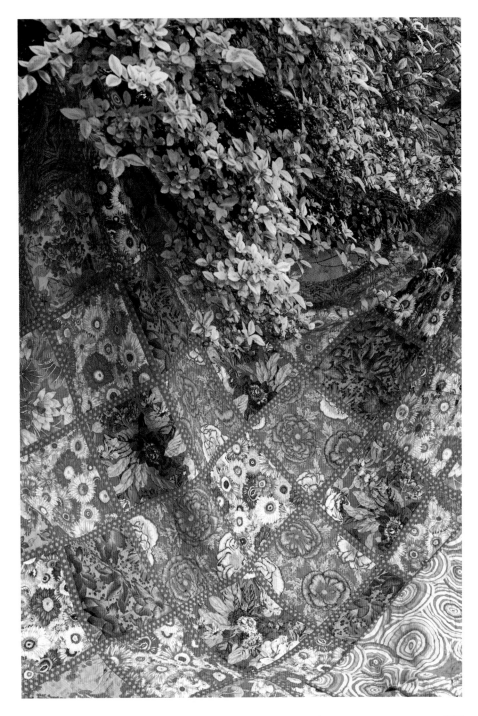

Chelsea Squares quilt from *Quilts in Ireland*, 2017 (with detail)

Kaffe Fassett Exhibitions

1969
Paintings by Kaffe Fassett, Gump's Gallery, San Francisco

1988
Kaffe Fassett at the V&A, Victoria and Albert Museum, London

1991
Kaffe Fassett, Textile Museum of Canada, Toronto

Kaffe Fassett, Museum of Applied Arts, Helsinki, Finland

1992
Kaffe Fassett World Tour, Canadian Craft Museum, Vancouver

1994
A Pattern of Glorious Colours, TextielMuseum, Tilburg, Netherlands

Kaffe's Choice, American Museum in Britain, Bath

1995
Kaffe Fassett, Contemporary Applied Arts Gallery, London

Kaffe Fassett: Textile Art, Davis and Langdale, New York

1997
Kaffe Fassett, Catto Gallery, London

Spring Greens, Devon Guild of Craftsmen, Bovey Tracey

1999
Kaffe Fassett, Catto Gallery, London

Kaffe Fassett, Louise Ross Gallery, New York

2000
Kaffe Fassett, Museum of Garden History, London

2001
The Textile Tradition, Then and Now, American Museum in Britain, Bath

2002
Kaffe Fassett, Catto Gallery, London

2003
Kaffe Fassett, Röhsska Museum, Gothenburg, Sweden

2004
Kaffe Fassett, Steninge Palace, Märsta, Sweden

2005
The Artist and Radio 4, Bankside Gallery, London

Fassett!, Textile Museum of Canada, Toronto

2006
Kaffe Fassett, Prins Eugens Waldemarsudde, Stockholm, Sweden

2007
Kaffe Fassett, Hasselt Fashion Museum, Hasselt, Belgium

Kaffe Fassett, Museum Schloss Fellenburg, Merzig, Germany

2008
Blue and White Show, Victoria Art Gallery, Bath

King Bladud's Pigs in Bath, Bath

Kaffe Fassett, Fries Museum, Leeuwarden, Netherlands

2009
Quiltmania, Quiltmania Editions, Nantes, France

Kaffe Fassett, Museum Schloss Fellenburg, Merzig, Germany

2010
Pour L'Amour du Fil, Quiltmania Editions, Nantes, France

Kaffe Fassett, Silkeborg Museum, Silkeborg, Denmark

2011
Colours, Cornwall Crafts Association, Trelowarren Gallery

Kaffe Fassett Flowers, Charleston, Firle, Sussex

Kaffe Fassett, Sophienholm, Kongens Lyngby, Denmark

2012
Kaffe Fassett, Röhsska Museum, Gothenburg, Sweden

Sitges Quilt Show, Sitges, Spain

Shades of Autumn, RHS Chelsea Flower Show, London

2013

Kaffe Fassett: A Life in Colour, Fashion and Textile Museum, London

Kaffe Fassett, Festival of Quilts, Birmingham

Kaffe Fassett, La Conner Quilt and Fiber Arts Museum, La Conner, Washington

Kaffe Fassett, Quiltmania Editions, Nantes, France

Kaffe Fassett, Jen Jones Welsh Quilt Centre, Pontbrendu

Kaffe Fassett, Welsh Wool Museum, Llandysul

2014

Kaffe Fassett, Aberdeen Art Gallery, Aberdeen

The Colourful World of Kaffe Fassett, American Museum in Britain, Bath

2015

Kaffe Fassett: 50 Years in Colour, Hadeland Glassverk, Jevnaker, Norway

Ancestral Gifts, York Quilters Guild, York

2016

Blanket Statements, San Jose Quilt Museum, San Jose

Kaffe Fassett, Festival of Quilts, Birmingham

2017

Kaffe Fassett meets William Morris, Standen House, East Grinstead

Kaffe Fassett at Mottisfont, Mottisfont Abbey, Romsey

Christmas Decorations, Standen House, East Grinstead

2018

Kaffe Fassett, Jen Jones Welsh Quilt Centre, Pontbrendu

Celebration of Flowers, Victoria Art Gallery, Bath

Kaffe Fassett, Festival of Quilts, Birmingham

Kaffe Fassett, Texas Quilt Museum, La Grange

2019

Kaffe Fassett: Quilts in America, American Museum in Britain, Bath

Kaffe Fassett, Anthropologie, London

2021

Joy is in the Making, Standen House, East Grinstead

Color Duets, Monterey Museum of Art, Monterey

Kaffe Fassett, Festival of Quilts, Birmingham

2022

Colour with Kaffe at Hidcote, Hidcote Manor, Hidcote Bartrim

Kaffe Fassett, Mottisfont Abbey, Romsey

Kaffe Fassett: The Power of Pattern, Fashion and Textile Museum, London

Kaffe Fassett Publications

Glorious Knitting, photography by Steve Lovi, London: Century, 1985 (repr. 1989)

Glorious Knits, photography by Steve Lovi, London: Clarkson Potter, 1985

Kaffe Fassett Glorious Needlepoint, photography by Steve Lovi, London: Century Hutchison, 1987

Kaffe Fassett's Glorious Color for Needlepoint & Knitting, photography by Steve Lovi, New York: Sterling Publishing, 1988

Glorious Color, photography by Steve Lovi, London: Clarkson Potter, 1988

Glorious Colour, photography by Steve Lovi, London: Century, 1988

Kaffe Fassett at the V&A, photography by Steve Lovi, London: Century, 1988

Family Album - Knitting for Children and Adults, photography by Steve Lovi, London: Century, 1989

Glorious Inspiration, London: Ebury Press, 1991

Kaffe's Classics - 25 Glorious Knitting Designs, photography by Tony Boase, London: Ebury Press, 1993

Glorious Interiors, photography by Debbie Patterson, London: Ebury Press, 1995

Glorious Patchwork, photography by Debbie Patterson, London: Clarkson Potter, 1997

Patchwork, photography by Debbie Patterson, London: Ebury Press, 1997

Glorious Knitting, photography by Debbie Patterson, London: Ebury Press, 1999

Welcome Home, photography by Debbie Patterson, Woodinville, WA: Martingale & Company, 1999

Mosaics, photography by Debbie Patterson, London: Ebury Press, 1999

Rowan Patchwork and Quilting Book 1, photography by Debbie Patterson, Holmfirth: Rowan, 1999

Rowan Patchwork and Quilting Book 2, photography by Debbie Patterson, Holmfirth: Rowan, 2000

Passionate Patchwork, photography by Debbie Patterson, London: Ebury Press, 2001

Rowan Patchwork and Quilting Book 3, photography by Joey Toller, Holmfirth: Rowan, 2001

Rowan Patchwork and Quilting Book 4, photography by Mark Scott, Holmfirth: Rowan, 2002

Kaffe Fassett's Pattern Library, photography by Debbie Patterson, London/Newtown, CT: The Taunton Press, 2003

A Colourful Journey, photography by Debbie Patterson, London/Holmfirth: Rowan, 2003

Caravan of Quilts, photography by Debbie Patterson, London/Holmfirth: Rowan, 2004

Kaffe Fassett's V&A Quilts (Museum Quilts), photography by Debbie Patterson London: Ebury Press, 2005

Kaffe Fassett's Quilt Road, photography by Debbie Patterson, London/Holmfirth: Rowan, 2005

Kaffe Fassett's Kaleidoscope of Quilts, photography by Debbie Patterson, London/Newtown, CT: The Taunton Press, 2006

Kaffe Knits Again, photography by Sheila Rock, London/Holmfirth: Rowan, 2007

Kaffe Fassett's Quilts in the Sun, photography by Debbie Patterson, London/Holmfirth: Rowan, 2007

Kaffe Fassett's Country Garden Quilts, photography by Debbie Patterson, London/Holmfirth: Rowan, 2008

Kaffe Fassett's Quilt Romance, photography by Debbie Patterson, London/Holmfirth: Rowan, 2009

Kaffe Fassett's Simple Shapes: Spectacular Quilts, photography by Debbie Patterson, London/New York: Stewart Tabori and Chang, 2010

Kaffe Fassett's Quilts en Provence, photography by Debbie Patterson, London/Newtown, CT: The Taunton Press, 2010

Kaffe Fassett's Quilts in Sweden, photography by Debbie Patterson, London/Holmfirth: Rowan, 2011

Knitting with the Color Guys, with Brandon Mably, photography by Debbie Patterson, London/New York: Sixth & Spring Books, 2012

Dreaming in Colour: An Autobiography, London/New York: Stewart Tabori and Chang, 2012

Kaffe Quilts Again, photography by Debbie Patterson, London/Holmfirth: Rowan, 2012

Kaffe Fassett Quilts Shots and Stripes, photography by Debbie Patterson, London/New York: Stewart Tabori and Chang, 2013

Kaffe Fassett's Quilt Grandeur, photography by Debbie Patterson, London/Holmfirth: Rowan, 2013

Kaffe Fassett's Quilts in Morocco, photography by Debbie Patterson, London/Holmfirth: Rowan, 2014

Kaffe Fassett's Heritage Quilts, photography by Debbie Patterson, London/Holmfirth: Rowan, 2015

Kaffe Fassett's Bold Blooms, photography by Debbie Patterson, London/New York: Abrams, 2016

Kaffe Fassett's Brilliant Little Patchwork Cushions and Pillows, photography by Debbie Patterson, London/Newtown, CT: The Taunton Press, 2016

Kaffe Fassett's Brilliant Patchwork Cushions, photography by Debbie Patterson, London/Holmfirth: Rowan, 2016

Kaffe Fassett's Quilts in Italy, photography by Debbie Patterson, London/Newtown, CT: The Taunton Press, 2016

Kaffe Fassett's Adventures in Color, photography by Debbie Patterson, London/New York: Abrams Noterie, 2017

Kaffe Fassett's Sew Artisan, photography by Steven Wooster, London: Berry & Co., 2017

Welcome Home Kaffe Fassett (new edition), photography by Debbie Patterson, London/Urbandale, IA: Landauer Publishing, 2017

Kaffe Fassett's Quilts in Ireland, photography by Debbie Patterson, London/Newtown, CT: The Taunton Press, 2017

Kaffe Fassett's Quilts in America, photography by Debbie Patterson, London/Newtown, CT: The Taunton Press, 2018

Kaffe Fassett's Sew Simple! Quilts and Patchwork, photography by Steven Wooster, London/Newtown, CT: The Taunton Press, 2019

Kaffe Fassett's Quilts in the Cotswolds, photography by Debbie Patterson, London/Newtown, CT: The Taunton Press, 2019

Kaffe Fassett's Quilts in Burano, photography by Debbie Patterson, London/Newtown, CT: The Taunton Press, 2020

Kaffe Fassett in the Studio, photography by Debbie Patterson, London/New York: Abrams, 2021

Kaffe Fassett's Quilts in an English Village, photography by Debbie Patterson, London/Newtown, CT: The Taunton Press, 2021

Kaffe Fassett's Quilts in Wales, photography by Debbie Patterson, London/Newtown, CT: The Taunton Press, 2022

By Brandon Mably
Brilliant Knits, London: Ebury Press, 2001

Knitting Colour: Design Inspiration from around the World, New York: Sixth & Spring Books, 2006

Further Reading

Black, Sandy, *Knitting: Fashion, Industry, Craft*, London: V&A Publishing, 2012

Bratich, Jack Z., and Heidi M. Brush, 'Fabricating Activism: Craft-Work, Popular Culture, Gender', in *Utopian Studies 22*, no. 2 (2011), pp. 233–60

Bygrave, Mike, Tony Elliott, Jill Liddingdon and Jean McNeil, *Time Out's Book of London*. London: Time Out, 1972

Davies, Hunter (ed.), *The New London Spy: A Discreet Guide to the City's Pleasures*, London: Corgi, 1966

Donald, Elsie Burch (ed.), *Soft Furnishings: Ideas and Fabrics by Designers Guild*, London: Pan, 1980

Ginsburg, Madeleine, *Fashion: An Anthology by Cecil Beaton* (exh. cat., Victoria and Albert Museum, London), London, 1971

Guild, Robin, *Homeworks: The Complete Guide to Displaying your Possessions*, London and New York: Van Nostrand Reinhold, 1979

Hinchcliffe, John, and Angela Jeffs, *Rugs from Rags*, London: Orbis, 1977

Holstein, Jonathan, *Abstract Design in American Quilts: A Biography of an Exhibition*, Louisville, KA: Kentucky Quilt Project 1992

Howell, Georgina, *In Vogue: Sixty Years of Celebrities and Fashion from British Vogue*, London: Penguin, 1978

Jacopetti, Alexandra, *Native Funk and Flash: An Emerging Folk Art*, San Francisco: Scrimshaw, 1974

Katz, Anna, *With Pleasure: Pattern and Decoration in American Art 1972–1985* (exh. cat., Museum of Contemporary Art, Los Angeles), Los Angeles 2019

Klein Barbara, J., *The Carmel Monterey Peninsula Art Colony: A History* (www.tfaoi.com/aa/5aa/5aa300a.htm, accessed 13 February 2022)

Lutyens, Dominic, and Kirsty Hislop, *70s Style and Design*, London: Thames & Hudson, 2009

Marks, Ben, 'Meet the Swedish Artist who Hooked British Rock Royalty on her Revolutionary Crochet', *Collectors Weekly*, 15 March 2021 (www.collectorsweekly.com, accessed 25 January 2022)

Mendes, Valerie D., and Frances M. Hinchcliffe, in collaboration with Lida Ascher, *Ascher: Fabric, Art, Fashion* (exh. cat., Victoria and Albert Museum, London), London, 1987

Moore, James, 'Neo-Sufism: The Case of Idries Shah', *Religion Today*, 3, no. 3 (1986), pp. 4–8 (published online 25 June 2008, doi:10.1080/13537908608580605, accessed 13 February 2022)

O'Connor, Kaori, *The Fashion Guide*, London: Farrol Kahn, 1976

O'Connor, Kaori, *Creative Dressing*, London: Routledge, 1980

O'Neill, Alistair, *London: After a Fashion*, London: Reaktion, 2007

Peach, Andrea, 'What goes around comes around? Craft revival, the 1970s and today', *Craft Research*, 4, no. 2 (1 October 2013), pp. 161–79

Pittaway, Andy, and Bernard Scofield, *Country Bazaar: A Handbook to Country Pleasures*, London, 1974

Pittaway, Andy, and Bernard Scofield (eds), *The Complete Country Bizarre*, London: Astragal, 1976

Rinzler, Alan, *The New York Spy: A Discreet Guide to the City's Pleasures*, London, 1967

Roscoe, Barley, 'Textiles', in *Crafts Council Collection 1972–1985*, London, 1985, pp. 168–75

Rudorff, Raymond, *The Paris Spy: A Discreet Guide to the City's Pleasures*, London: Anthony Blond, 1969

Samuel, Raphael, *Theatres of Memory: Past and Present in Contemporary Culture*, London, Verso, 2012

Schlesinger, Peter, *A Chequered Past: My Visual Diary of the 60s and 70s*, London: Thames & Hudson, 2004

Shah, Idries, *Reflections*, London: Zenith, 1968

Stanley, Montse, *Reader's Digest Knitter's Handbook: A Comprehensive Guide to the Principles and Techniques of Handknitting*, London: David & Charles, 1993

Steele, Romney, *My Nepenthe*, Kansas City: Andrews McMeel, 2009

Thanhauser, Sofi, *Worn: A People's History of Clothing*, London: Allen Lane, 2022

Webb, Iain, *Bill Gibb: Fashion and Fantasy*, London: V&A Publishing, 2008

Williams-Ellis, Clough and Amabel, *The Pleasures of Architecture*, London: Jonathan Cape, 1924

A tree, yarn-bombed for a charity fund-raiser in Port Eliot, 2012

Acknowledgements

This book would not have been possible without the support, encouragement, and contributions of many people to whom I owe a great deal of thanks.

First and foremost, I would like to thank the inspirational Kaffe Fassett, who supported this project from its conception and very generously gave his time and access to his archival material and studio work. I also thank Brandon Mably for his time and valuable insight, and a big thank you to Bundle Backhouse at the Kaffe Fassett studio for all her able assistance and ready answers to my innumerable questions.

A huge thank you to Debbie Patterson, whose stunning photographs and insightful essay add so much to this book.

To Mary Shoeser and NJ Stevenson, colleagues whom I hold in high esteem, for their brilliant contributions exploring Kaffe's career. Thanks also to Suzy Menkes, Dame Zandra Rhodes, Sarah Campbell, Tricia Guild, Hugh Ehrmann, and Janet Lipkin for their contributions.

Another note of thanks to my colleagues at the Fashion and Textile Museum – Melissa French, Marta Martin Soriano, Charlotte Neep, Beth Ojari, Victoria Rodrigues-O'Donnell, Georgia Allen – for being such a great group to work with; to Newham College of Further Education and Paul Stephen for supporting our work at the museum.

Thank you to the team at Yale for believing in this project and making it a reality: Mark Eastment, Anjali Bulley, Johanna Stephenson, Julie Hrischeva; and to Mike Crook and Charlie Smith at Charlie Smith Design for designing this beautiful book.

And a final enormous thank you to Dominic Fenton, for everything.

Flower Vase collage, using some of the current Kaffe Fassett Collective Fabrics, created as a poster for the *Kaffe Fassett: The Power of Pattern* exhibition at the Fashion and Textile Museum, 2022

Index

Page numbers in *italic* refer to the illustrations

Photo and Caption Credits

First published by Yale University Press 2022
302 Temple Street, P.O. Box 209040
New Haven, CT 06520-9040

47 Bedford Square, London WC1B 3DP
yalebooks.com | yalebooks.co.uk

Published to accompany the exhibition
Kaffe Fassett: The Power of Pattern
at the Fashion and Textile Museum, London
23 September 2022 – 12 March 2023
and at Dovecot Studios, Edinburgh
31 March – 8 July 2023

ISBN 978-0-300-26712-9 HB
Library of Congress Control Number: 2022937871

10 9 8 7 6 5 4 3 2
2025 2024 2023

Designed by Charlie Smith Design
Editor Johanna Stephenson
Printed in Italy

MIX
Paper | Supporting
responsible forestry
FSC® C015829
www.fsc.org